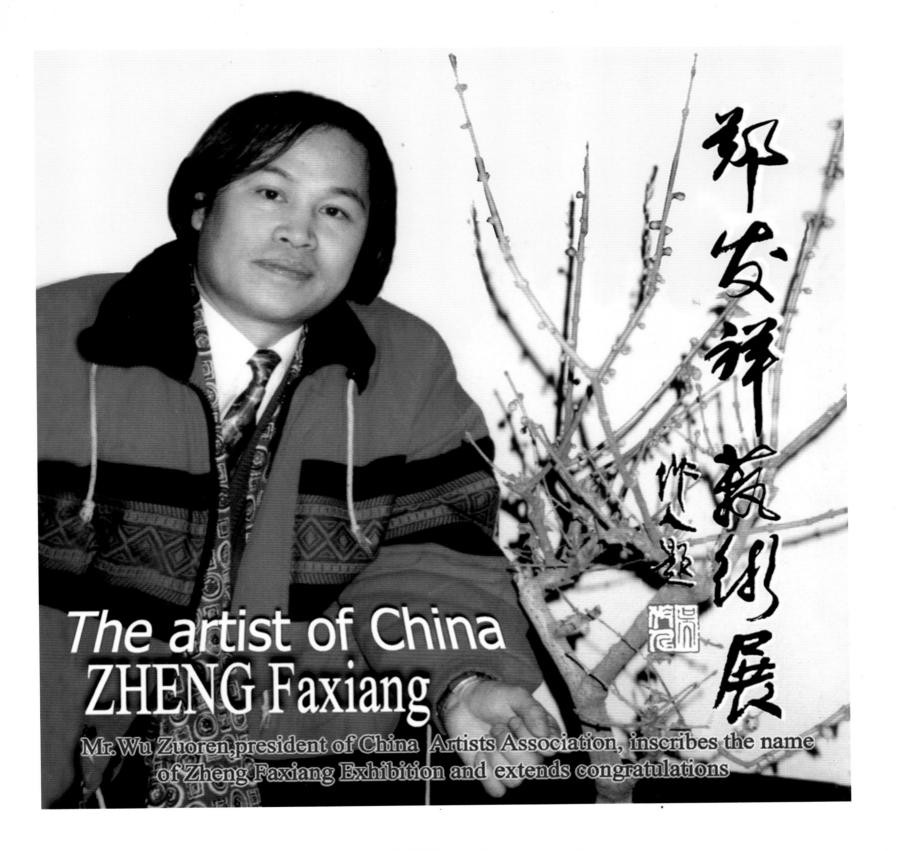

The artist of China
ZHENG Faxiang

Mr. Wu Zuoren, president of China Artists Association, inscribes the name
of Zheng Faxiang Exhibition and extends congratulations

鄭發祥個人照

鄭發祥梅花書畫集

蔣緯國題

发祥画梅

启功 题

賀鄭發祥「梅之韻」藝術展
圓滿成功

丹青梅花民族魂

馬英九

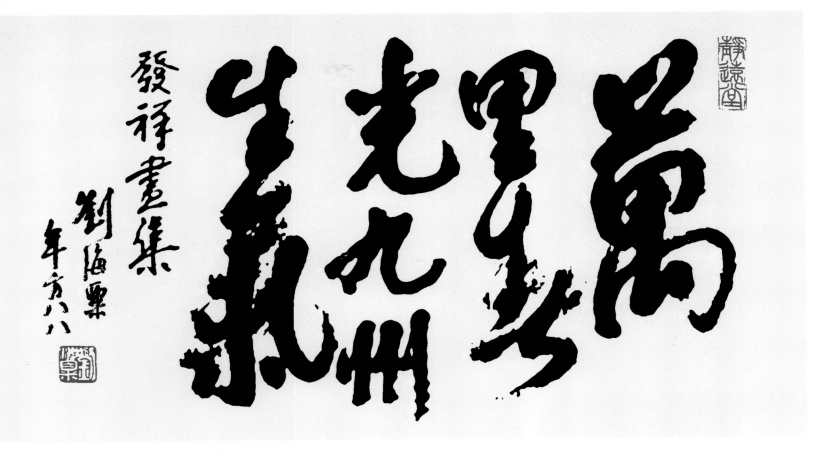

萬里生
光九州
生氣

發祥畫集
劉海粟
年方八八

劉海粟 題詞

賀郇發祥梅之韻藝術展圓滿成功　丹青梅花民族魂　馬英九

　　梅花是中華民族的一個民族精神的象徵。她不畏冷風和嚴寒，笑傲怒放，具有斗雪傲霜的精神，她的香是從苦寒中來的。梅花高洁，化作泥土也依然香如故，而且還具有高尚的情操，只是為了報春而不與群花爭艷。我以為對于一個有心的人來說，站在詠梅的詩書畫面前，使人的性靈起到了一種激勵和凈化作用。我們現在正處在一個改革開放的建設時代，需要象梅花那樣傲霜斗雪的堅定信念，去克服前進中的各种困難；也更需要象梅花那樣高洁自律的崇高品格，繁榮我們的祖國。所以我要畫下去⋯⋯直到永遠。

鐵骨精神
民族之魂

稻白關山月書賀戊年八十五年

關山月　題詞

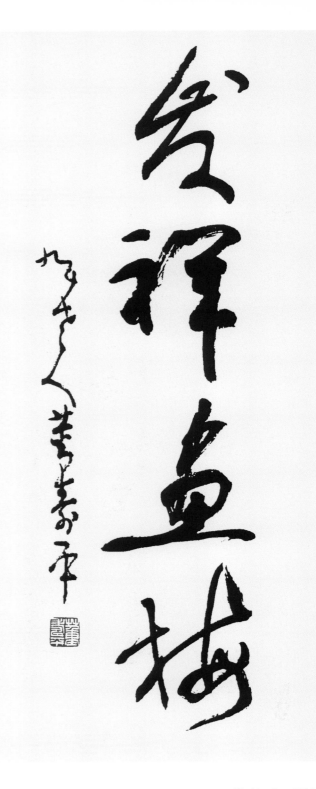

發祥畫梅

九九六董壽平

董壽平　題詞

2

洋洋畫梅
沈鵬

鐵骨錚錚鑄國魂
為鄧芙祥梅花大展題
周魏峙

簡 介

　　鄭發祥、(字雲凌)號梅道士、研究員、福州市人(祖籍福建長樂)，當代旅美著名藝術家。在華盛頓、紐約、倫敦、巴黎、莫斯科、北京、東京、新加坡、曼谷、臺北等世界各地舉辦過30多次個人大型藝術展。現爲：世界藝術家聯合會秘書長、環球出版集團董事長(美國)、紐約曼哈頓大學、華盛頓東南大學、日本櫻山書道院客座教授、香港(海外)文學藝術家協會高級顧問、北京幽州藝術院院長、中國翰圓碑林藝術總監、長樂發祥教育基金會名譽會長、美中人才協會理事長、中國美術家協會名譽理事。

　　作品曾榮獲：美國紐約世界藝術博覽會銀獎、歐洲東方藝術大賽特別優秀獎、中華全國梅花藝術大賽特等獎、中華咏梅詩書畫大聯展金獎。華盛頓電視臺、美國中文電視臺、新加坡電視臺、泰國電視臺、日本電視臺、中國中央電視臺CCTV "中國報道" "今日中國" 祖國各地 "等欄目均有人物專題播出。美國文摘、世界日報、星島日報、僑報、明報、人民日報、光明日報、中國文化報、文藝報、中國藝術報、美術報、中華英才、中國時代、中國之友、跨世紀人才等300多家報刊以及中央人民廣播電臺、中國國際廣播電臺、中國廣播廣播網等都詳細報道過鄭發祥的藝術成長道路。2003年被中華愛國工程聯合會授予 "杰出愛國人士" 榮譽稱號。
代表作品：
"冬韵" 梅花人類的精神與力量（珍藏于聯合國大厦）（紐約）
"梅之韵" 珍藏于華盛頓電視臺（華盛頓）
"紅梅報春" 珍藏于中國駐美國大使館（華盛頓）
"冰魂頌" 珍藏于中國駐英國大使館（倫敦）
"丹青梅花鑄國魂" 珍藏于中國駐紐約總領館（紐約）
"鐵梅暖千家" 珍藏于紐約中華公所（紐約）
"冰魂浩態古今頌" 珍藏于中國國家文物局（北京）
"國香贊" 珍藏于天安門城樓（北京）
"春韵" "晴雪" 珍藏于人民大會堂（北京）
"香溢環宇" 珍藏于中南海（北京）
"春冬韵" 珍藏于釣魚臺國賓館（北京）
"飛雪迎春到" "梅花歡喜漫天雪" 珍藏于毛主席紀念堂（北京）
"梅" "白梅" 珍藏于中國美術館（北京）
"國香頌" 珍藏于中國國家文化網（北京）
"紅梅贊" "壽者相" 珍藏于中國人民革命軍事博物館（北京）
"南國春深" "天下爲公志傳千秋" 珍藏于中國國民黨中央黨部（臺北）
"馨香浸月色" "春之聲" 珍藏于中國民族博物館（北京）
鄭發祥主要出版書目：
《鄭發祥梅花書畫集》人民美術出版社出版《鄭發祥畫集》中國畫報出版社出版
《當代藝術家鄭發祥》華韵出版社出版《鄭發祥世界藝術之旅》環球出版社出版
《鄭發祥梅花書畫冊》環球出版社出版
鄭發祥作品重要拍賣記録：
2004年美國紐約單幅梅花圖12.86萬美元，尺寸1100×960mm
2005年5月中國鄭州春拍會單幅梅花圖65萬元人民幣，尺寸1100×960mm
2003年中國深圳單幅梅花圖34萬元人民幣，尺寸1100×640mm
2005年中國鄭州秋拍會單幅梅花圖12萬元人民幣，尺寸680×360mm
1998年泰國曼谷單幅鬆鶴圖28.8萬泰珠，尺寸1330×980mm

BRIEF INTRODUCTION

Mr. Faxiang Zheng, styled himself Yunling, assumed name Meidaoren (the Plum Blossom doctrine fellow), research fellow, native place Fuzhou City (ancestral home Changle City, Fuzhou Province), being a contemporary Chinese nationals residing in USA, famous artist, held more than 30 times individual large-scale art exhibits in various places all over the world such as in Washington, New York, London, Paris, Moscow, Beijing, Tokyo, Singapore, Bangkok, Taipei and etc. Mr. Zheng is now secretary-general of The World Arts Federation, board chairman of The Huan Qiu (Whole World) Publication Group (USA), visiting professor with New York Manhattan University, Washington Southeast University and Japanese Saku Mountain Academy of Classical Learning, senior advisor of Hong Kong (Overseas) Literateurs & Artists Association, dean of Beijing You Zhou Art Academy, art majordomo of China Hanlin Academy, honor president of Changle Faxiang Education Foundation, director of US-Sino Talents Association and honor director of China Artists Association.

Mr. Zheng's works have honorably won silver prize on the World Art Expo, New York, USA, especially excellent prize on European Oriental Art Grand Contest, top grade prize on China National Plum Blossom Art Grand Contest, and gold prize on Chinese Grand United Exhibition of Poetry, Painting and calligraphy of "Ode to the Plum Blossom ". Washington TV, US Chinese TV, Singapore TV, Thailand TV, Nippon TV, and Columns such as "China News", "China Today", "Homeland Places" and etc. on CCTV, have ever broadcasted Mr. Zheng's Character Special Topics. More than 300 newspapers and periodicals such as The Reader's Digest (USA), The World Daily, The Star Island Daily, The Overseas Chinese News, The Ming News, The People's Daily, Guangming Daily, China Culture News, Literature News, China Art News, Art News, Chinese Talents, China Age, China's Friends, the Cross-Century Talents and etc., as well as Central People's Broadcasting Station, China International Broadcasting Station, China Broadcasting Network and etc. all have particularly reported Mr. Zheng's art-shaping road. Mr. Zheng was awarded by Chinese Patriotic Project League a honor title of "the Outstanding Patriotic Personage".

Mr. Zheng's representative works are:

"Winter Rhyme" Plum Blossom is human spirit and power (treasured up in U.N. Mansion) (New York)

"Plum Blossom's Rhyme"treasured up on Washington TV (Washington)

"Red Plum Blossom Reports Spring" treasured up in China Embassy to Washington (Washington)

"Ode to the Icy Soul "treasured up in China Embassy to the U.K. (London)

"Red and Green Plum Blossom Founds the National Soul "treasured up in New York Consulate General (New York)

"Iron Plum Blossom warms Thousands of Households"treasured up in New York China Mansion (New York)

"Ode to the Past and Present with Icy Soul and Bright Posture" treasured up in China National Cultural Relics Administration (Beijing)

"Commending the National Fragrance" treasured up on Tiananmen Gate Tower (Beijing)

"Spring Rhyme" "Clear Snow" treasured up in the Great Hall of the People (Beijing)

"Spring overflows the World" treasured up in Zhongnanhai (Beijing)

"Spring & Winter Rhyme"treasured up in Diao Yu Tai State Guesthouse (Beijing)

"The Flying Snow welcomes Spring" "Plum Blossom Enjoys Snow all over the Sky"treasured up in The Chairman Mao Memorial Hall (Beijing)

"Plum Blossom" "White Plum Blossom" treasured up in China Art Gallery (Beijing)

"Ode to the National Fragrance" treasured up in China National Cultural Network (Beijing)

"Commending the Red Plum Blossom" "Looks of The God of Longevity"treasured up in the Chinese People's Revolution Military Museum (Beijing)

"Southland Late Spring" "The Whole World as One Community, and the Ideal is Handed down to a thousand years"treasured up in the Central Committee Headquarter of China KMT (Taipei)

"Strong and Pervasive Fragrance Soaks the Moonlight"treasured up in China Nationalities Museum (Beijing)

Zheng Faxiang main published bibliography:

"Zheng Faxiang Plum Blossom Painting & Calligraphy Collection ", published by the People's Arts Publishing House

"Zheng Faxiang Paintings Collection" published by China Pictorial Publishing House

"Contemporary Artist Zheng Faxiang" published by Hua Yun Publishing House

"Zheng Faxiang's World Art Journey " published by Huan Qiu (The Whole World) Publishing House

"Zheng Faxiang Plum Blossom Painting & Calligraphy Volume"published by Huan Qiu (The Whole World) Publishing House.

Important auction records of Zheng Faxiang's works:

In 2004, New York, USA, single piece of Plum Blossom Picture - $128600, size - 1100×3960mm

In May, 2005, China Zhengzhou Springtime Auction Meeting, single piece of Plum Blossom Picture - ¥650000, size - 1100×3960mm

In 2003, Shenzhen, China, single piece of Plum Blossom Picture - ¥340000, size - 1100×2640mm

In 2005, China Zhengzhou Autumn Auction Meeting, single piece of Plum Blossom Picture - ¥120000, size - 680×1360mm

In 1998, Bangkok, Thailand, single piece of Pine & Crane Picture B 288000, size - 1330×980mm.

丹青梅韵鑄精神

——記畫梅聖手鄭發祥

　　梅花是人類大自然中的花木之一。古往今來畫梅者甚多，可謂高手競秀。然而被現時媒體冠以"梅聖"者，唯中國藝術家鄭發祥先生耳。

　　鄭發祥，字雲凌，號梅道人。先後就讀于中央美術學院、中國藝術研究院研究生部。現任中國國家人事部中國人才研究會藝術家學部委員會主任委員、中國國際藝術家研究中心理事長、美國世界藝術家聯合會執行主席、環球出版社總編輯、北京幽州藝術院院長。

畫梅，不但要達到反映自然和表現自我的統一，而且貴在創新，自成一家。傳統畫梅，在表現自我方面雖然有用梅寄寓高潔、堅貞的人格美者，但大多數則用梅來表現個人的幽閒、清寒和孤芳等情懷。鄭發祥畫梅，在結合梅的自然美特徵來抒情寓意方面大膽推陳出新，獨闢蹊徑。他賦予梅以强大的生命氣息、時代精神和中華民族的高貴品格，使梅花作品進入了反映主旋律的藝術角色。

　　鄭發祥爲了使梅作承載起新的美學使命，通過艱苦細致的實物觀察感悟，將自己的理想情懷同作爲藝術載體的梅的形神反復契合、交融，終于創造了一種物我統一、寓意鮮明、形象生動的嶄新意象造型。

龍是中華民族的象徵。畫梅的幹枝的技法中有"曲如龍"之説。鄭發祥抓住龍梅這一藝術聯系的契機，把"曲如龍"的技法加以擴張升華，將具有新時代中華民族風貌神采的巨龍形象化入整個梅的主幹造型，創造出了獨特的具有神威雄風的幹枝藝術語言。他以梅的幹枝的自然特徵爲基調，高于生活，誇張創意，賦予幹枝鬆柏般的形神氣勢，使之格外粗壯挺拔，頂天立地，蒼勁剛健，盤曲回旋，宛若巨龍升空出世，騰躍飛卷，勢不可遏。幾乎每幅畫中的這種氣勢雄健的在强烈運動感的幹枝，都譜出了一曲曲巨龍騰躍的雄壯交響樂。鄭發祥爲梅的幹枝造型時，采用了没骨、骨墨、虛實綫條以及渲染等技法，强化了鐵幹虬枝的蒼勁剛健氣質。這種藝術手法，進一步突出了中華民族久經血火磨煉、不畏艱難險阻、頑强奮鬥的精神品格。

鄭發祥創作的梅的花朵，是一種折射時代美艷光華的新穎藝術語言。傳統畫梅的花朵的技法，多用簡筆點垛法和圈勾法。這樣畫出的梅的花朵形態雖然不會簡潔傳神佳作，但造型却大同小異。鄭發祥畫梅的花朵則活用古典成語，兼收中西畫風，將綫條造型與水彩畫、油畫的技法相結合，融進方位透視、明暗質地、暈染映襯等技巧，以更豐富、更有表現力的造型藝術手法，全方位表現梅花的形貌神采。他這樣畫出的梅的花朵，幾乎朵朵有立體感，瓣瓣綻現神采。

　　古人品梅，有花朵貴稀不貴繁、以疏美之説。而鄭發祥畫的梅的花朵，往往在畫面上多層次、多方位繁盛群集。整個畫面仿佛是一幅幅絢爛耀眼的彩錦，輝映着祖國繁榮昌盛的時代光華，襯托着百業俱興、群星燦爛的改革開放之光，迸發着各族人民的蓬勃朝氣與昂揚活力。重彩繁花群落間，那剛勁的幹枝盤旋伸展，猶如巨龍在流霞中遨游，尤爲雄奇壯觀。

　　鄭發祥的梅作，畫面大都是全方位布置景物。如果景物中有天地山川時，梅總是處于立地接天的顯眼近景位置，天地山川皆爲遠景，造成了一種梅爲乾坤主宰的效果。他既用定點透視法，又用動點透視法，甚至突破時空限制來構圖，大大拓展了有限畫面的藝術容量。這樣一來，他的梅作便形成一種壯幹勁枝奔來眼底、溢彩繁花鋪天蓋地的奇特構圖風格。這種構圖使整個畫面的景物闊大雄渾、宏偉壯觀、神透形顯、情意酣暢，最大限量地展示了梅花的形神美、韻律美和氣質美。這種繪畫的構圖藝術美，正符合表現人類社會的博大襟懷、雄偉氣魄的需要，正是振興大業蓬勃發展這一重大主題的恰當的藝術表現形式。

　　通觀鄭發祥的梅作，既能領悟到梅花寓興功能大拓展所達到的新的思想感情高度，又能引人進入與此相應的超越造化、氣韻生動的梅魂勝境。有了這樣的審美感受，對于鄭發祥的梅作進入中國駐美國、中國駐英國大使館和中國國家文物局、中國美術館、天安門城樓、人民大會堂、中南海、釣魚臺國賓館和海内外博物館、藝術館等長期收藏和展覽，便會覺得自然而然了。對于中外幾百種媒體專題報道鄭發祥的繪事業績并稱作"梅聖"，也就會覺得名符其實了。

中共中央文獻研究室中央文獻出版社總編輯　郭永文　2000年12月5日于北京

6

Painting of Plum Blossom Expresses National Soul
—— Note of Mr. Faxiang Zheng, the plum blossom painting saint

The plum blossom is one of traditional hot subject matters of traditional Chinese painting: "three cold-winter friends – pine, bamboo and plum blossom". Of all ages, those who have painted the plum blossom are very many, and it can be called that master-hands contest the excellence. However, that who is headed as "the plum blossom painting saint" is only Mr. Faxiang Zheng, native of Changle City, Fujiang Province.

Mr. Faxiang Zheng, styled himself Yunling, assumed name Meidaoren (the Plum Blossom doctrine fellow). He studied successively in China Calligraphy and Painting University Teaching by Correspondence, Central Academy of Fine Arts and Xu Beihong Studio and the Graduate Students Dept. of China Art Academy. He is now appointed director of the Artists Academic Committee under China Talents Academy of the Ministry of Personnel of the People's Republic of China and director-general of China International Artists Research Center.

Painting the plum blossom not only needs to achieve unification of reflecting the nature and representing one's self, but also to be valuable in innovation and be unique in one's style. In traditionally painting the plum blossom, in aspect of representing one's self, although there were those who use the plum blossom to imply the noble, faithful personality beauty, but the majority uses the plum blossom to represent the gentle and serene, impoverished and self-admired affection. Mr. Faxiang Zheng painting the plum blossom, in aspect of combining the plum blossom's natural beauty character to express one's emotion and imply meaning, bravely gets rid of the stale and brings forth the fresh, and develops a new style. He endows the plum blossom with a powerful life flavor, time spirit and Chinese national noble character, making the plum blossom works coming into an artistic role that reflects the main rhythm.

In order to allow the plum blossom works to bear a new aesthetic mission, Mr. Zheng repeatedly tallied and blended own ideal and affection with the shape and spirit of the plum blossom as an artistic carrier, through the arduous and careful observation and feeling of the practicality, and finally created a kind of new imago sculpting of unifying the substance and own self, brilliant moral and lively image.

Dragon is the symbol of Chinese nationality. In skill to paint the plum tree branches, there is a saying of "bending as dragon". Grasping the artistic contact of dragon and plum tree, Mr. Faxiang Zheng expands and sublimes the skill of "blending as dragon", visualizing the huge dragon that has style, features and expression of Chinese nationality in new age as a trunk sculpting of a whole plum tree, and created the unique artistic language of trunk branches that have invincible might and majestic appearance. He, taking the natural character of the plum blossom tree trunk branches as a keynote and exceeding the life, exaggerates and creates meaning, and endows the trunk branches with the pine-cypress-likely vigor of appearance and spirit. This makes the trunk branches especially thick and strong, tall and straight, of indomitable spirit, vigorous and energetic, tortuous and whirling, just liking the huge dragon being of blastoff and born, of buckjump and flying, and advancing irresistibly. Such trunk branches of powerful vigor and of strong moving sense in almost every piece of painting, all chart more and more majestic symphonies of buckjump of the huge dragon. When sculpting the plum tree trunk branches, Mr. Zheng used skills such as absence of bone, bone ink, false and true lines, romance etc., strengthening thus the vigorous and energetic temperament of the iron trunks and curly branches. Such artistic technique further gives prominence to the spirit and character for Chinese nationality to experience for a long time the annealing trails and tribulations by the blood and fire, to not fear hardship and dangerous, difficult road and to indomitably struggle.

The created by Mr. Faxiang Zheng plum's flowers are a artistic novel language that refracts the pretty, colorful brilliance of the age. The traditional skill to paint the plum's flowers mostly uses the brush's spot piling method and the encircling and hooking method. For the painted in this way plum's flowers' shape, there is although no lack of terse and vivid excellent works, the sculpting is largely identical but with minor differences. Mr. Faxiang Zheng painting the plum flowers use exactly the classical idioms, accepting concurrently Chinese and Western painting styles, combine the skill of line sculpting with the skill of watercolor painting and oil painting, and blend skills such as the azimuth perspective, light and shade texture as well as the faintly dyeing and setting-off etc. This is a rather rich sculpting artistic technique of more expressive force, which represents in full azimuth the plum blossom's appearance and expression. With painted by him in this way the plum's flowers, almost every flower has third dimension, and every petal bursts expression.

For the ancients to enjoy the plum blossom, there is a saying of that the flowers are valuable in being rare not in being numerous, and taking the scattering as a beauty. The painted by Mr. Faxiang Zheng plum's flowers sometimes bloom and throng on menu in multilayer and multiazinuth. The entire menu, being as though gorgeous and dazzling color brocades, shines the homeland's well-off era splendor, sets off the reform and opening's scenery for all kind of industries to prosper and for group of starts to be resplendent, and spurts flourishing youthful spirit and high-spirited energy of all national people.

Mr. Faxiang Zheng's plum blossom works mostly dispose in full azimuth sceneries on the menu. If there are field, hill and river in scenery, the plum blossom is always located in a showy close shot position of standing on the earth and connecting the sky, and with the sky, earth, hill and river all being establishing shot, producing thus a kind of effect of that the plum blossom is master of the universe. He uses both the stabling points scenography and the moving points scenography, and even breaks through space-time restriction for composition of a picture, developing thus greatly the artistic capability of the limited menu. In this way, His plum blossom works form a kind of vagary style of composition of a picture for the strong trunks and vigor branches to rush at the eyeground and for the excessively color numerous flowers to blot out the sky and cover up the earth. Such composition of a picture makes the whole menu's sceneries being broad and forceful, grand and spectacular, being of spirit penetrating and shape showing as well as of affection with easy and verve, thus bringing forth mostly the plum blossom's appearance and spirit beauty, rhythm beauty and temperament beauty. Such painting artistic beauty of composition of a picture is namely in compliance with demand of the broad mind and majestic verve of Chinese nationality, and is namely grave subject matter's right art representing form for re-energizing the great undertaking and vigorously developing.

Generally viewing Mr. Faxiang Zheng's plum blossom works, we can both comprehend new ideological and feeling height the great development of the plum blossom's function to imply the re-energizing achieves, and can enter into the corresponding the plum blossom soul's wonderful resort of exceeding the Creator and vivid artistic conception. Having such aesthetic experience, forMr. Faxiang Zheng's plum blossom entering into U.N. Mansion, China Embassy to Washington, China Embassy to U.K., China National Cultural Relic Administration, China Art Gallery, Beijing Tian'anmen Gate Tower, the Great Hall of the People, Zhongnanhai, Diao Yu Tai State Guesthouse, the Chinese People's Revolution Military Museum, China Nationalities Museum and numerous overseas and home museums and art salons etc. for collection, we can feel, it comes very naturally. And for that numerous home and abroad media reported in special topics Mr. Faxiang Zheng's painting outstanding achievements and called him as "The plum blossom saint", we can also feel, it is worthy of the name.

中共中央文獻研究室
中央文獻出版社總編輯 郭永文
The Literatures Research Chamber of the Central Committee of the Communist Party of China
The Central Literatures Publishing House
Chief editor Guo Yongwen

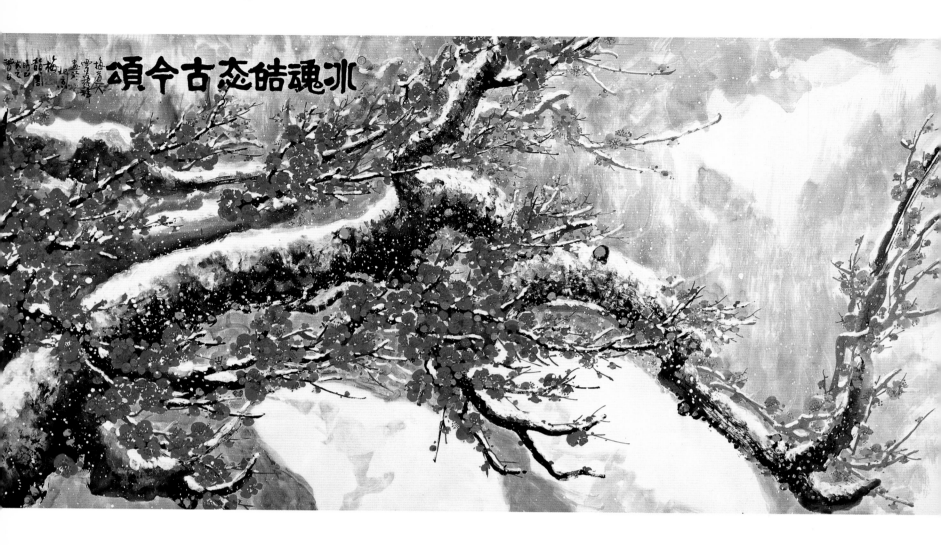

8

冰魂皓態古今頌　　680mm × 1360mm

Ode to the Past and Present with Icy Soul and
Bright Posture　　(680mm × 1360mm)

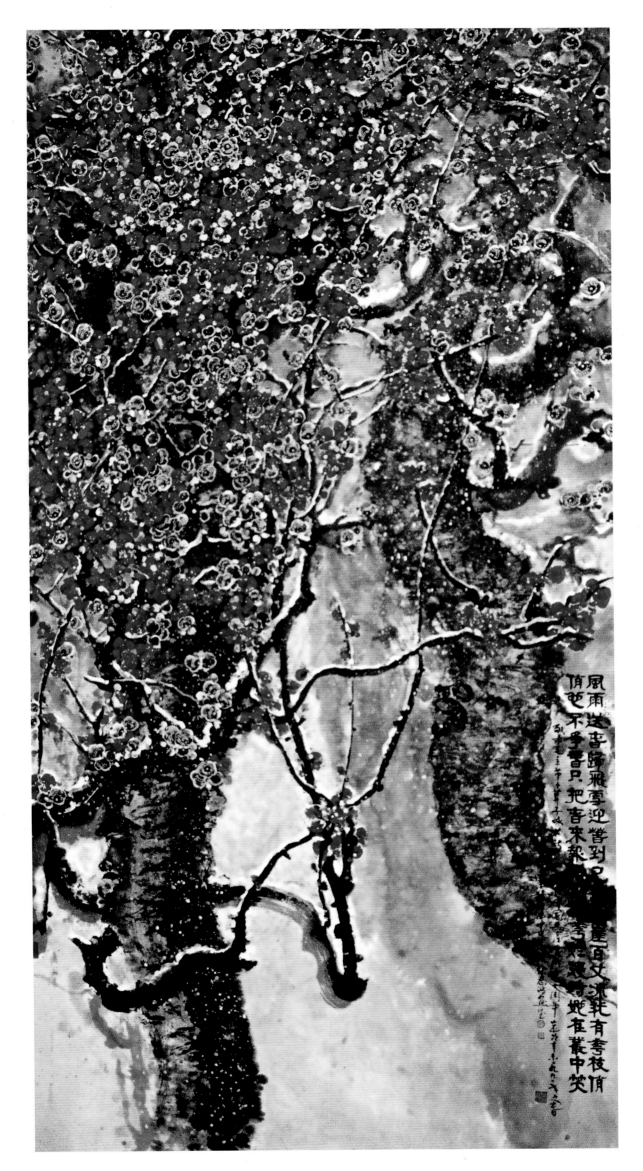

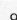

飛雪迎春到

1320mm × 2640mm

Flying Snow Welcomes Spring

（1320mm × 2640mm）

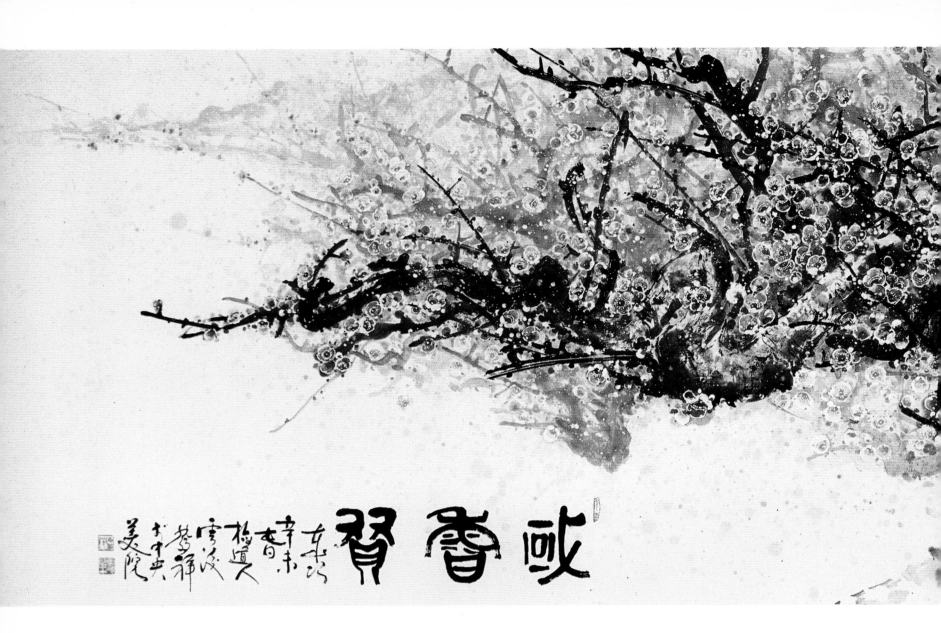

岐香賢

國香贊　1100mm × 3960mm

Commending the National Fragrance 1100mm × 960mm

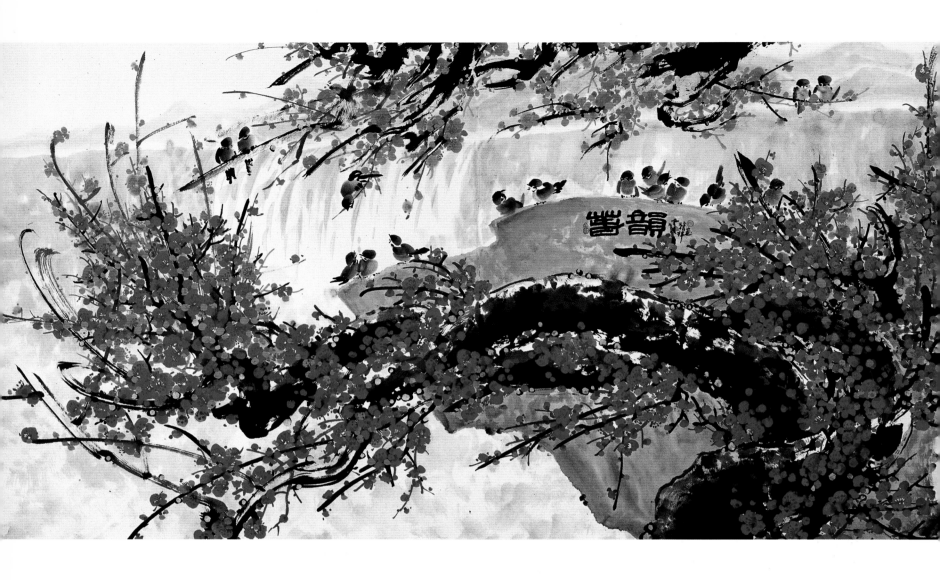

12

春韵
1320mm × 2640mm

Spring Rhyme
（1320mm × 2640mm）

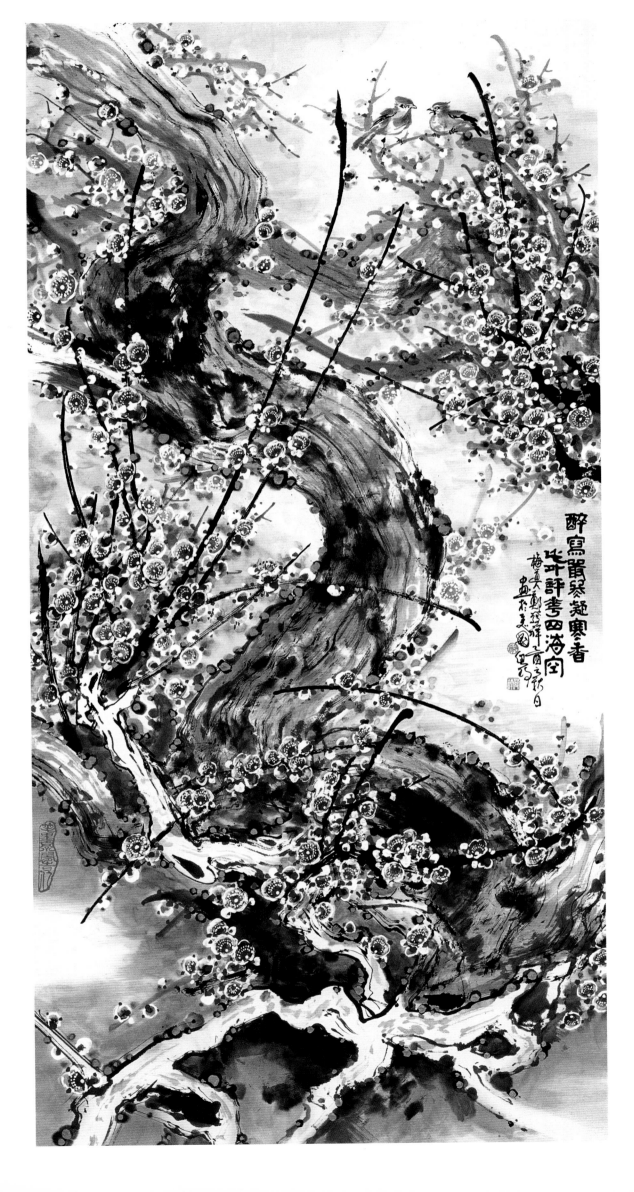

13

醉寫春秋筆帶香
660mm × 1330mm

Drinking–painting by Style of
Writing in Which Sublime Words
with Deep Meaning with Brush
with Fragrance （660mm ×
1330mm）

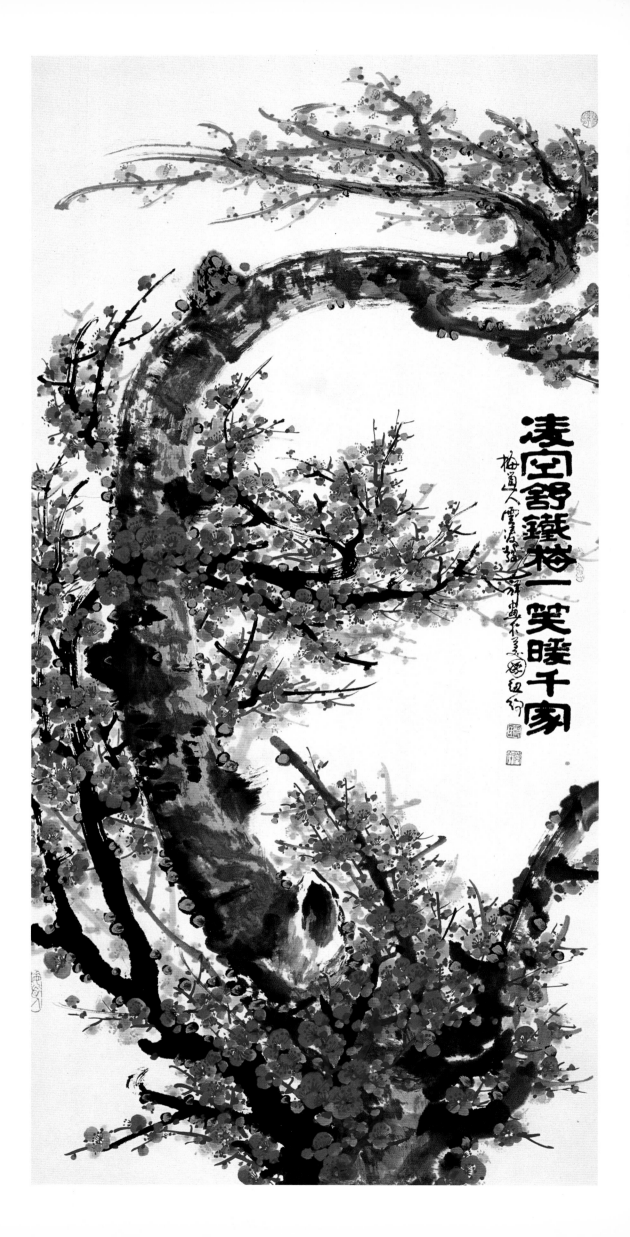

14

凌空鐵梅、一笑暖千家
660mm × 1330mm

Iron Plum Blossom, Being High
up in the Sky, and a Laugh Warms
Thousands of Householders.
（660mm × 1330mm）

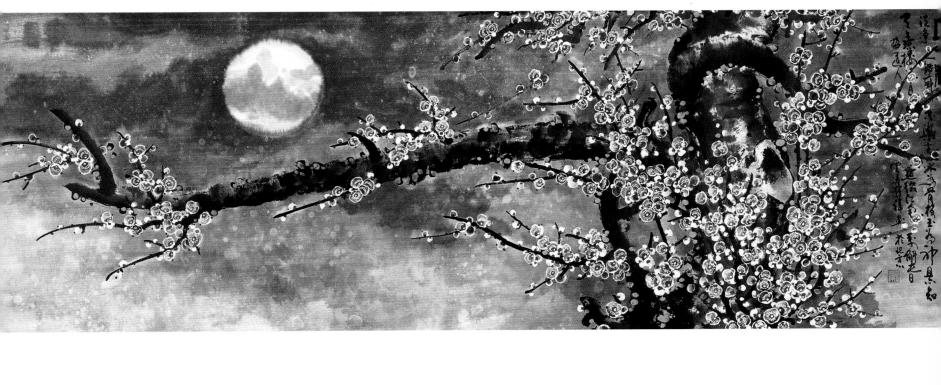

月光梅
680mm × 1360mm
Moonlight Plum Blossom
（680mm × 1360mm）

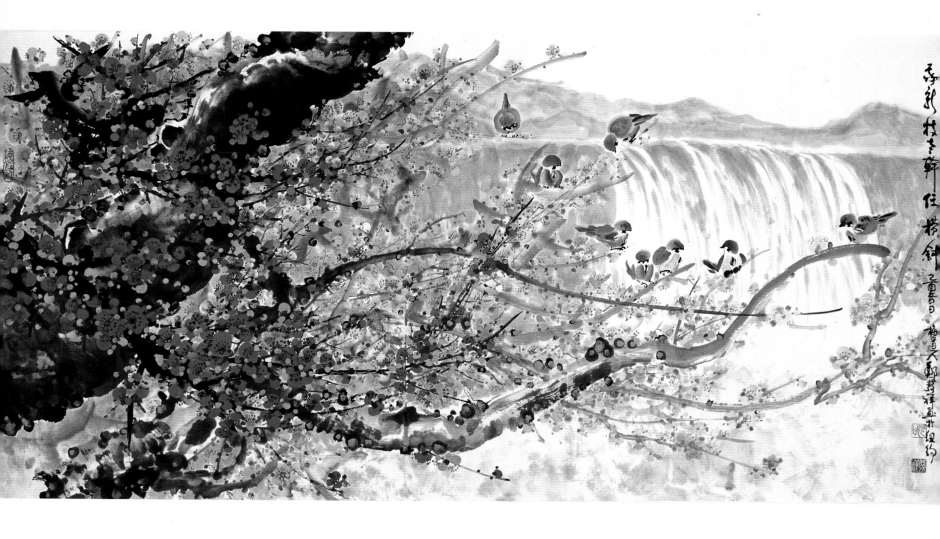

春潮
660mm × 1330mm

婀娜之氣（右頁圖）
660mm × 1330mm

Spring Tide
（660mm × 1330mm）

Graceful Temperament（detail）(right)
（660mm × 1330mm）

16

潇洒淋漓画笔
梅花雪最宜人
枝头半日の
温纯洁净等坐
庚辰春梅道人
雲溪
祥画於
北京

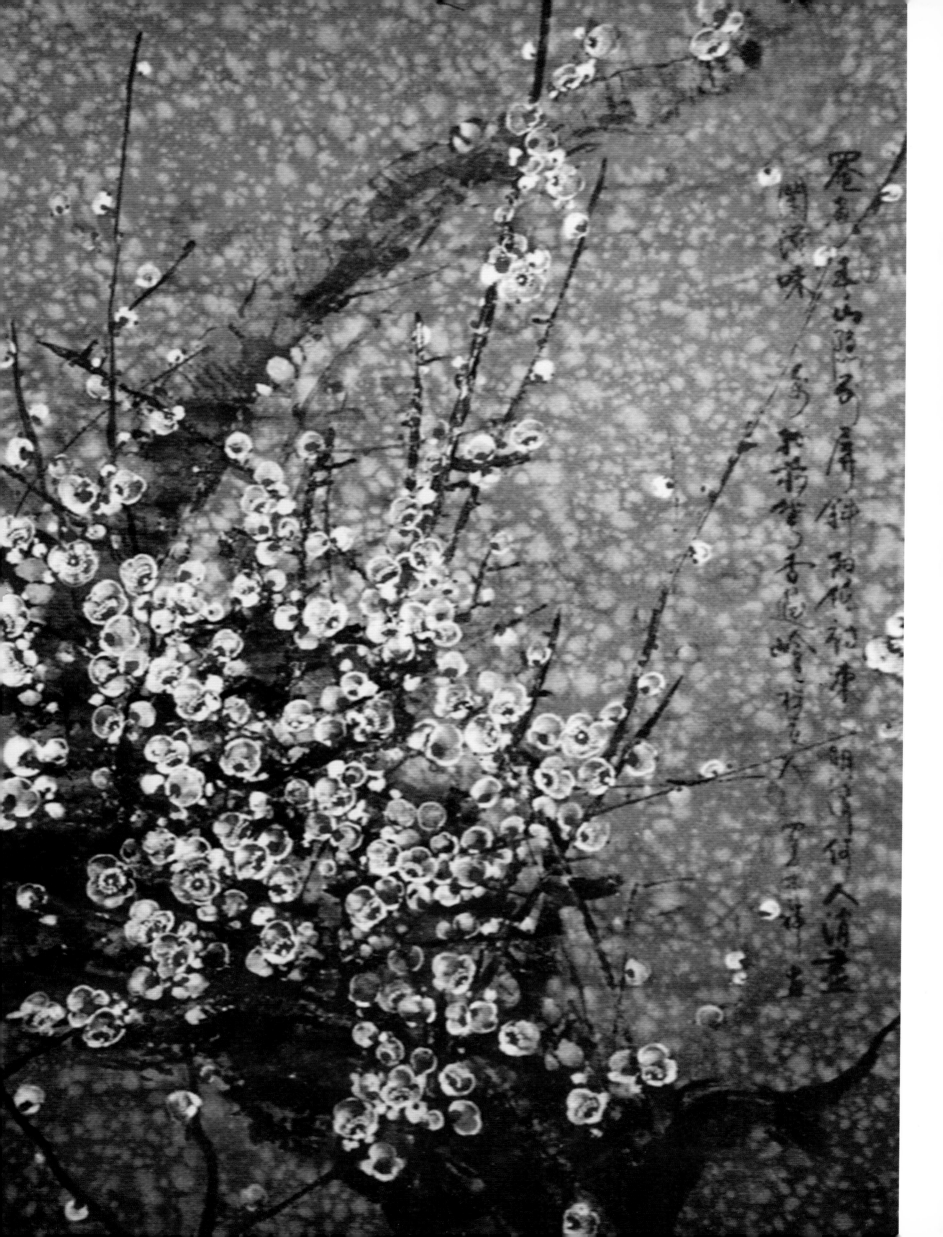

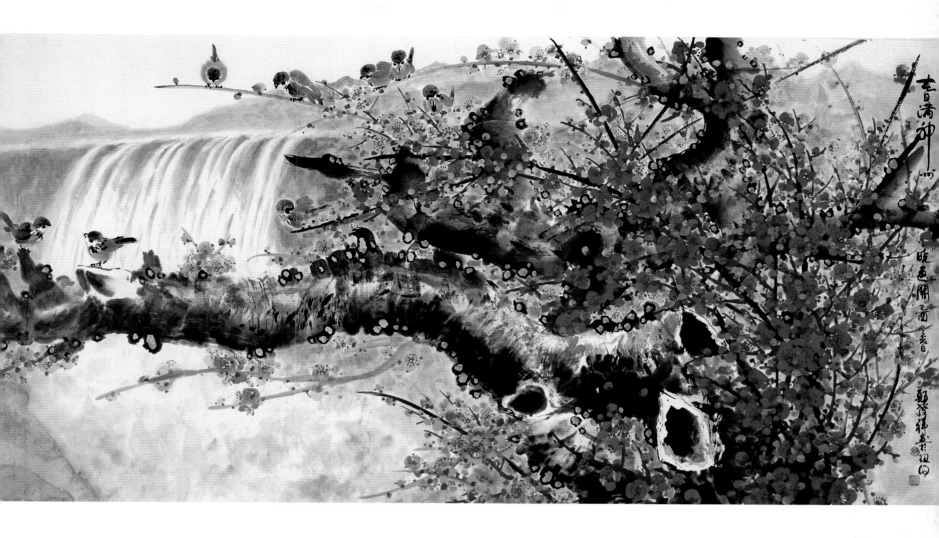

香溢環宇（左頁圖）
490mm × 650mm

春滿神州
660mm × 1330mm

Fragrance Overflows the Whole World
（far　left）
（490mm × 650mm）

China is Full of Splendor of Spring
（660mm × 1330mm）

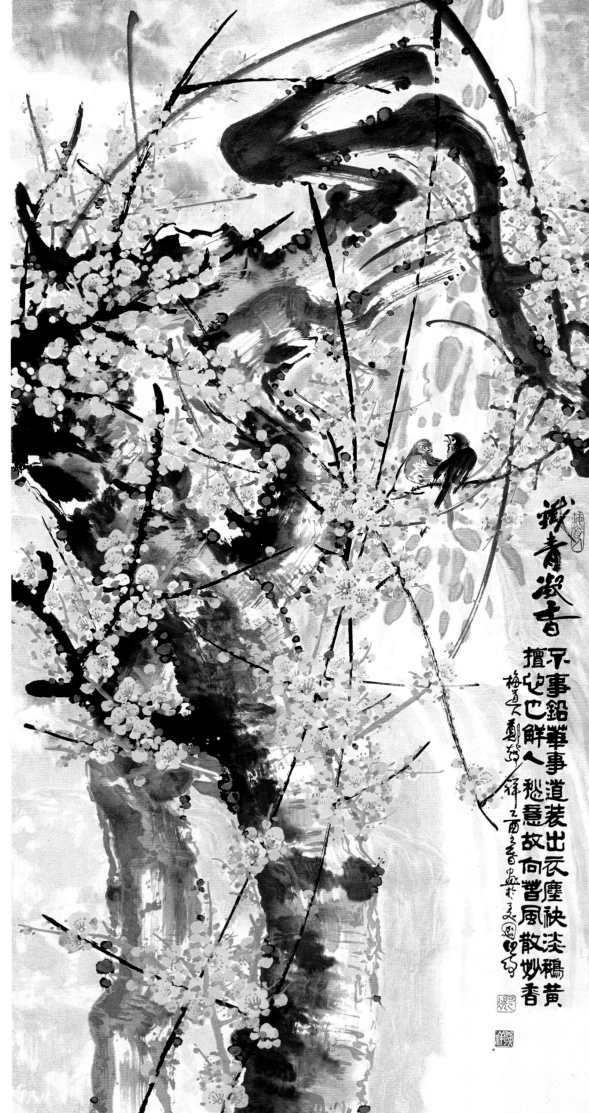

鐵青凝香
660mm × 1330mm

Lividity Coagulates Fragrance
(660mm × 1330mm)

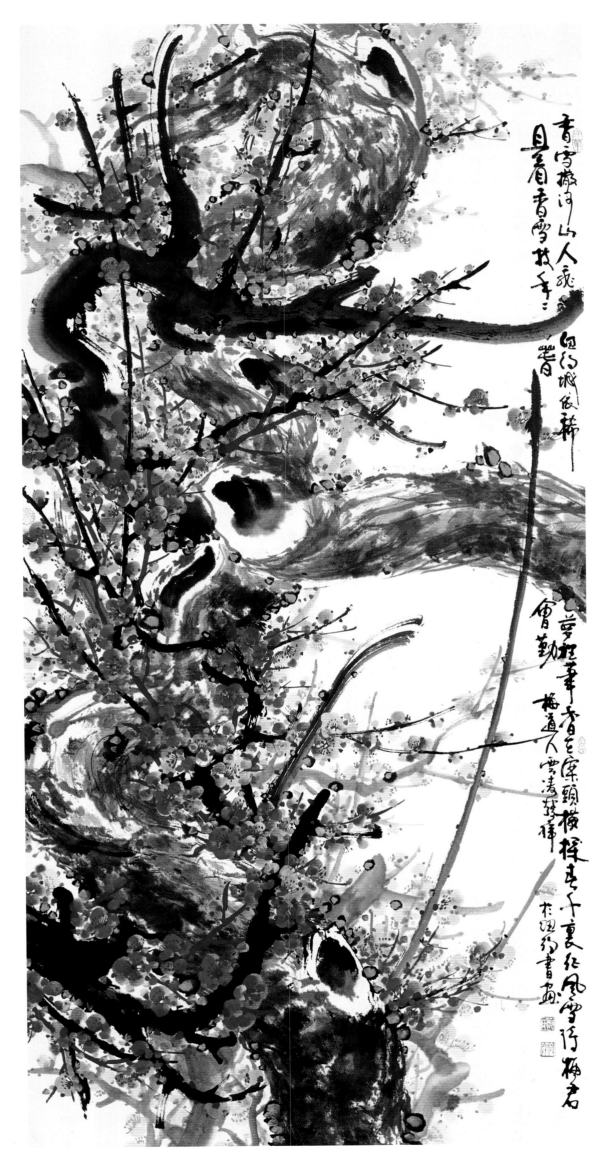

年年春會勤
660mm × 1330mm

Spring is Industrious Year after Year
（660mm × 1330mm）

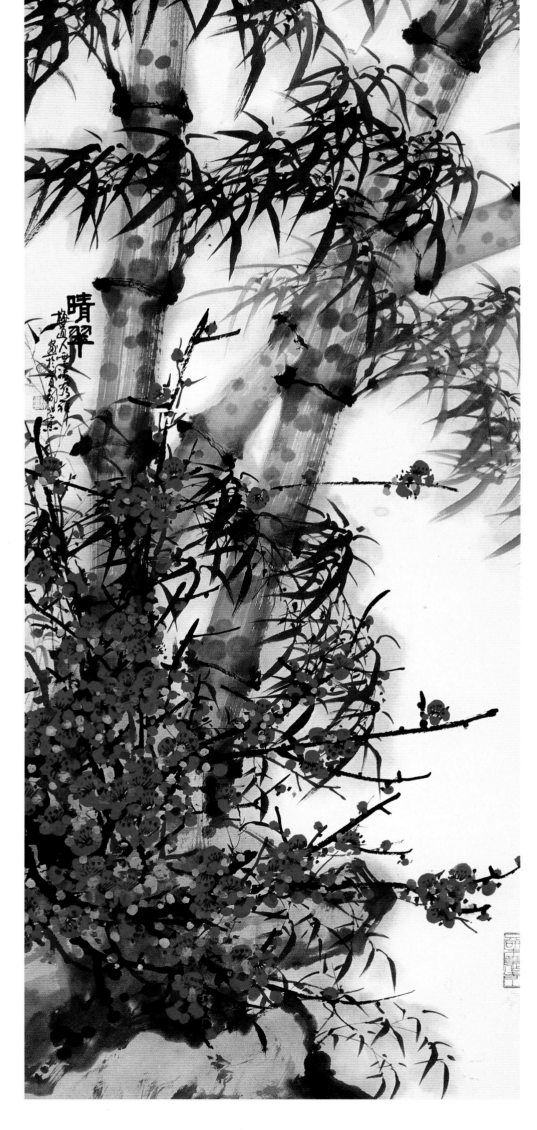

22 晴翠　650mm × 1350mm
Sunny Jade Green　(650mm × 1350mm)

南國春深　990mm × 190mm

Late Spring in Southland

（990mm × 190mm）

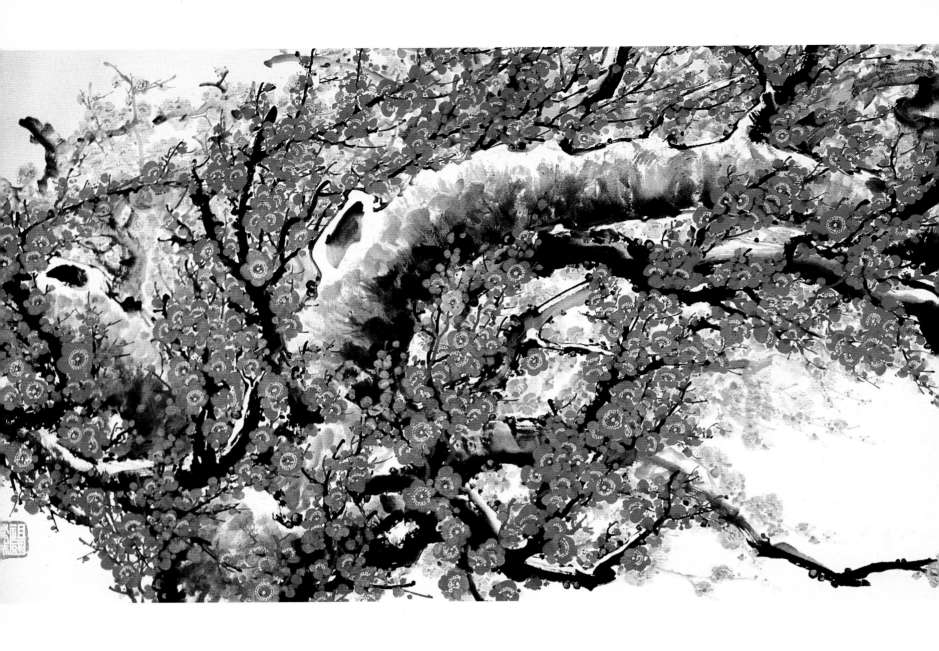

24

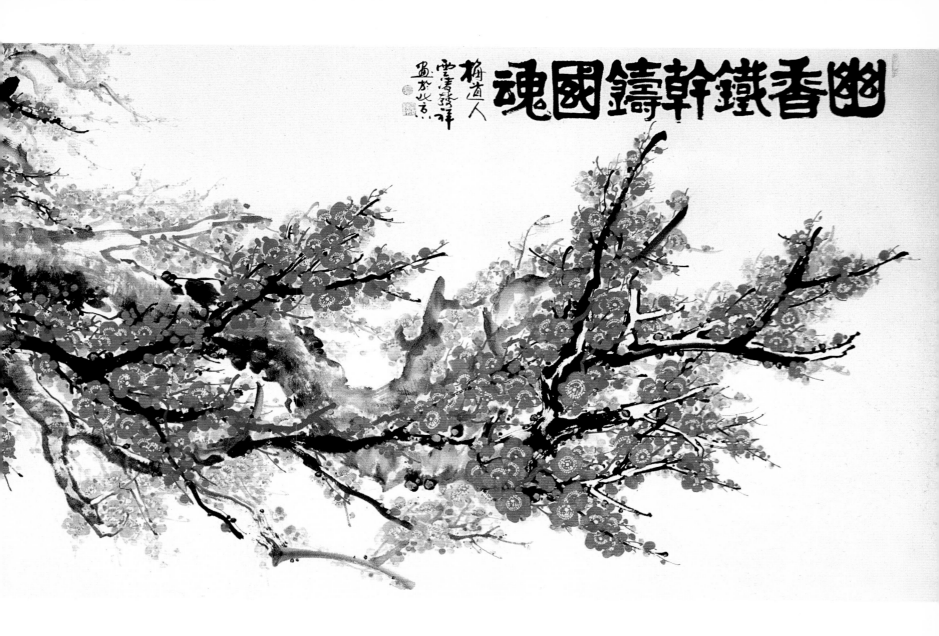

幽香鐵幹鑄國魂
110mm × 3960mm

Faint Fragrance and Iron Bone
Founds National Soul
（110mm × 3960mm）

25

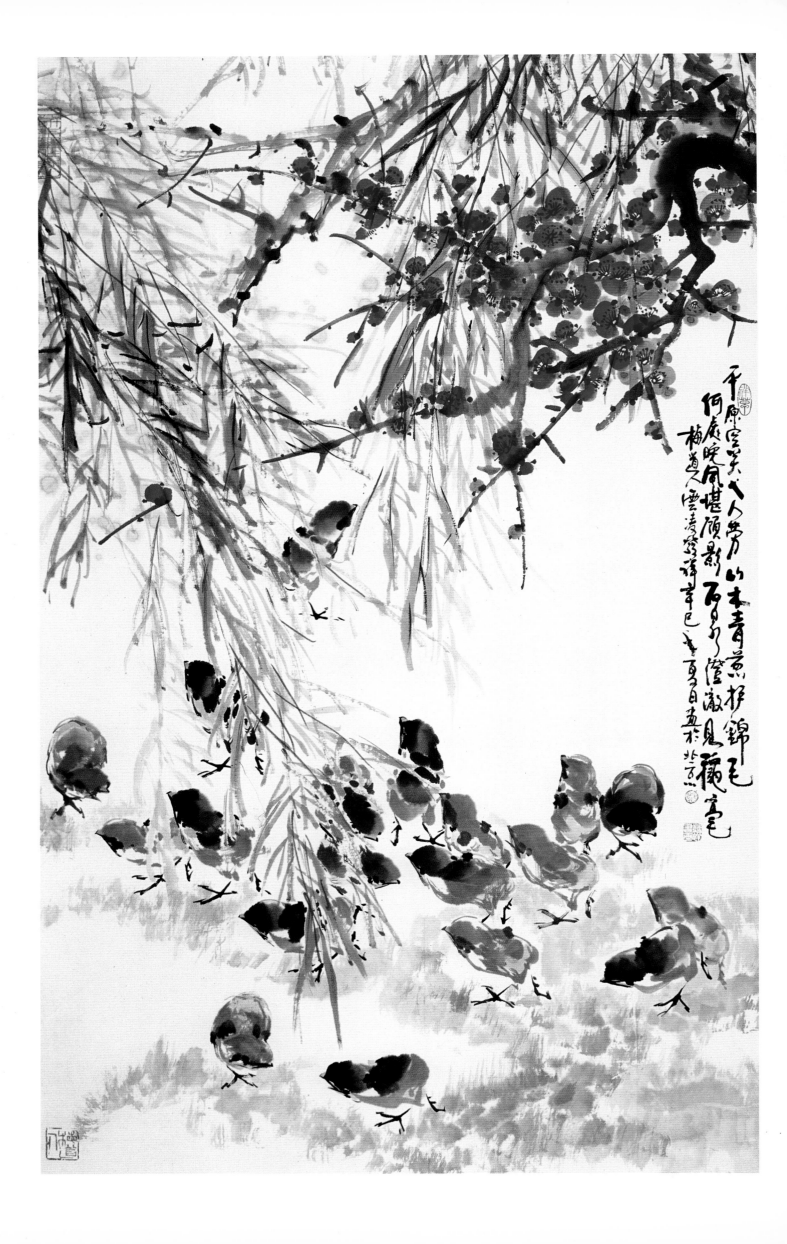

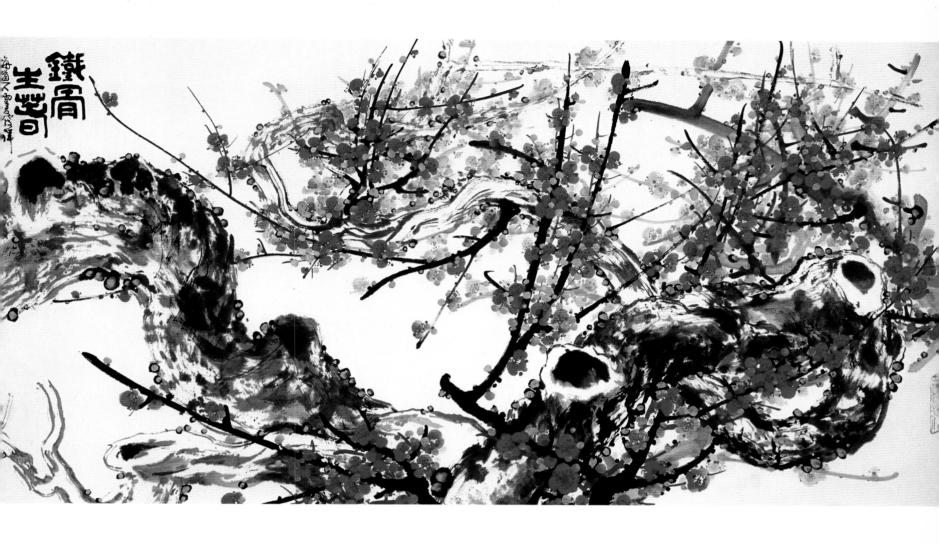

晚風 （左頁圖）
680mm × 1110mm

鐵骨生春
660mm × 1330mm

Small Chicken Willow （far left）
（680mm × 1110mm）

Iron Bone Produces Spring
（660mm × 1330mm）

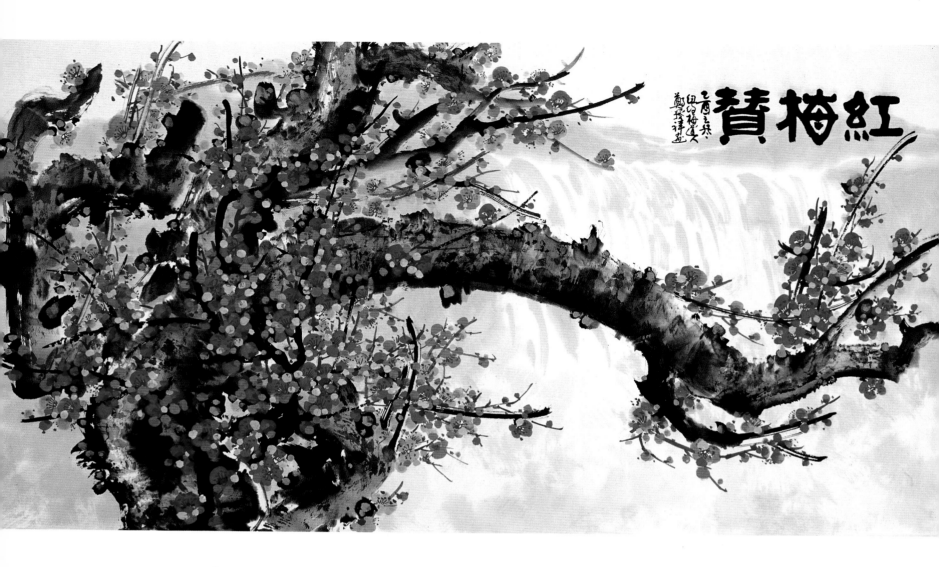

28

紅梅贊　　680mm × 1360mm

Praising the Red Plum Blossom (680mm × 1360mm)

不要人誇顏色好　29
祇留清氣滿乾坤
660mm × 1330mm

Need not for People to Read the
Fine Color, Nothing but to
Leave the Universe being Full of
Clear Temperament
（1320mm × 2640mm）

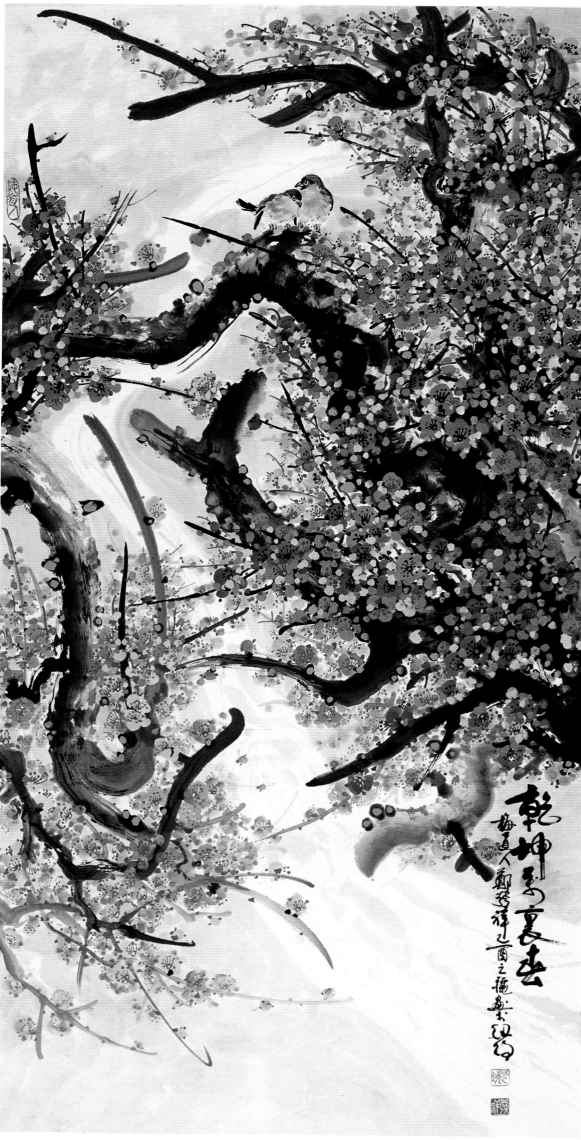

乾坤萬裏春
660mm × 1330mm

春鐵鑄幹玉戴花（右頁圖）
660mm × 1000mm

The Universe is of Ten Thousand
Li Spring
（660mm × 1330mm）

Spring Iron Founds Trunk and Jade
Wears Flowers(detail)(right)
（660mm × 1000mm）

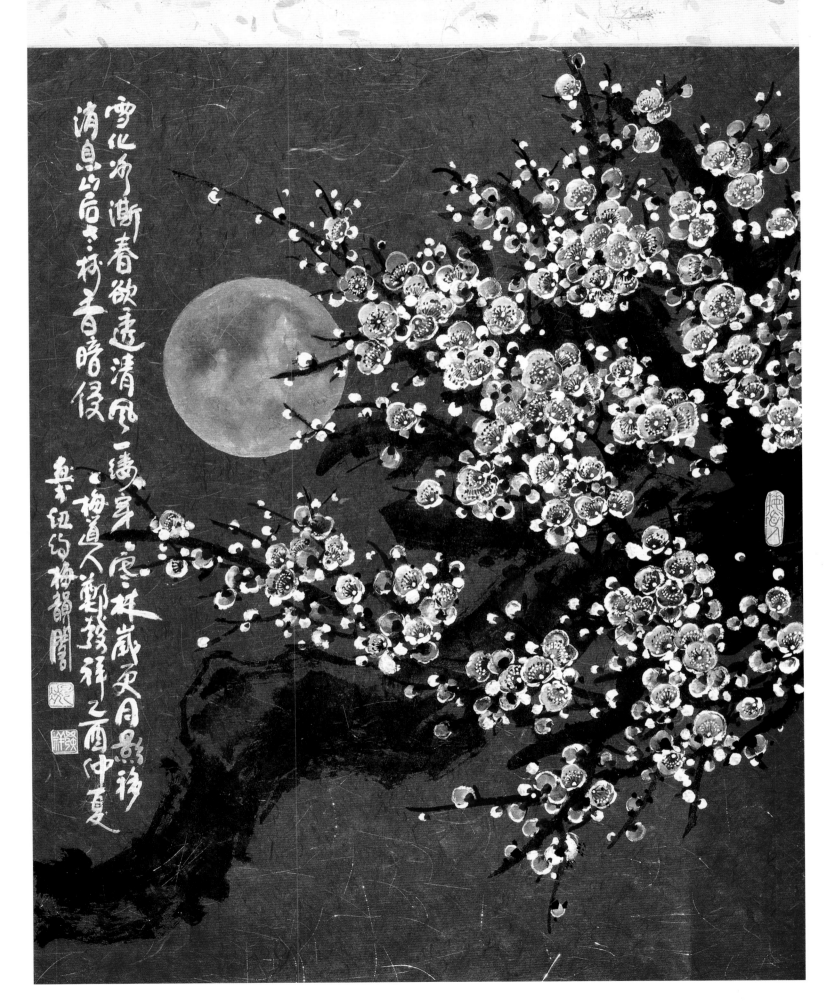

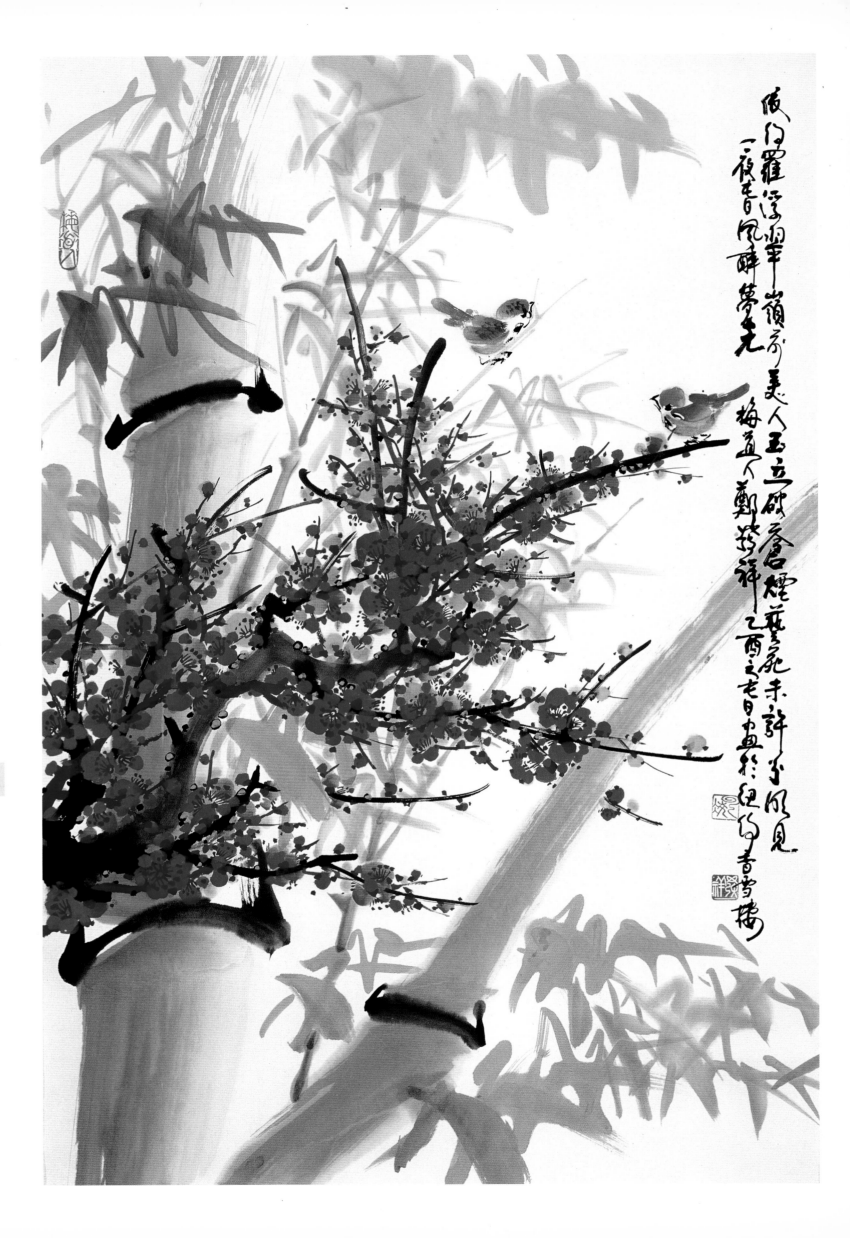

32

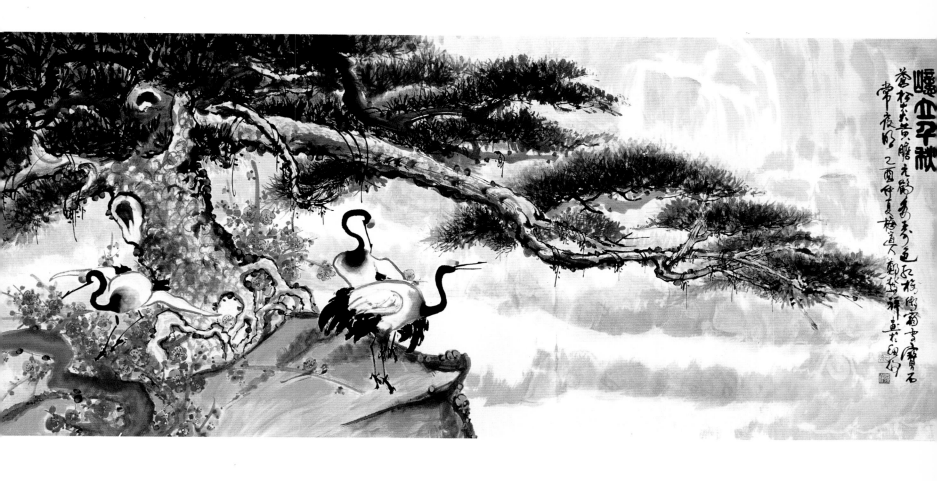

一夜春風醉夢先（左頁圖）
480mm × 1000mm

屹立千秋
660mm × 1330mm

A Night Spring Breeze Drinks Rosy
Clouds（far　left）
（480mm × 1000mm）

Standing Towering a Thousand Years
（660mm × 1330mm）

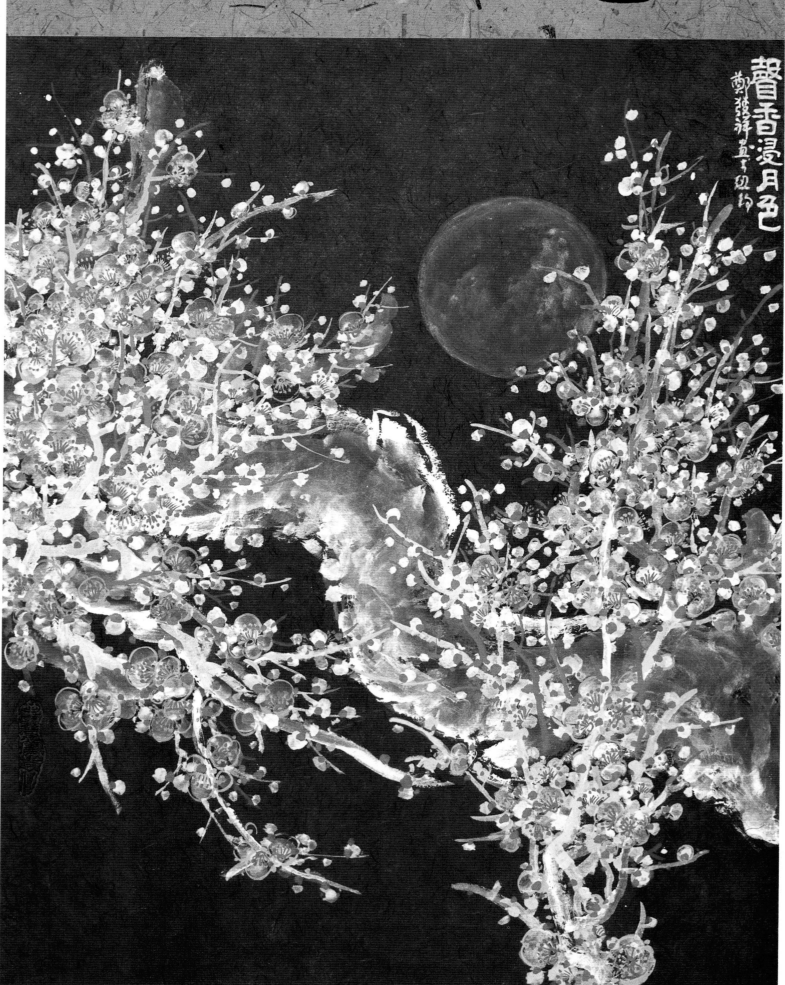

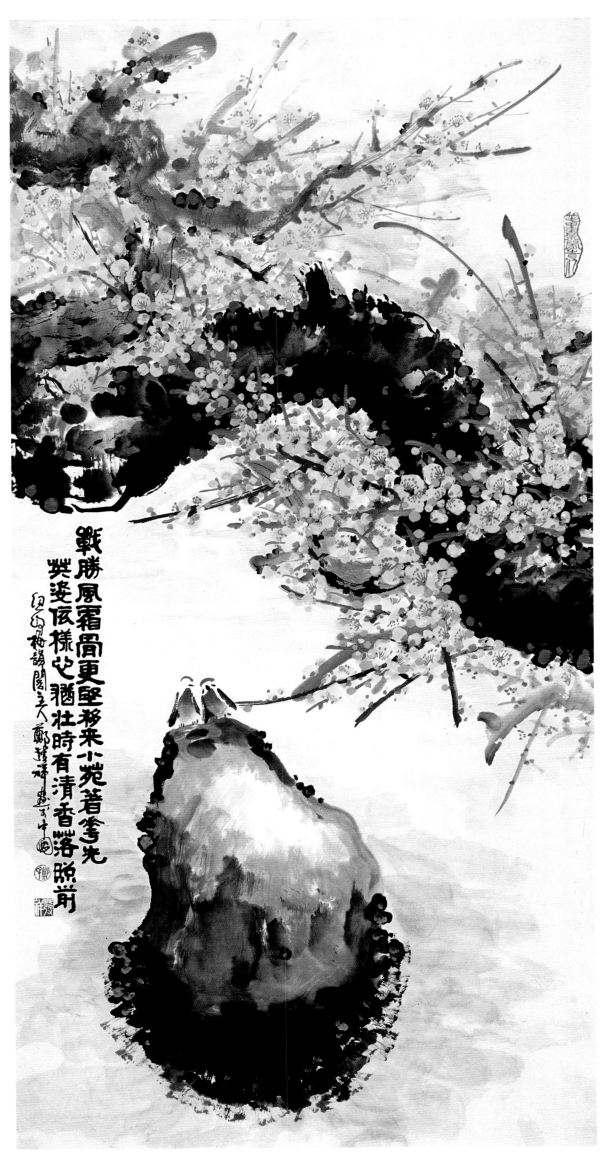

戰勝風霜骨更堅
獎姿依樣心猶壯
時有清香落照前
移来小苑著先

紅梅詩閣主人
鄭楚祥書於……

綠蔓橫波醉彩霞（左頁圖）
660mm × 1100mm

35

戰勝風霜骨更堅
660mm × 1330mm

Green Tendrils and Transverse
Wave Drinks Rosy Clouds（far
left） （660mm × 1100mm）

Surmounting Wind and Frost,
Bone is even more Solid
（660mm × 1330mm）

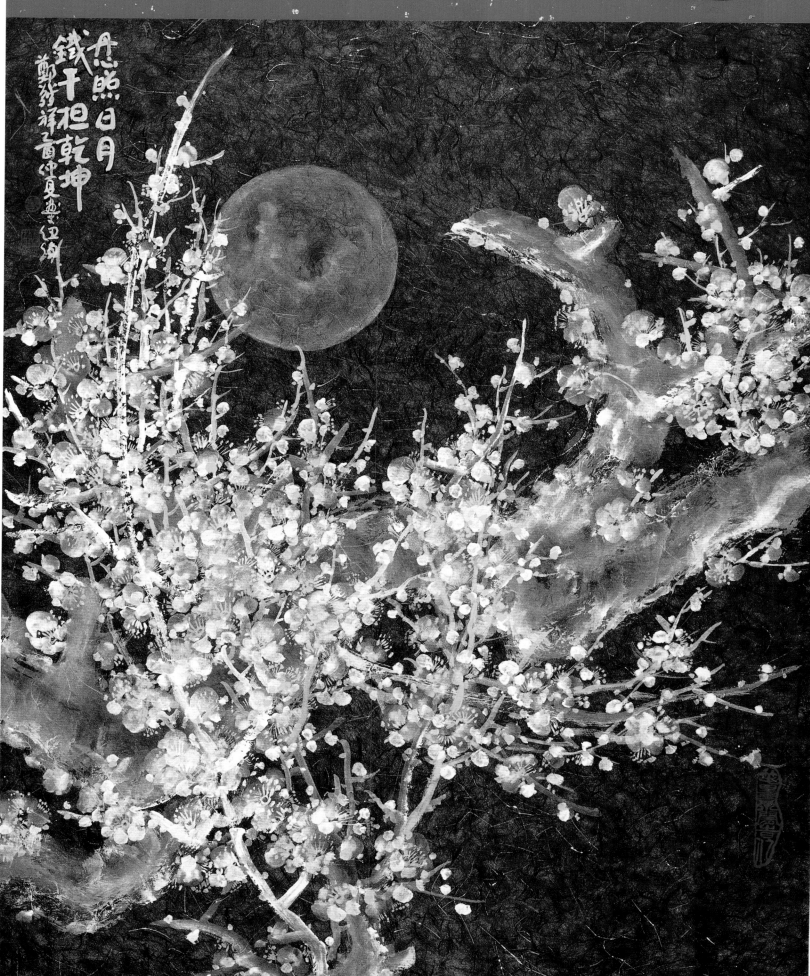

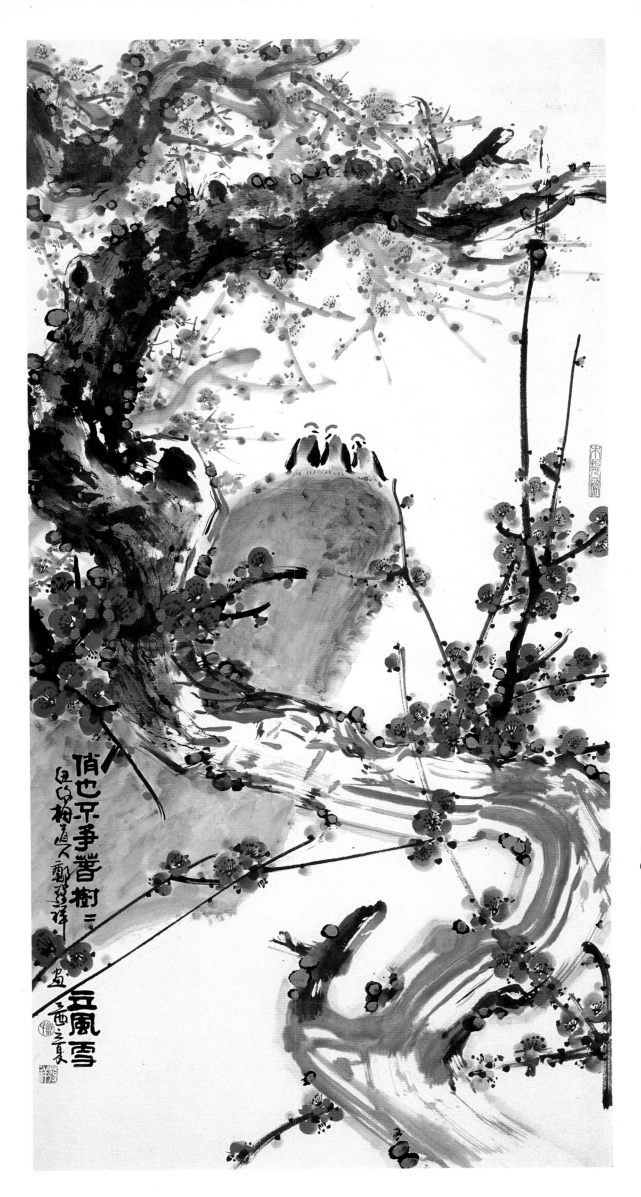

春光照爾霞 （左頁圖）
660mm × 1100mm

悄也不争春
660mm × 1300mm

Spring Scenery Shines Early
Morning Glow （far left）
（660mm × 1100mm）

Being Silent, but not Striving for
Spring（660mm × 1300mm）

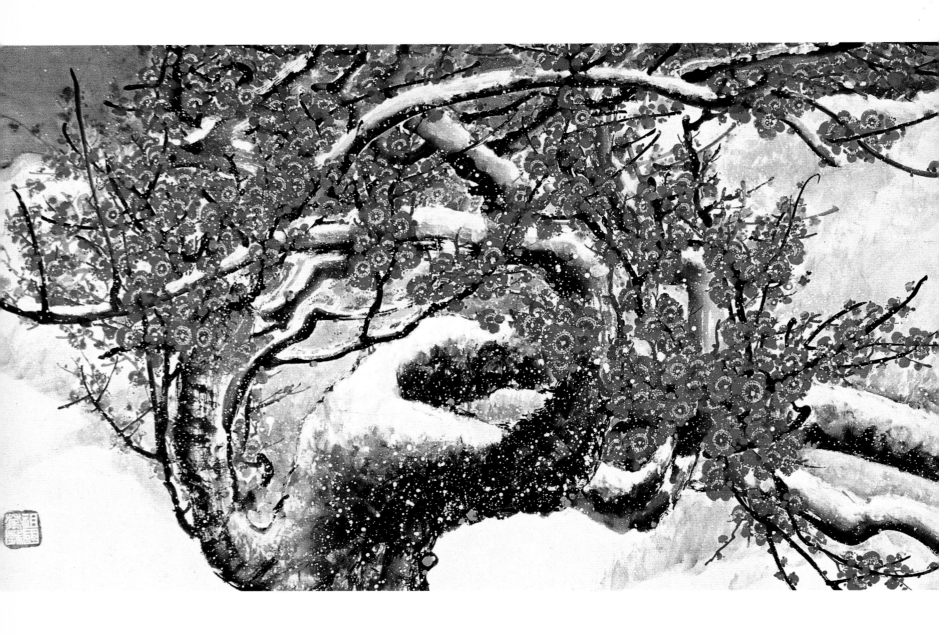

38

香雪海　　1100mm × 3960mm

Fragrant Snow Sea (1100mm × 3960mm)

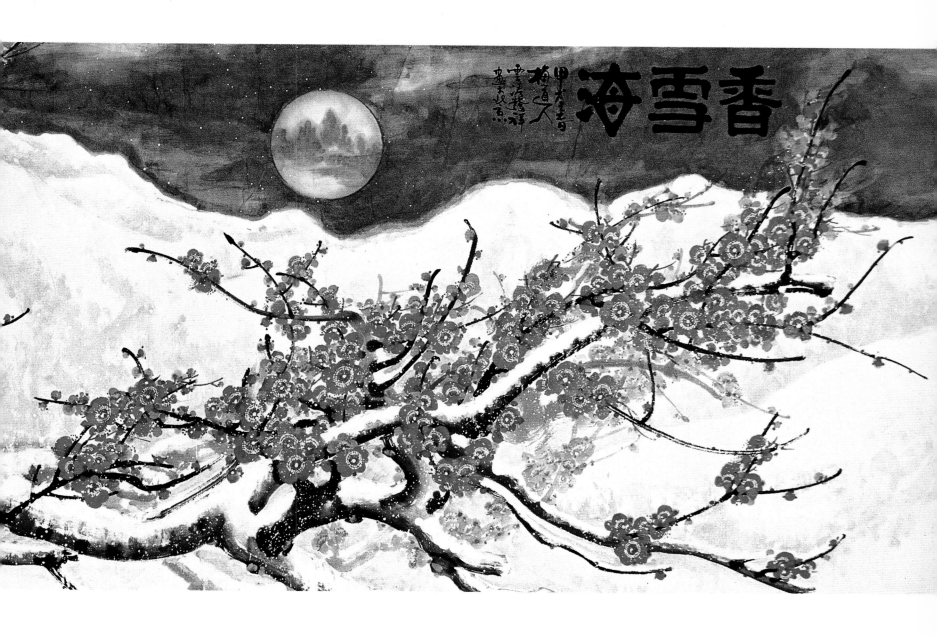

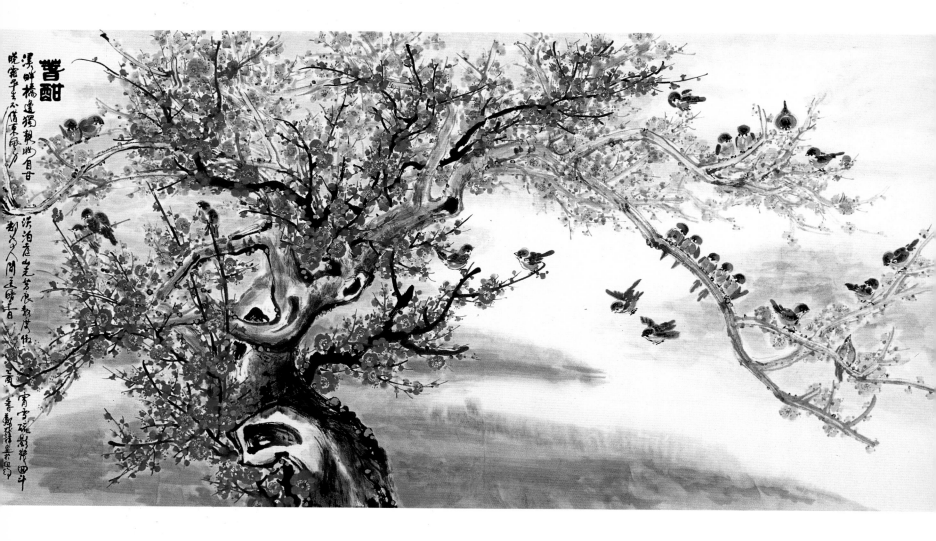

春酣
760mm × 1960mm

40

祇留清氣在叢中（右頁圖）
660mm × 1000mm

Spring with Ease and Verve

（660mm × 1330mm）

Merely Leaving Clear Temperament in Cluster（detail）(right)

（660mm × 1000mm）

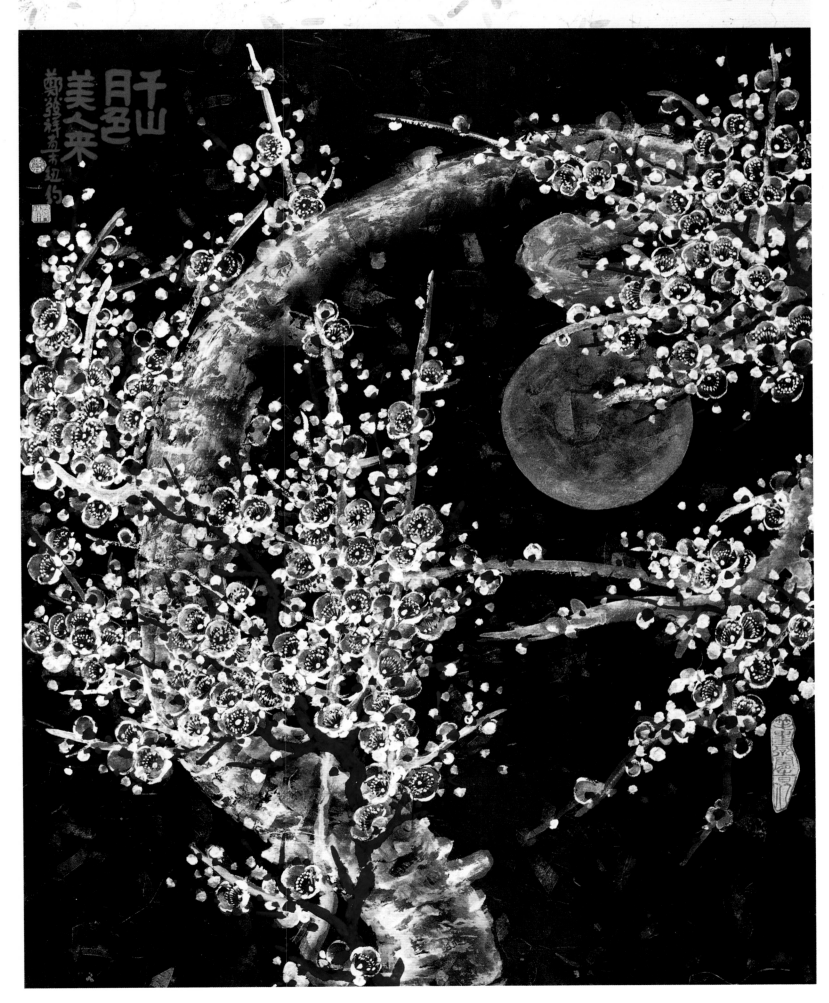

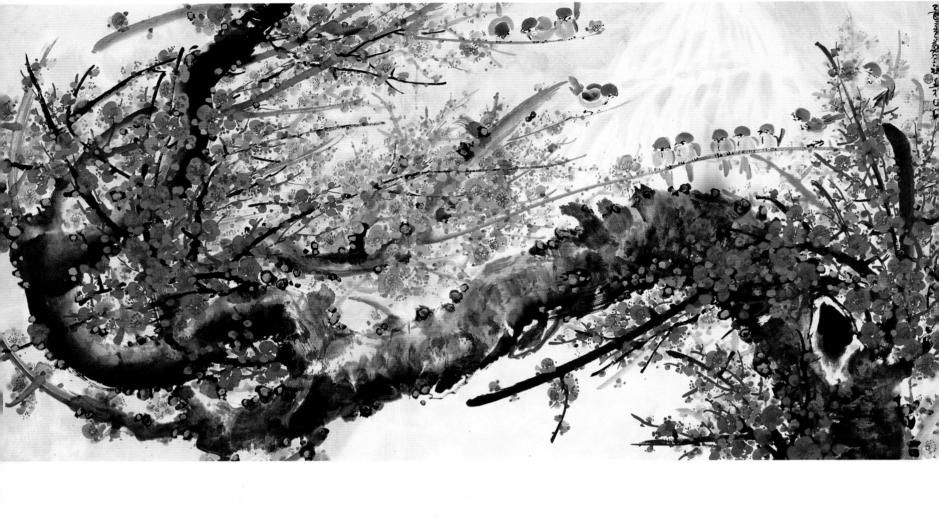

42

春意情濃 660mm × 1330mm

The Awaken of Spring and Dense Feeling
(660mm × 1330mm)

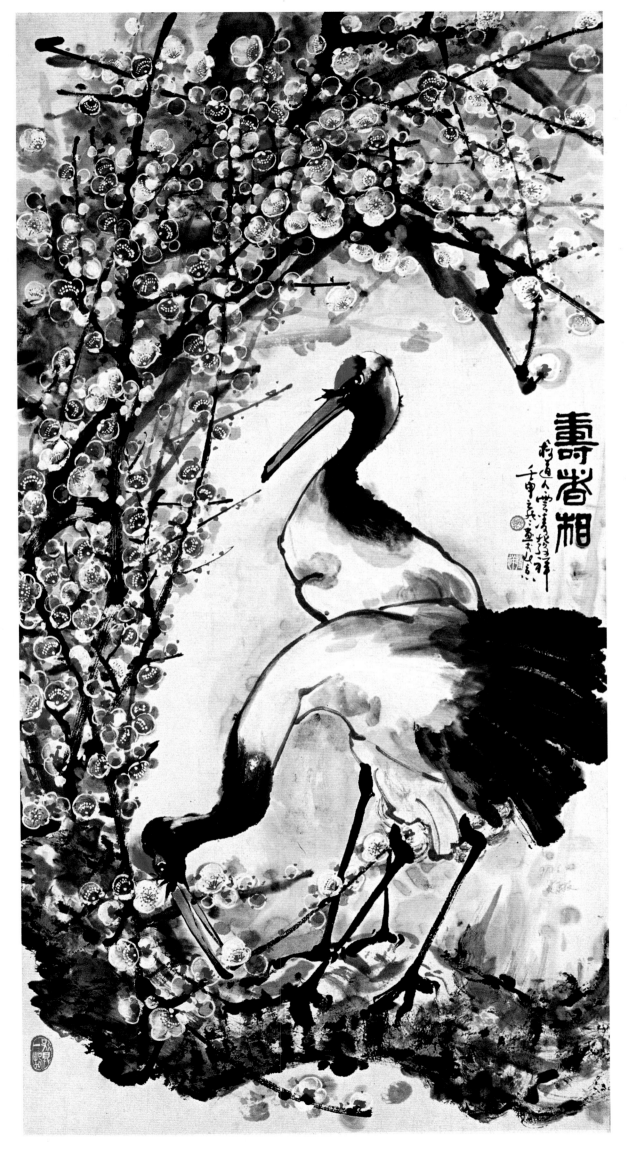

43

壽者相
480mm × 1100mm

Looks of The God of Longevity
（480mm × 1100mm）

44

香溢環宇
650mm × 860mm

Fragrance Overflows the World
(650mm × 860mm)

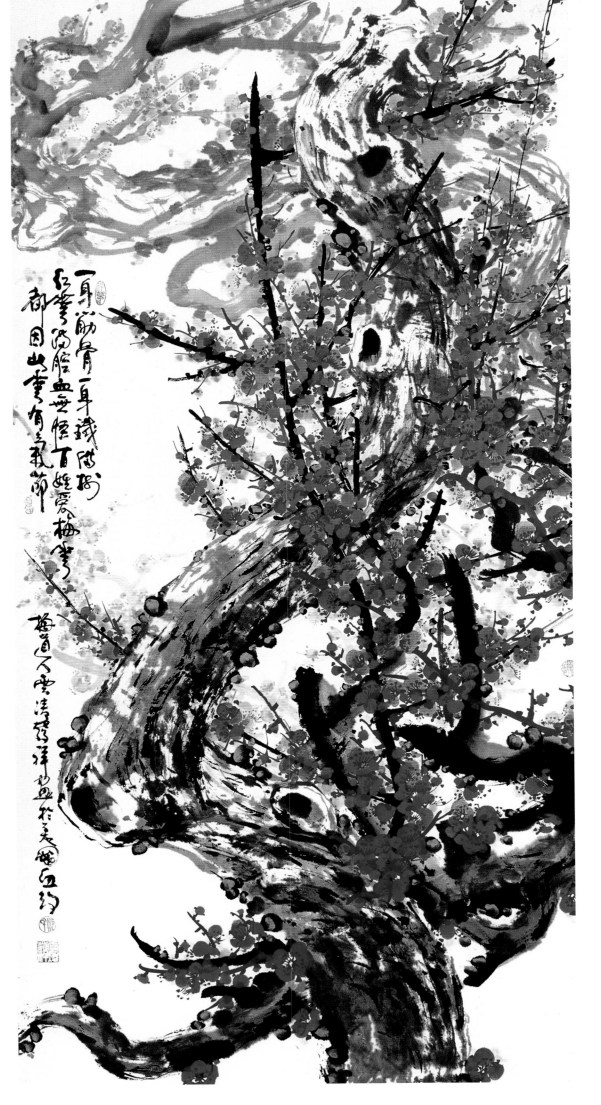

一身筋骨一身鐵
660mm × 1330mm

Bones and Muscles all over the
Body and Iron all over the Body
（660mm × 1330mm）

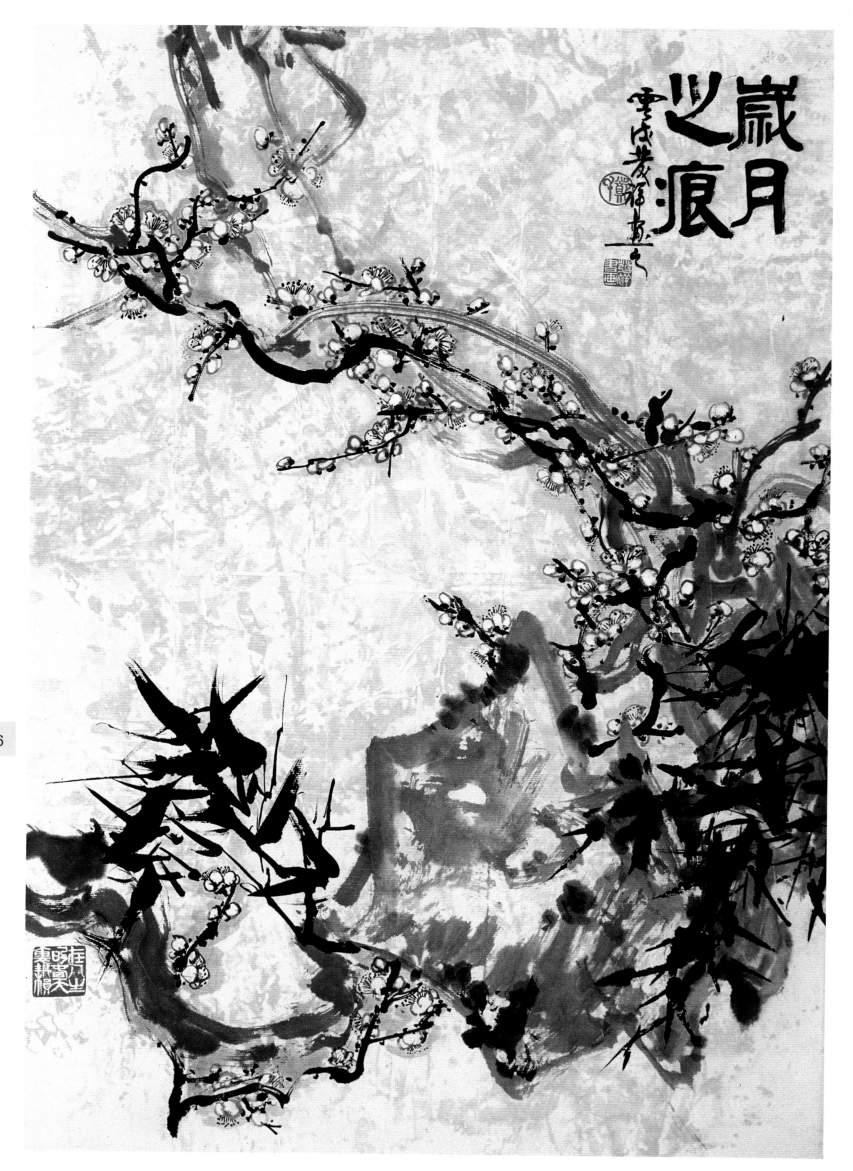

歳月之痕

46

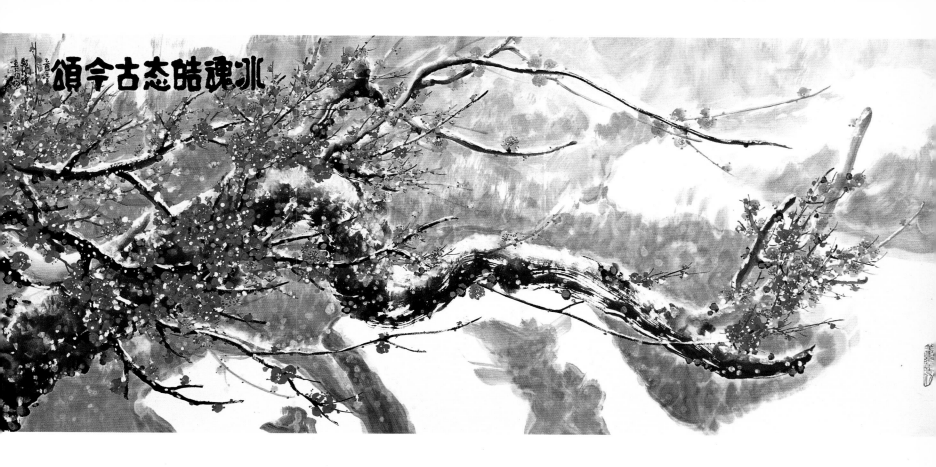

歲月之痕 （左頁圖）
330mm × 680mm

嚴冬消盡春來早
720mm × 1980mm

The Years' Trace（far left）
（330mm × 680mm）

Severe Winter Disappears and
Spring Comes Early
（720mm × 1980mm）

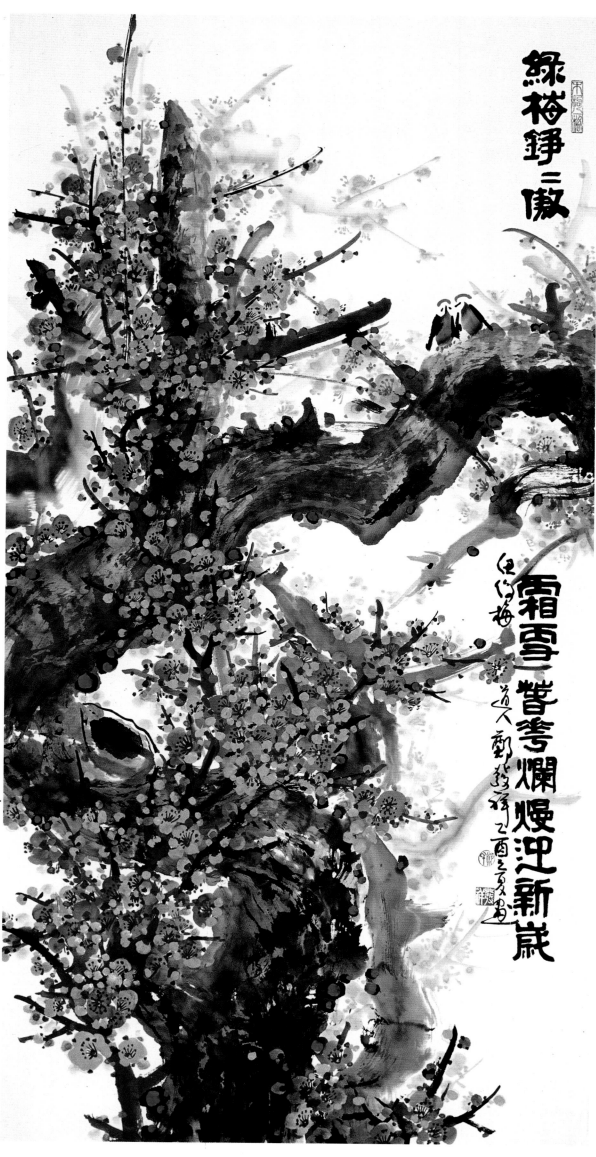

綠梅錚錚傲霜雪
660mm × 1330mm

春光（右頁圖）
580mm × 1200mm

Green Plum Blossom Clanks to
Brave Frost and Snow
（660mm × 1330mm）

Spring Scenery（detail）(right)
（580mm × 1200mm）

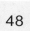
48

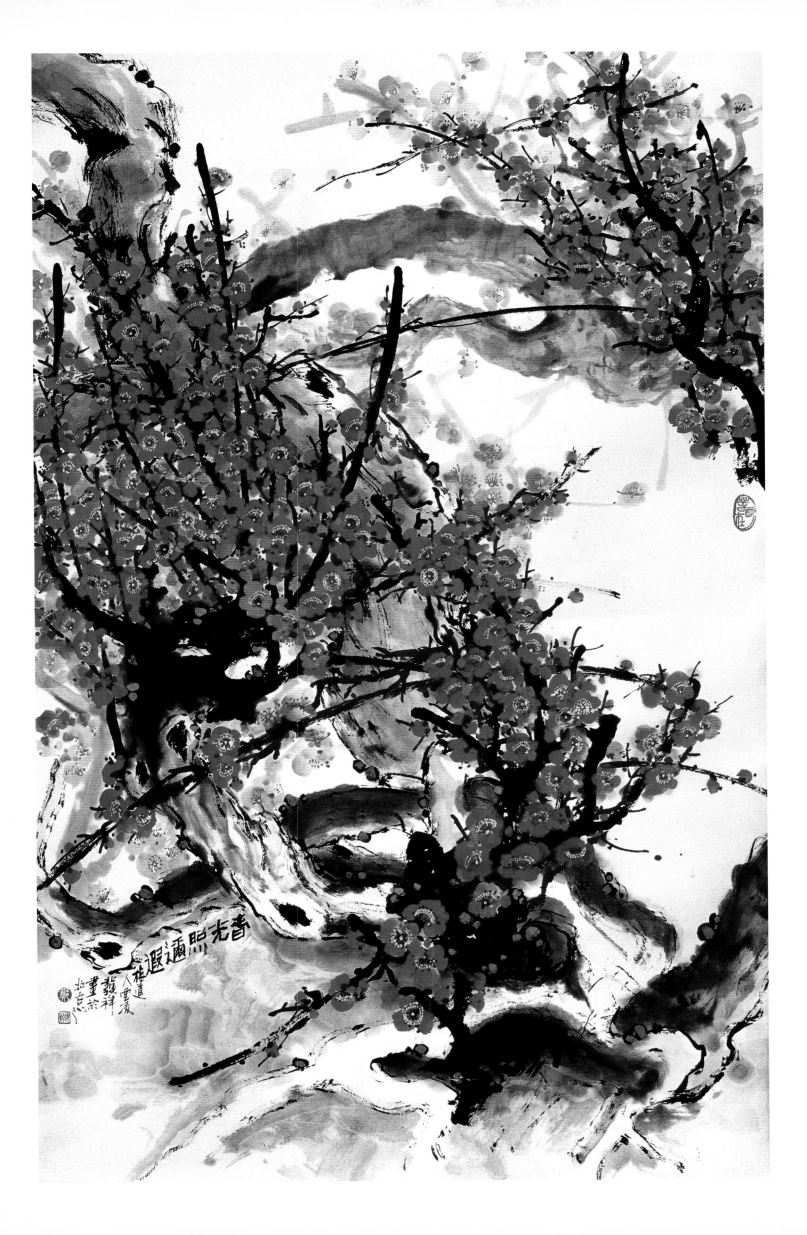

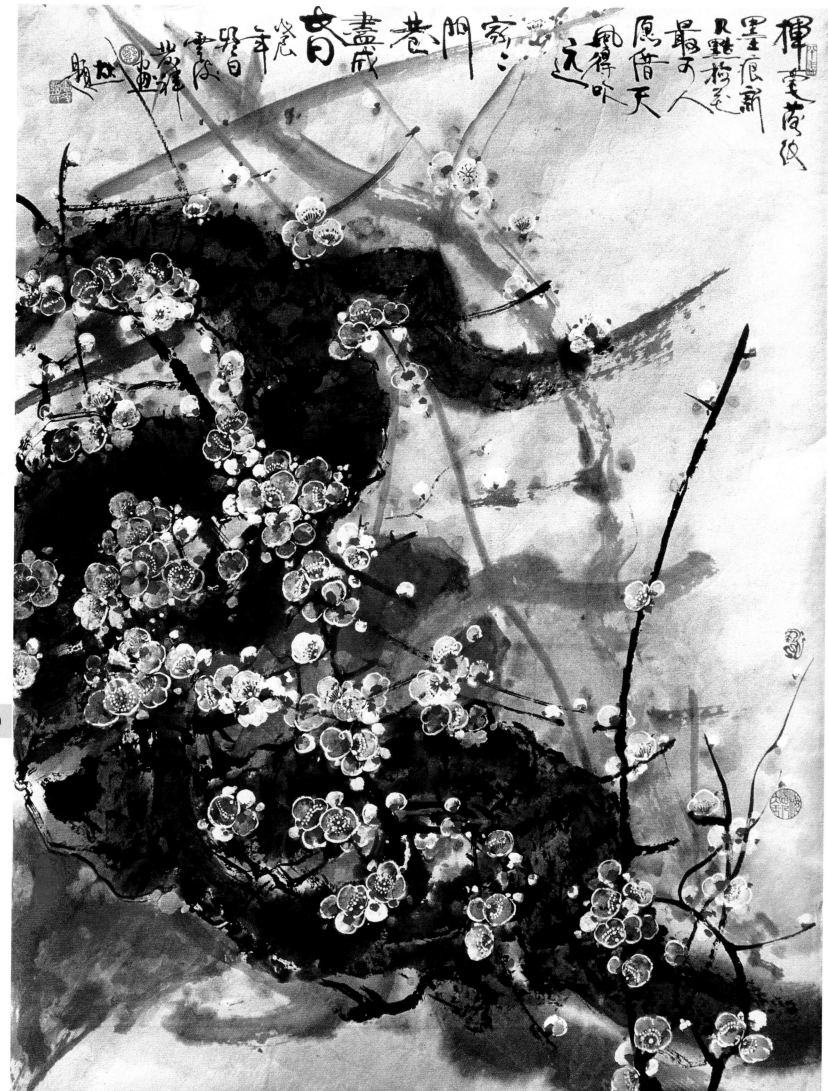

50

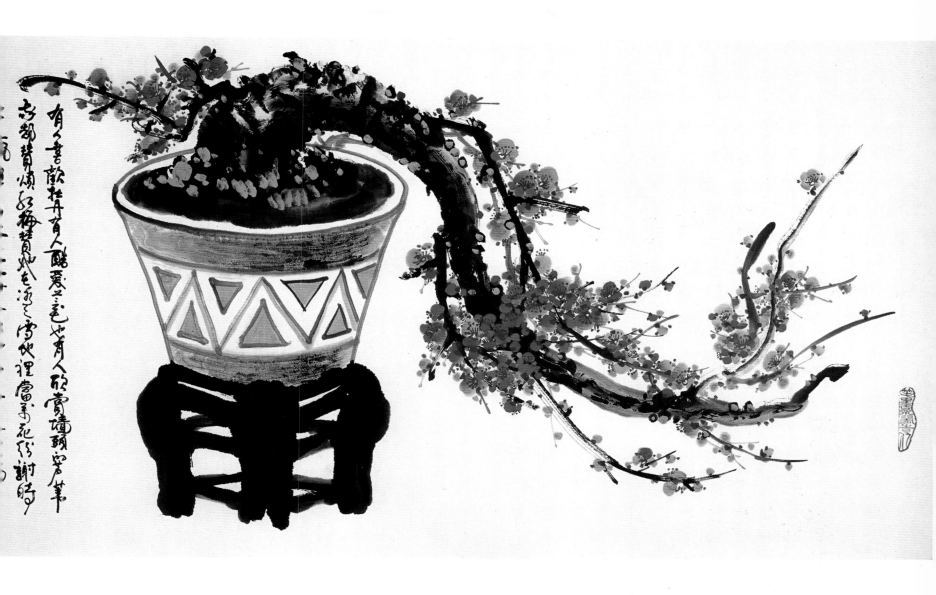

願借天風傳春訊　（左頁圖）
480mm × 680mm

鐵骨屹立
660mm × 1330mm

Hoping to Borrow the Sky Wind to
Send Spring Message　(fat left)
（480mm × 680mm）

Aweather Passing Writing and
Snowflake Standing Towering
（660mm × 1330mm）

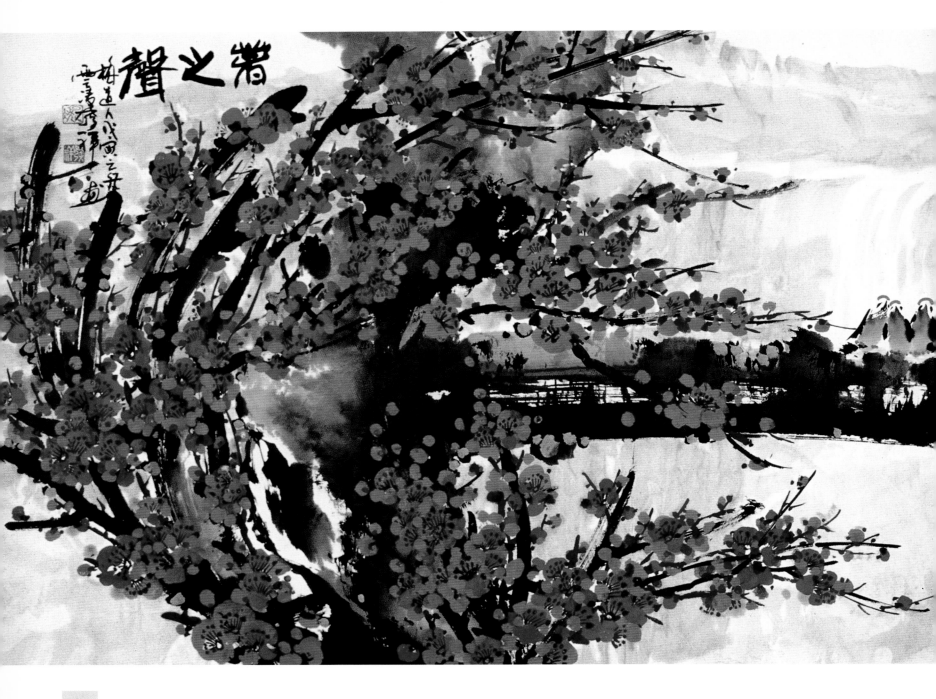

52

春之聲　660mm × 2460mm

Spring's Voice (660mm × 2460mm)

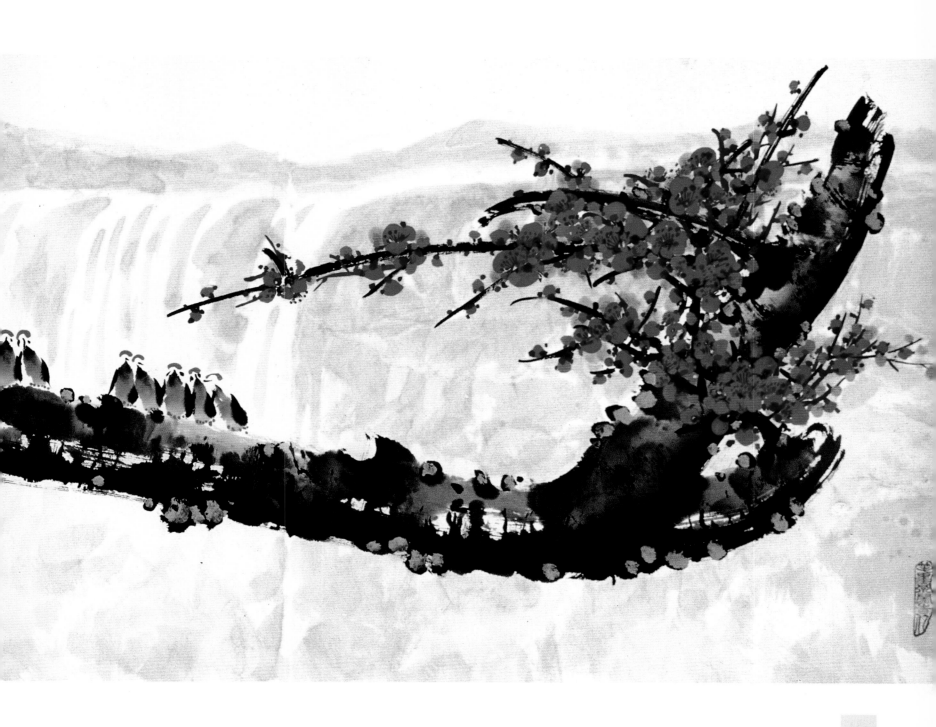

53

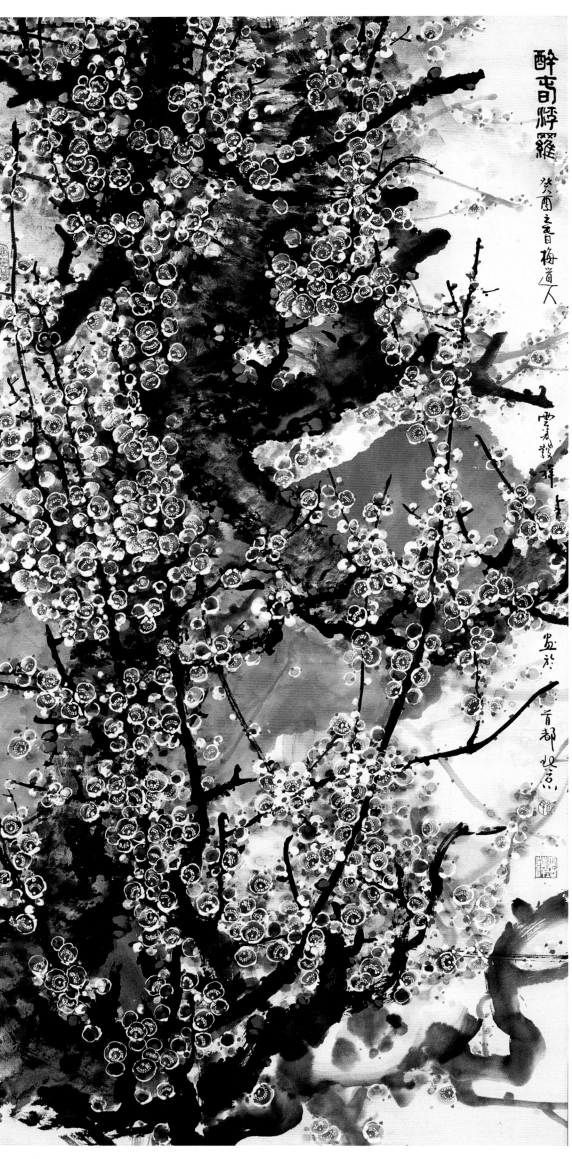

54

醉春浮羅　　680mm × 1360mm

Drinking Spring Floats Display
(660mm × 1330mm)

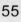

55

春歸大地
660mm × 1330mm

Spring Returns to the Good
Earth （660mm × 1330mm）

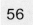

56

梅花春酒圖　　660mm × 1100mm

Plum Blossom is Free and Easy in Spring
(660mm × 1100mm)

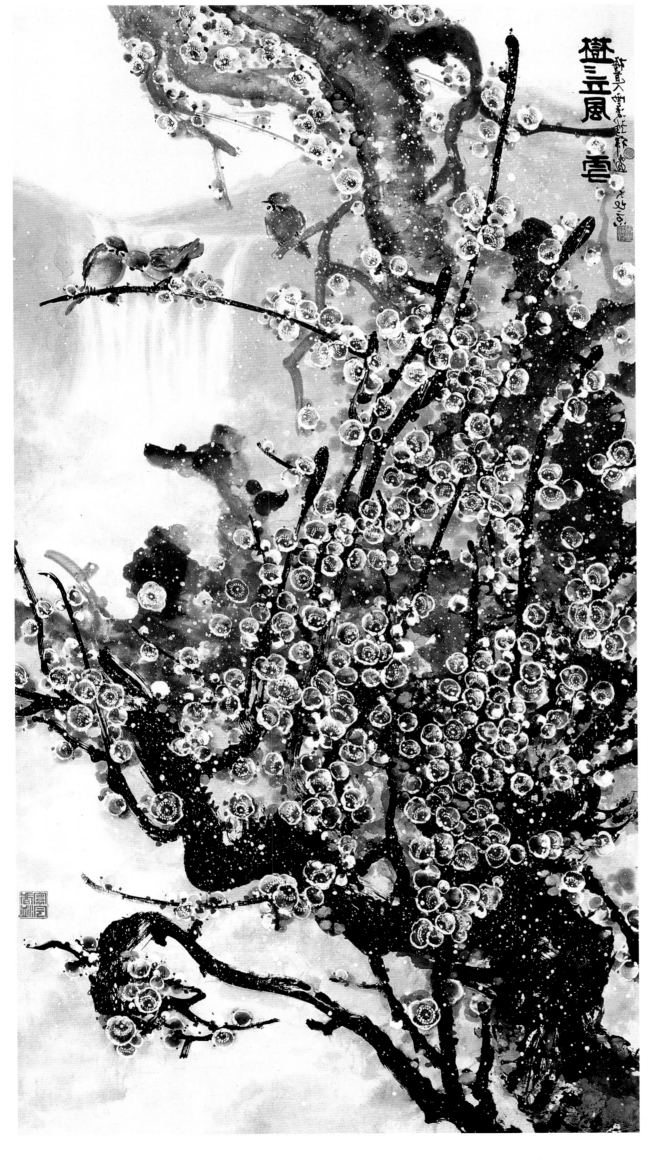

57

樹立風雪
660mm × 1360mm

Trees Stand in Wind and Snow
（660mm × 1360mm）

火紅不盡寒春來
660mm × 1330mm

**Red as Fire Isn't to the Greatest Extent
and the Cold Spring Has Come**
(660mm × 1330mm)

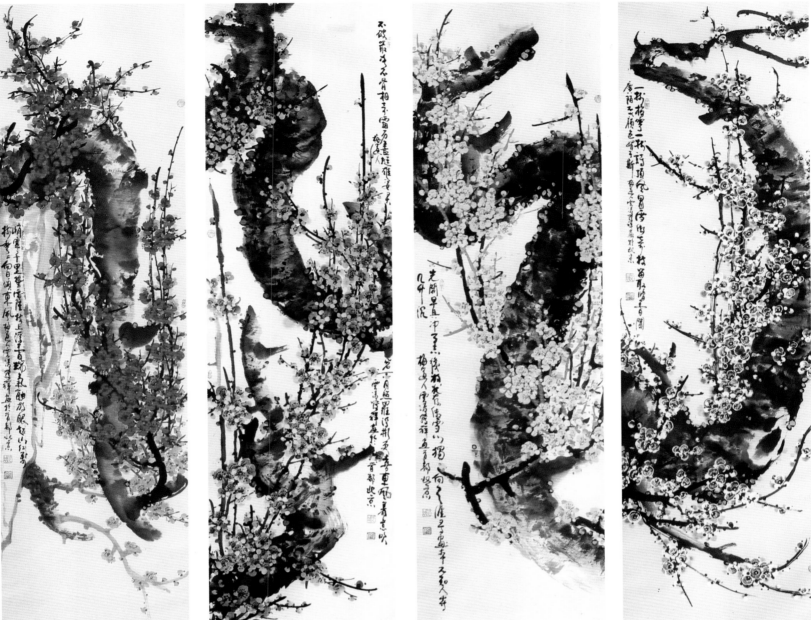

春夏秋冬

330mm × 1360mm × 4

Spring, Summer, Autumn and Winter
（330mm × 1360 × 4mm）

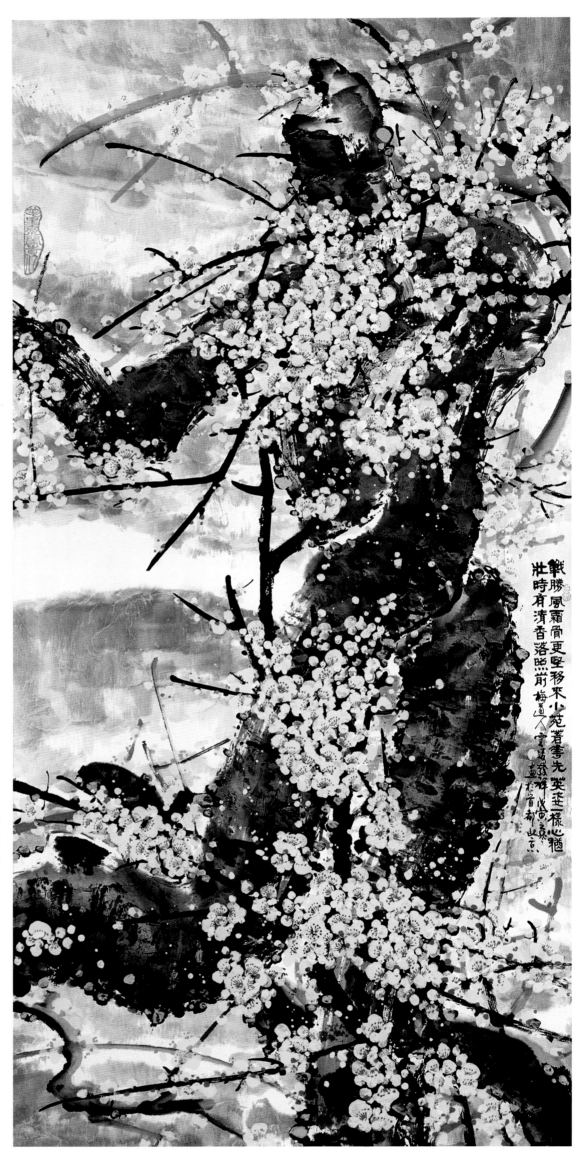

戰勝風霜骨更堅
660mm × 1350mm

Surmounting the Wind and Frost, the
Bone Is even more Solid
(660mm × 1350mm)

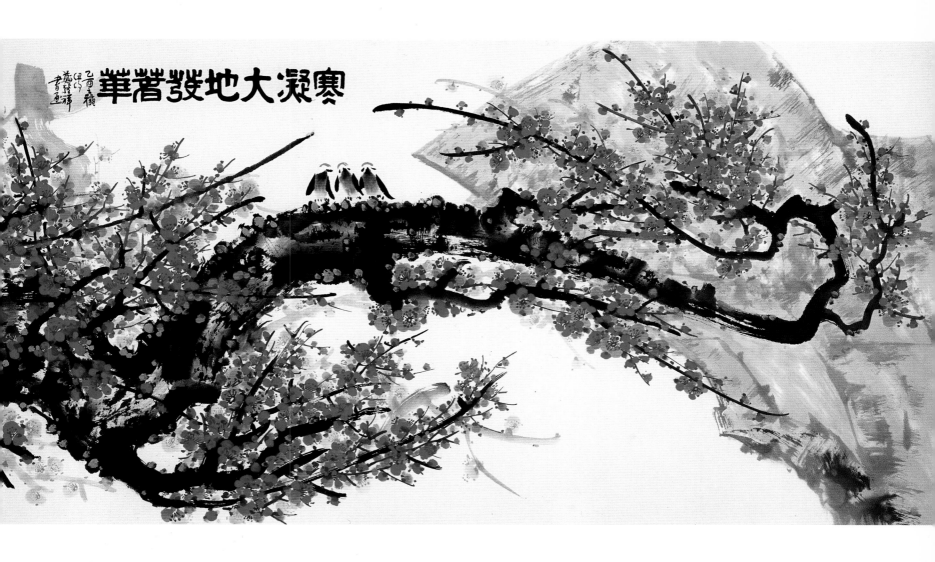

寒凝大地發春華
660mm × 1980mm

The Cold Coagulates the Earth and Produces Glorious Flowers in Spring（660mm × 1980mm）

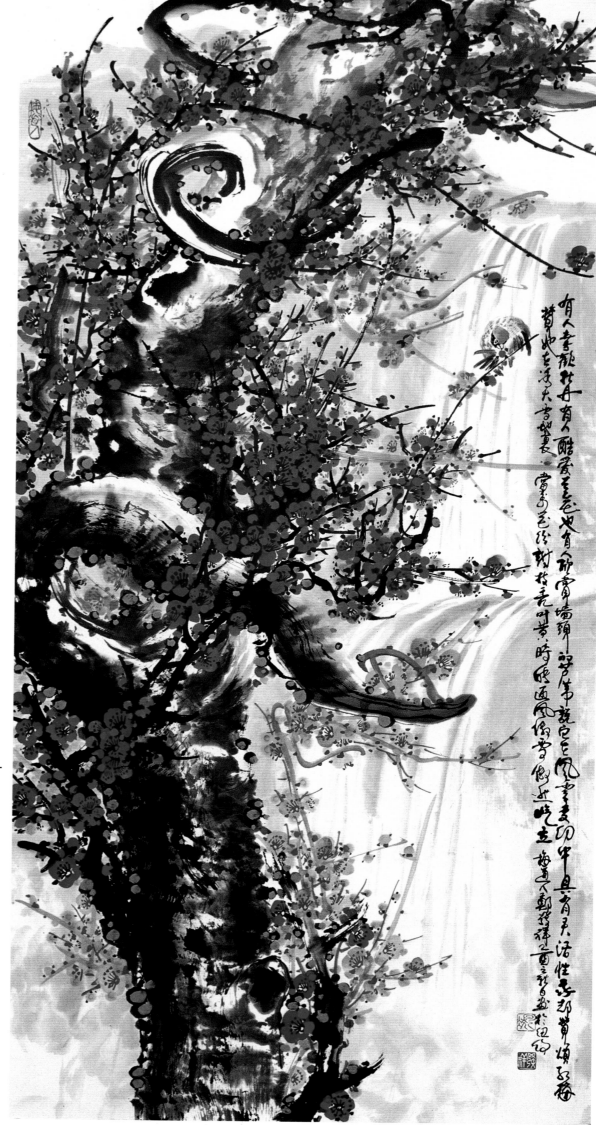

62

紅梅頌 660mm × 1350mm

Ode to Red Plum Blossom
(660mm × 1350mm)

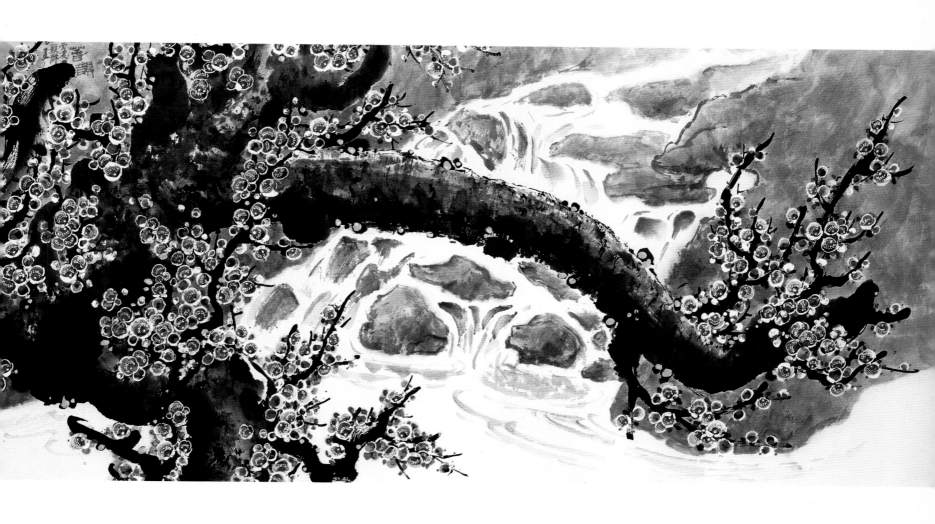

冬韵　680mm × 1360mm

Winter Rhyme
（680mm × 1360mm）

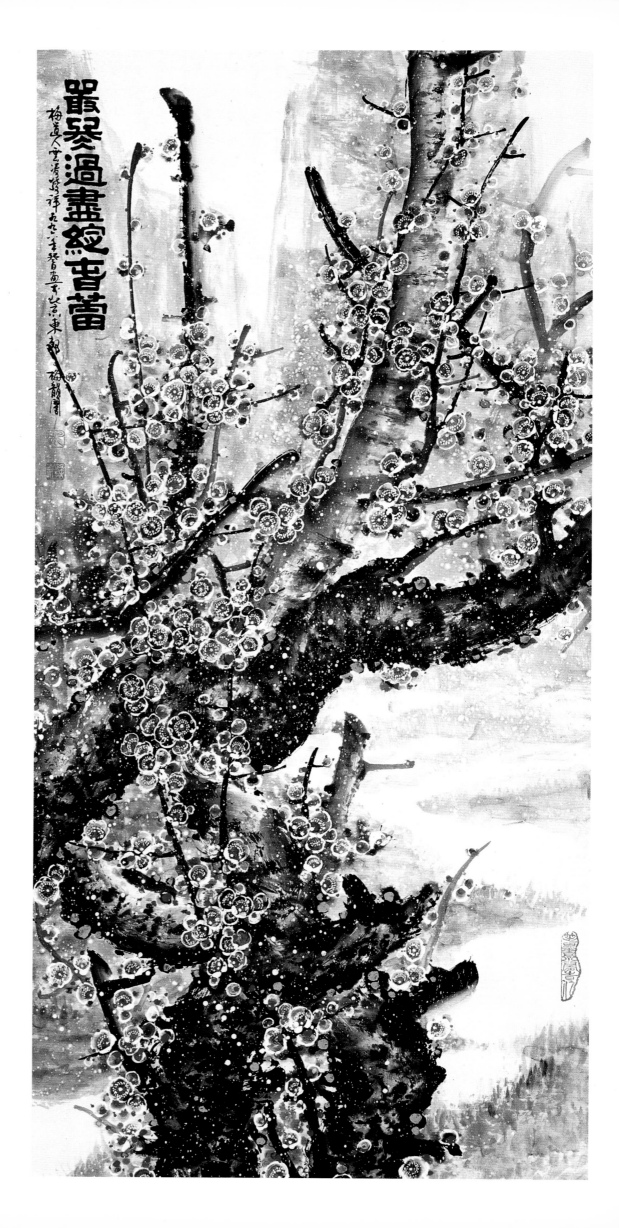

64

嚴冬過盡縱春雪
660mm × 1330mm

**Severe Winter Is Over and Releases
Spring Snow**
(660mm × 1330mm)

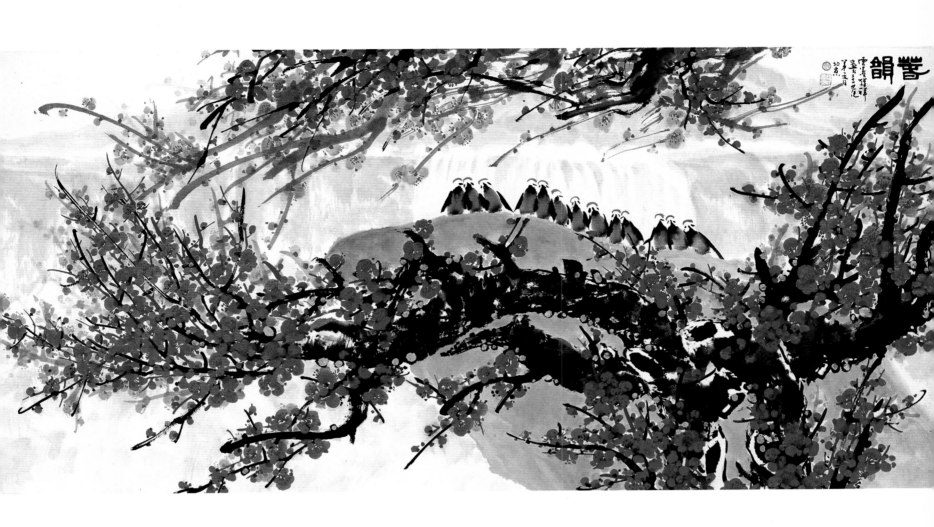

春的韵律　980mm × 1980mm

Spring's Rhythm
（980mm × 1980mm）

66

國香頌　　1100mm × 3960mm

Ode to National Fragrance (1100mm × 3960mm)

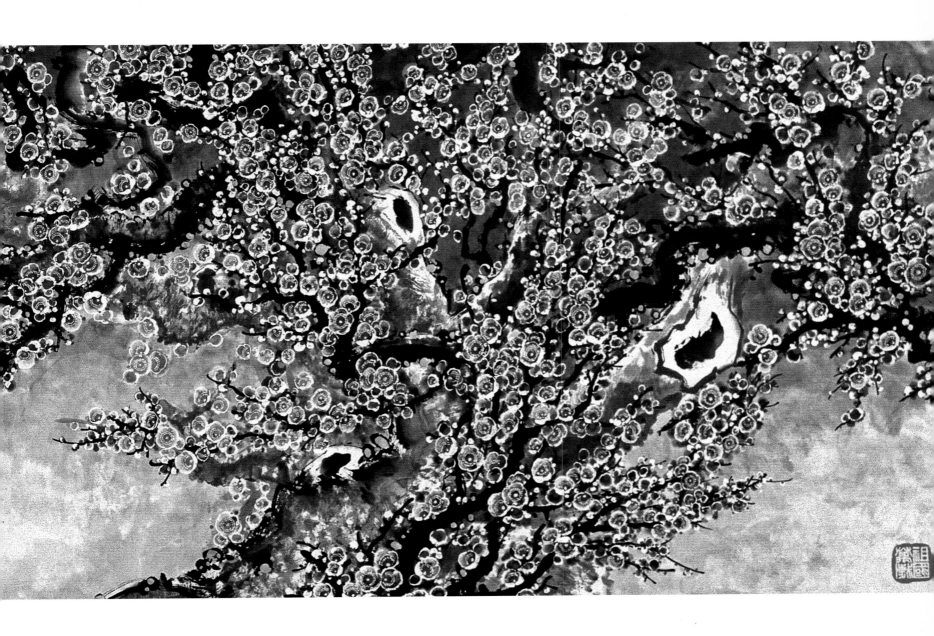

67

梅薯酱酒圖

68

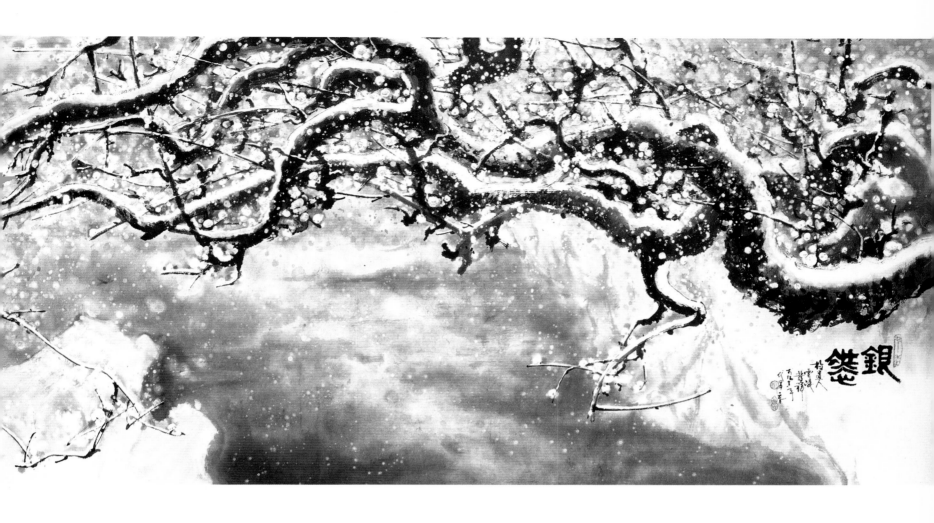

梅花酒圖 （左頁圖）
660mm × 1200mm

銀裝
680mm × 1360mm

69

Hoping to Borrow the Sky Wind to
Send Spring Message(Far right)
（660mm × 1200mm）

Silvery Dress
（680mm × 1360mm）

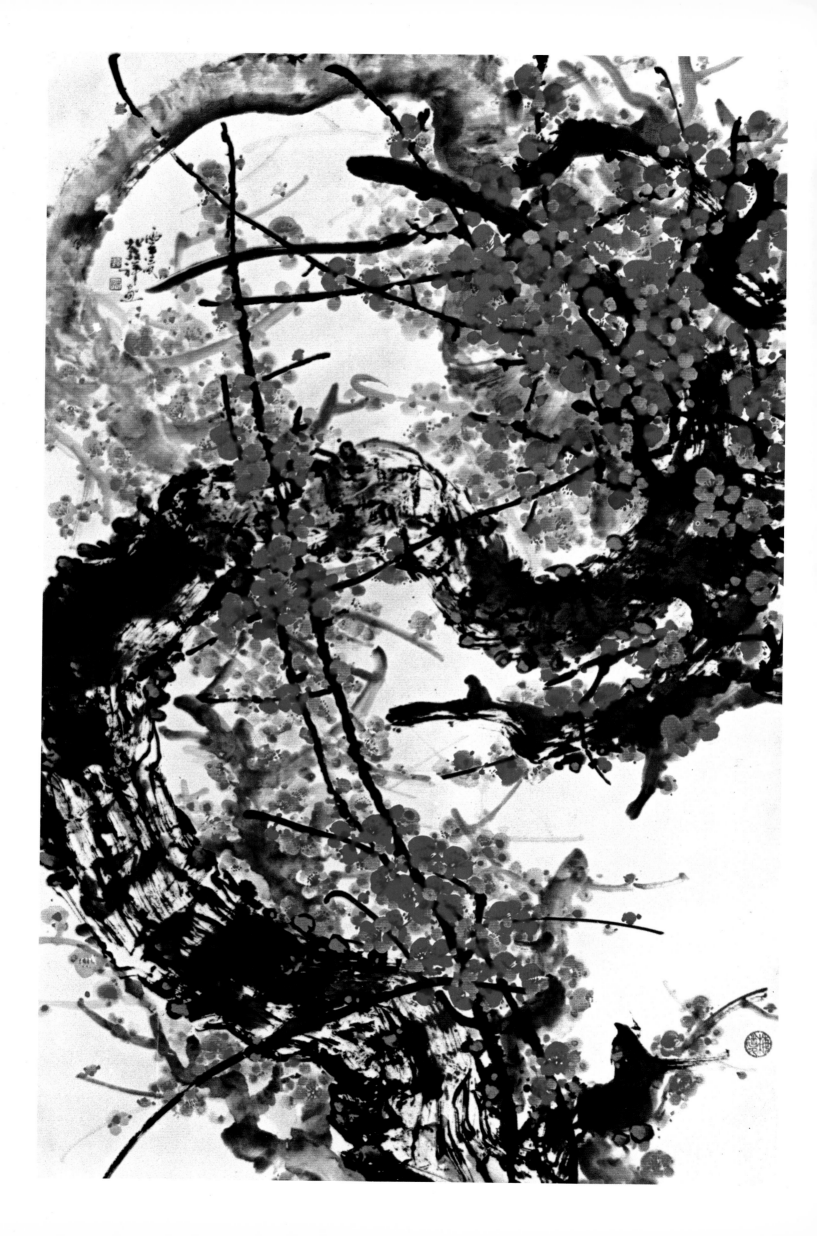

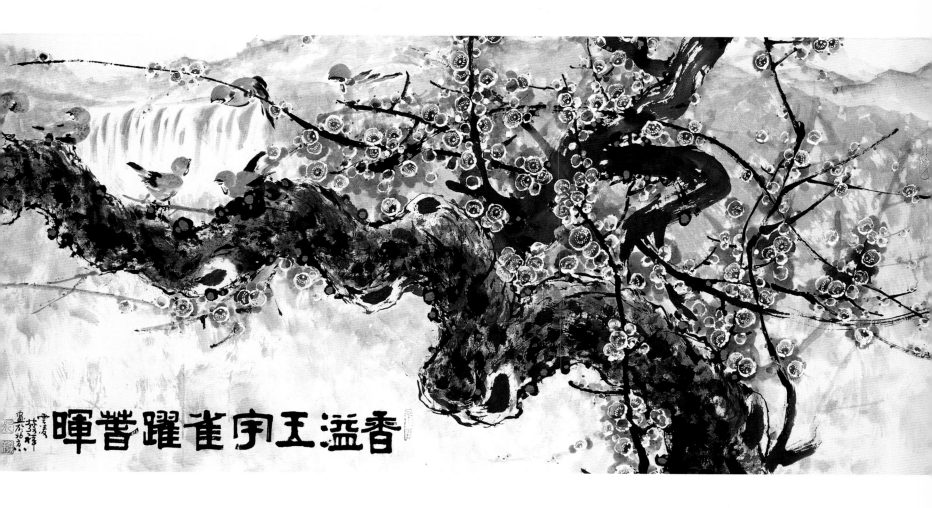

報春　（左頁圖）
680mm × 1100mm

香溢環宇　雀耀春暉
680mm × 1360mm

Reporting Spring(Far right)
（680mm × 1100mm）

Fragrance Overflows the World,
and Sparrows Dazzle Spring
Sunshine
（680mm × 1360mm）

天涯春消息　　680mm × 1360mm

Spring Message around the Skyline
(660mm × 1330mm)

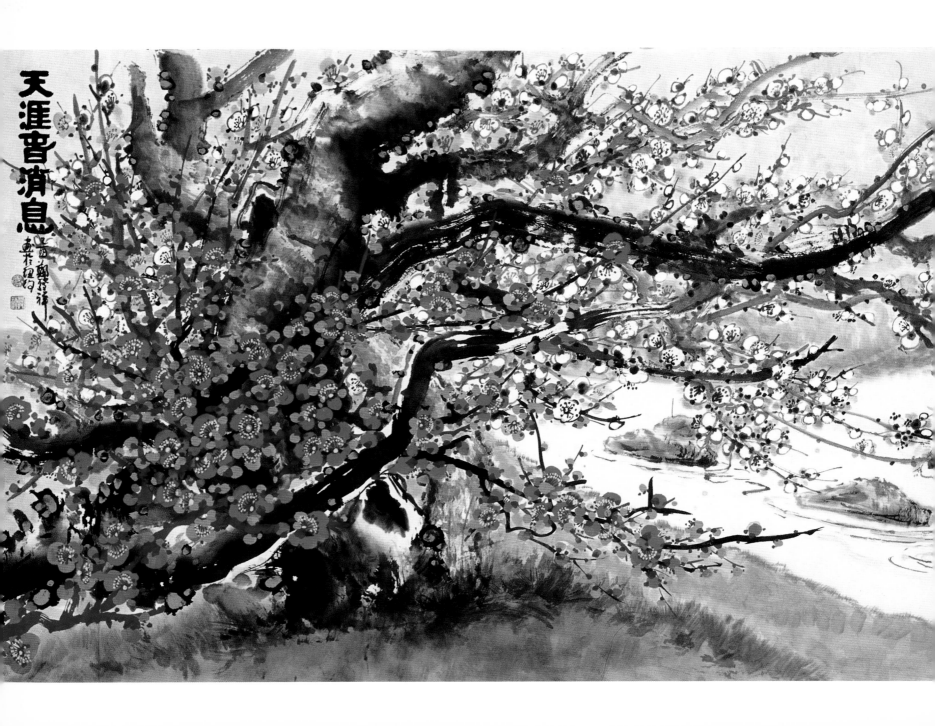

春光無限
660mm × 1330mm

Spring Scenery Is Infinite
（660mm × 1330mm）

春信　　660mm × 1360mm

Spring Message
(660mm × 1330mm)

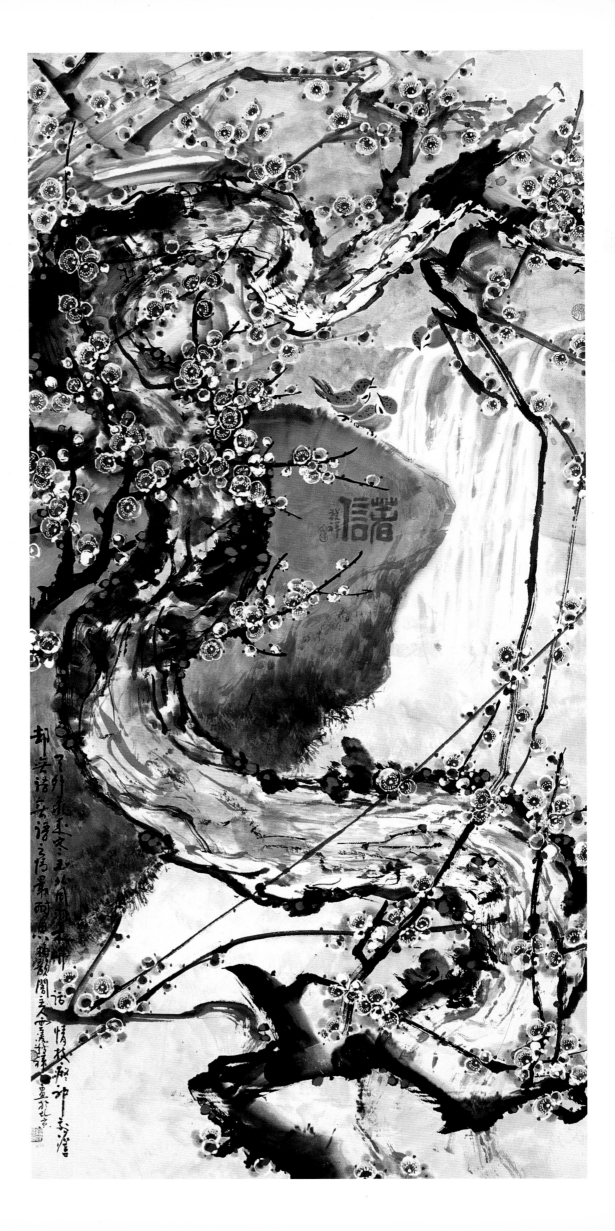

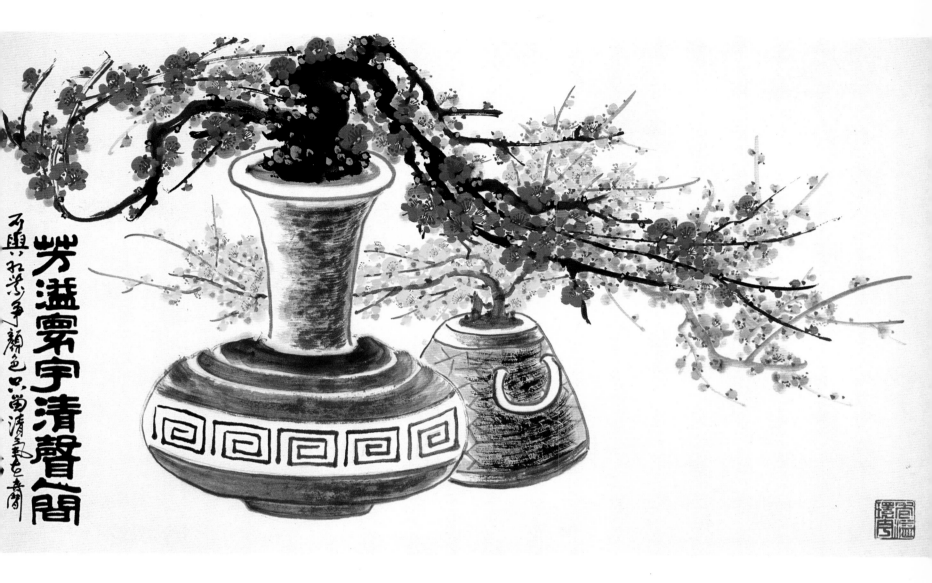

芳溢環宇清聲人間
（660mm × 1330mm）

Spring Returns to the Good
Earth （660mm × 1330mm）

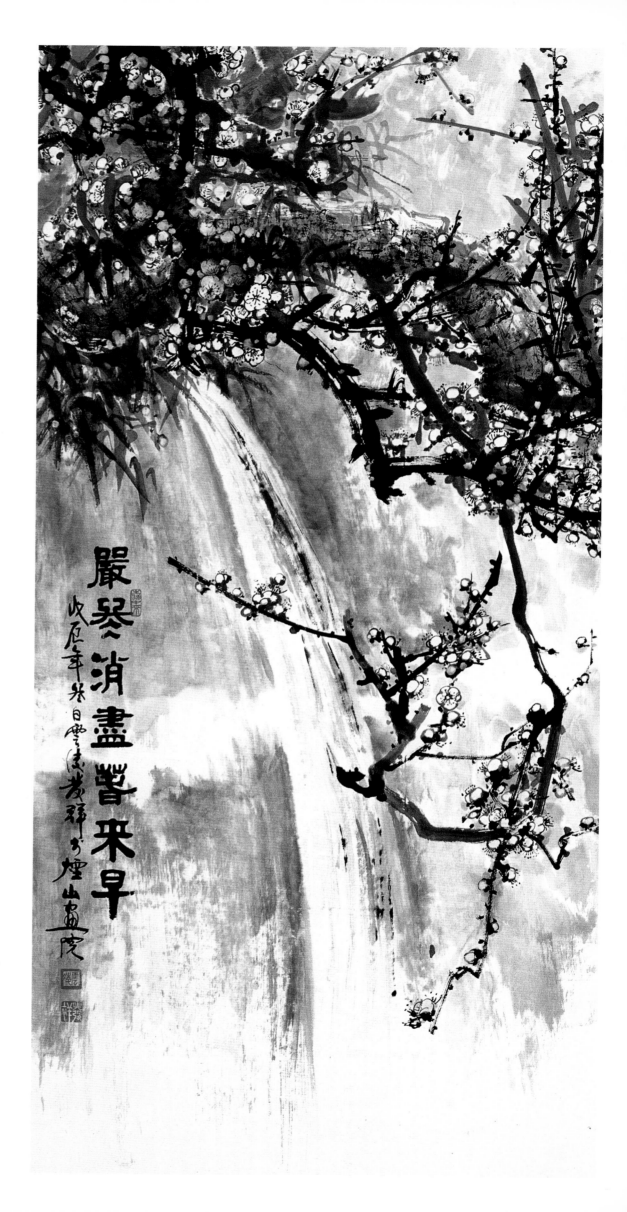

早春　480mm × 980mm

Early Spring
(480mm × 980mm)

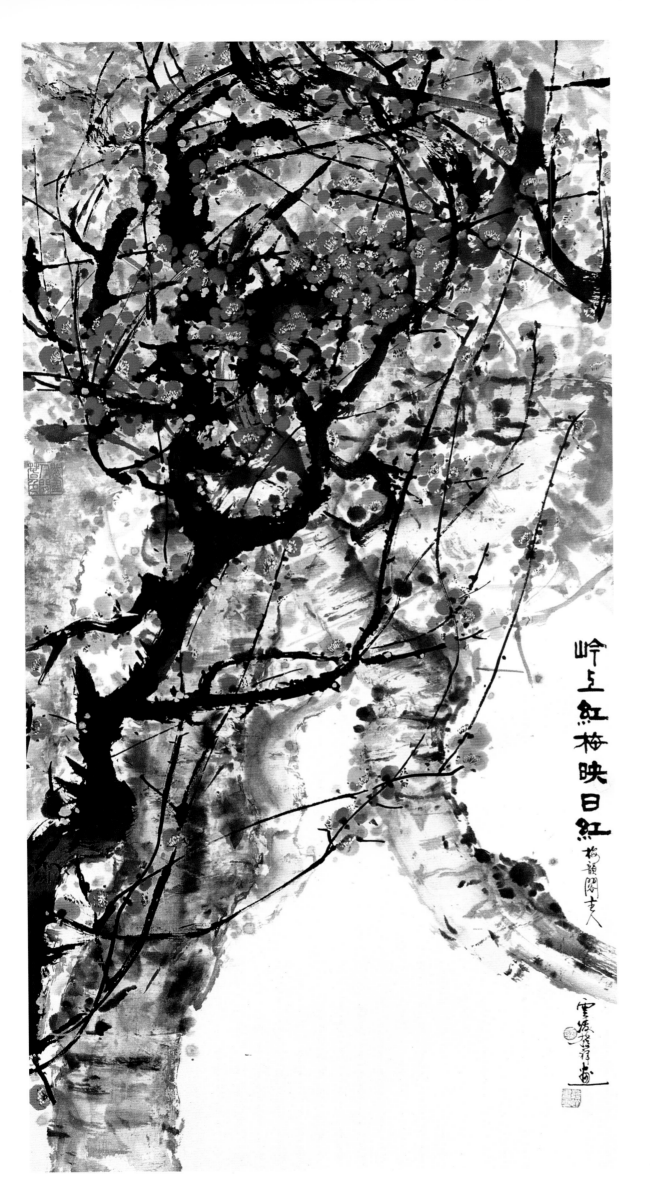

嶺上紅梅映日紅

嶺上紅梅映日紅
480mm × 1200mm

**Red Plum Blossom on Mountain
Shines Red Sun**
（480mm × 1200mm）

玉艷萬青
660mm × 1330mm

Jade Beauty Is Evergreen
（660mm × 1330mm）

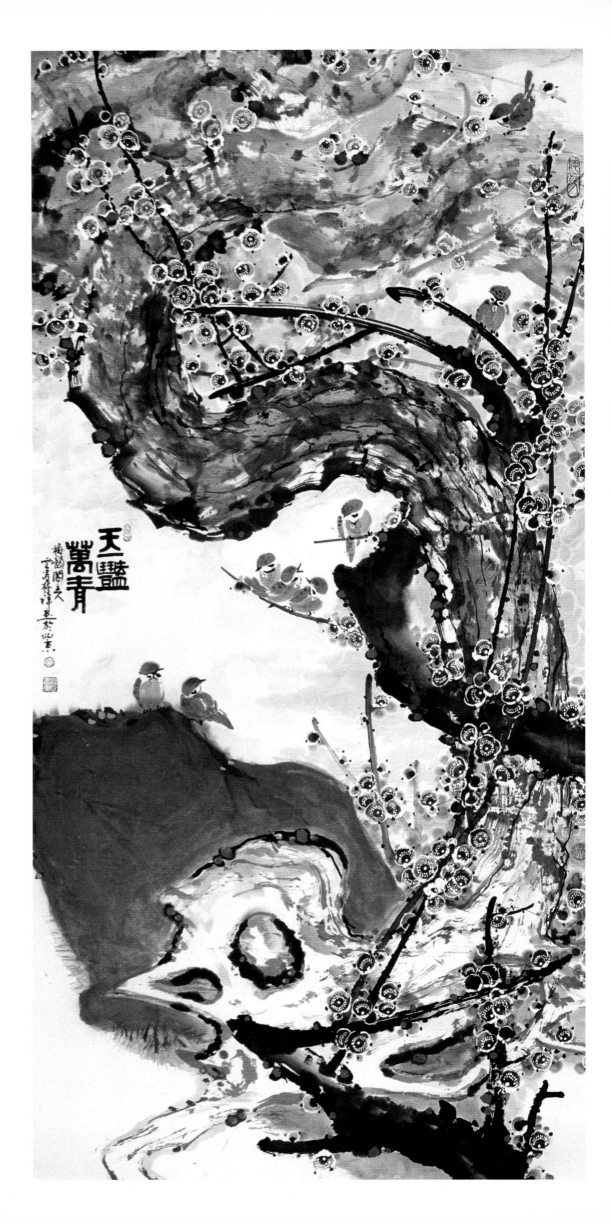

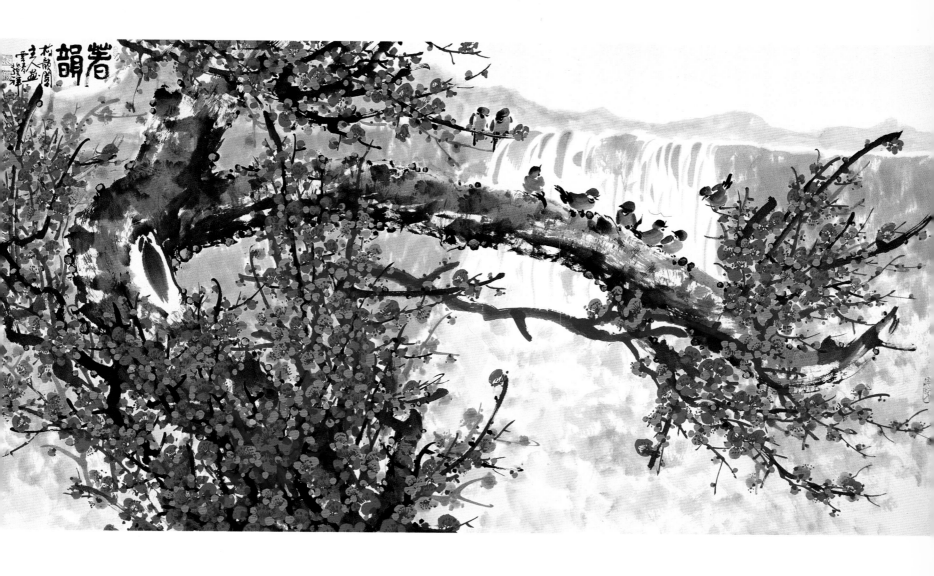

79

春潮
998mm × 1980mm

Spring Tide
（998mm × 1980mm）

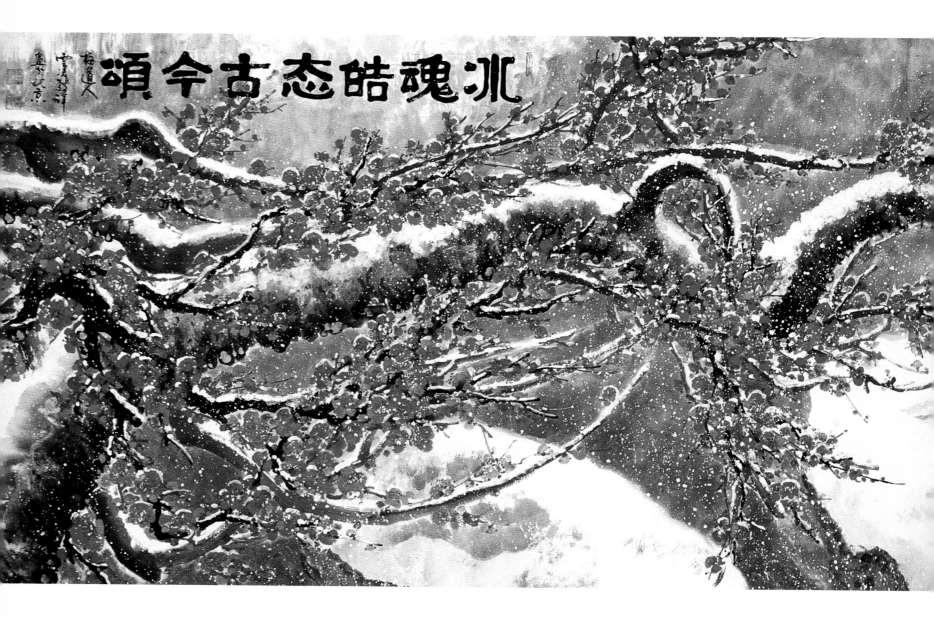

冰魂皓態古今頌
1100mm × 3960mm

Ode to the Past and Present with Icy Soul
and Bright Posture
(1100mm × 3960mm)

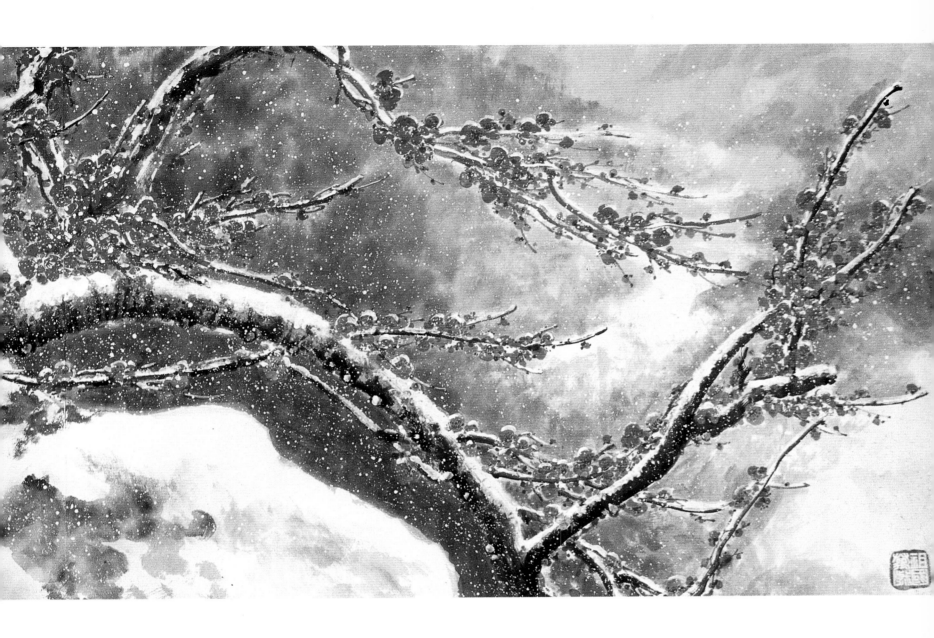

81

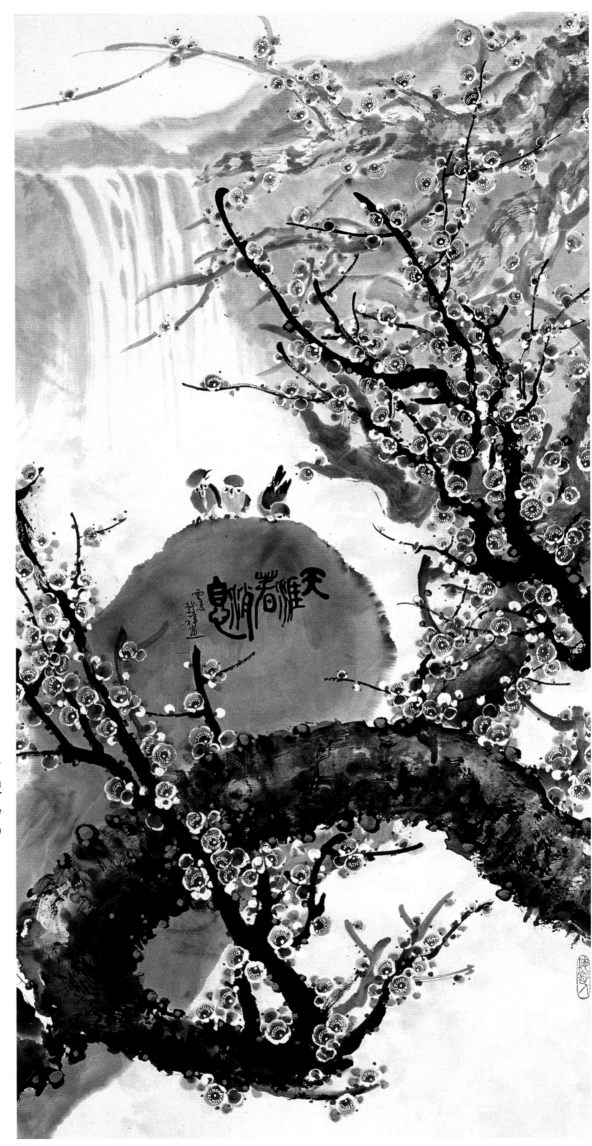

春消息
660mm × 1330mm

Spring Message
(660mm × 1330mm)

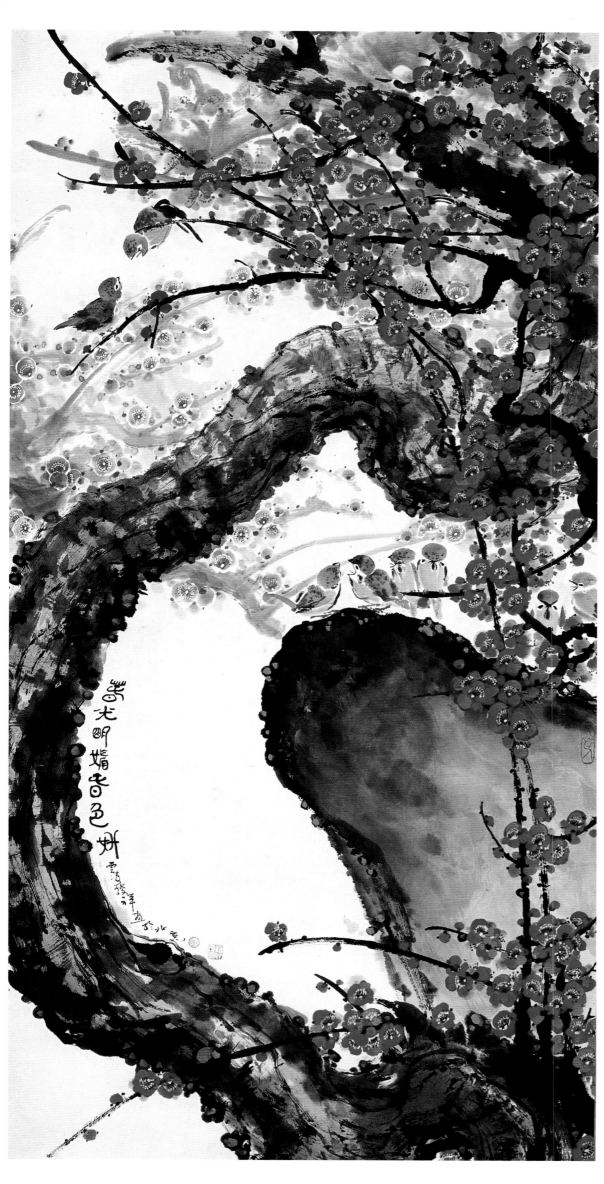

春妍
660mm × 1360mm

Spring Beauty
（660mm × 1360mm）

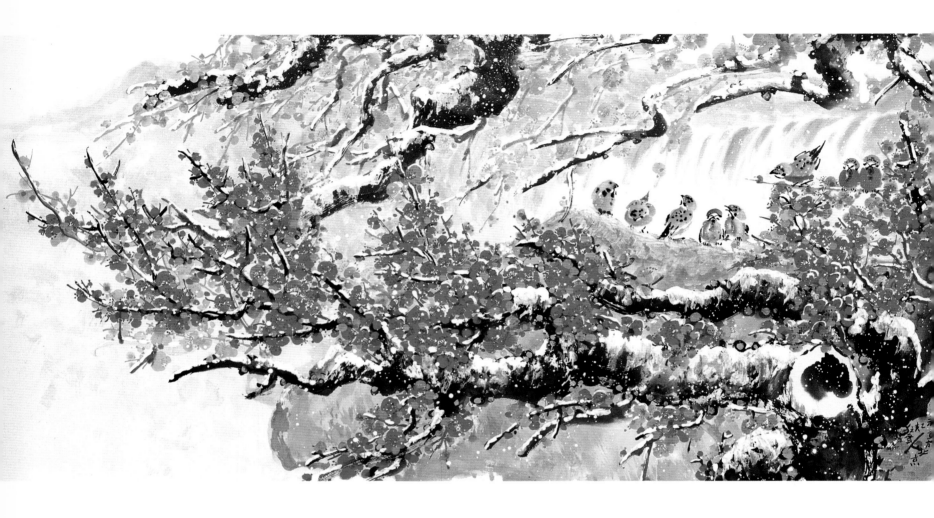

84

冬韵 680mm × 1360mm

Winter Rhyme
(680mm × 1360mm)

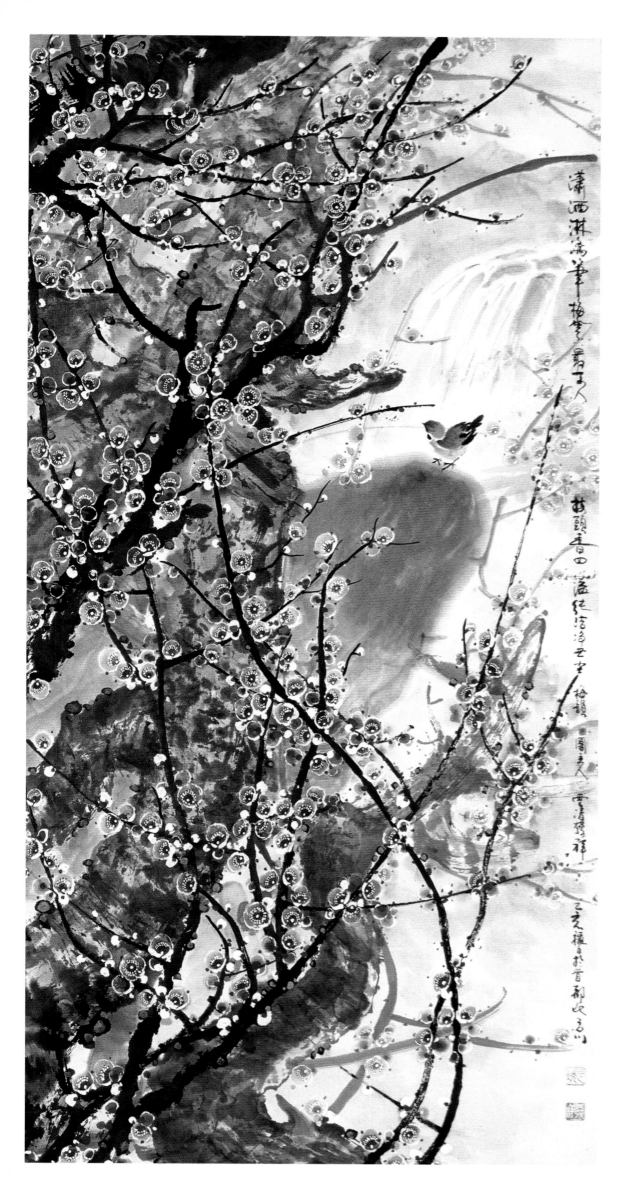

春花爛漫
680mm × 1360mm

Spring Flowers in Full Bloom
（680mm × 1360mm）

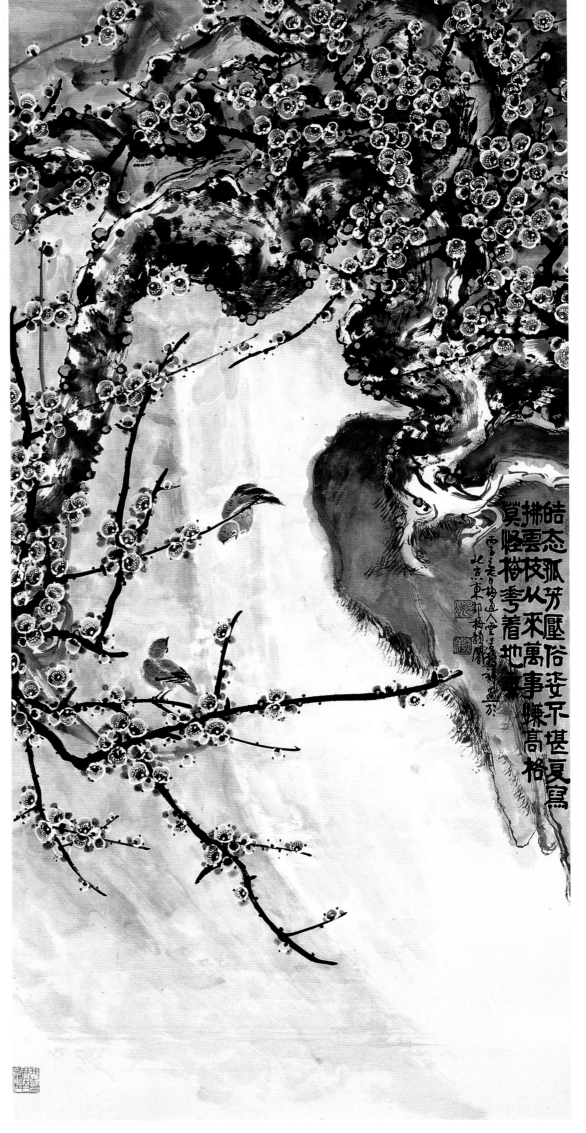

寒冬的對歌
680mm × 1360mm

Cold Winter's Singing in Antiphonal Style
(680mm × 1360mm)

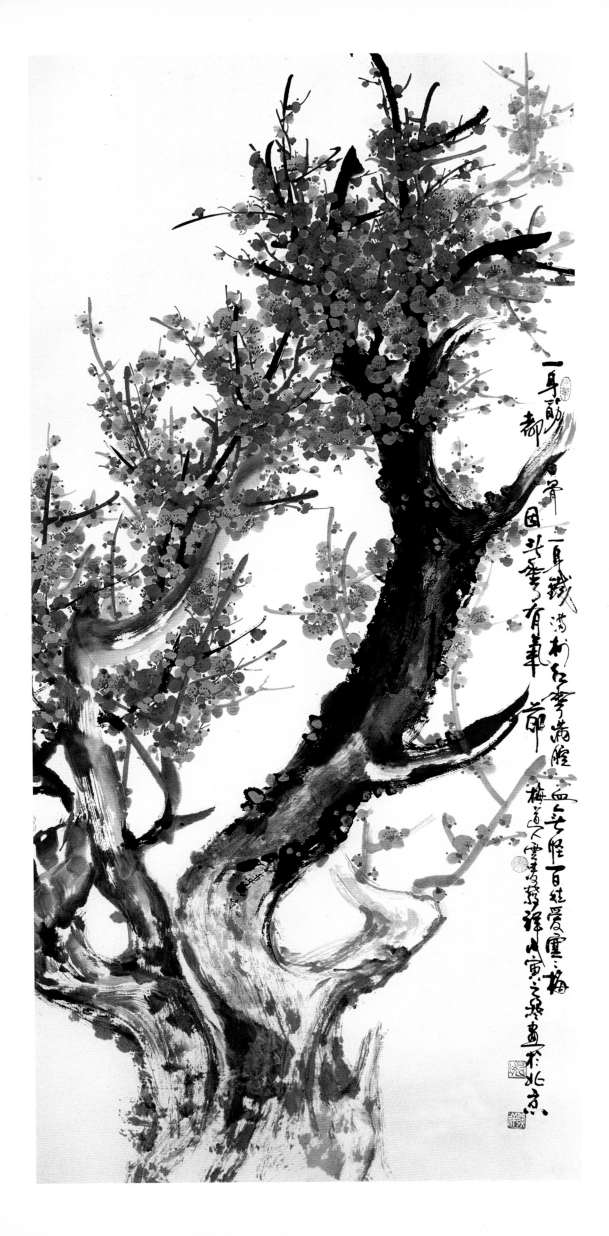

一身都是节

骨因此耸有花无

一身铁骨村红雪满腔

血气才旺百花爱雪三梅

梅道人云雪寒松深此寅之余画于北京

87

怒放的季節
660mm × 1360mm

Season is Blooming in Profusion
（660mm × 1360mm）

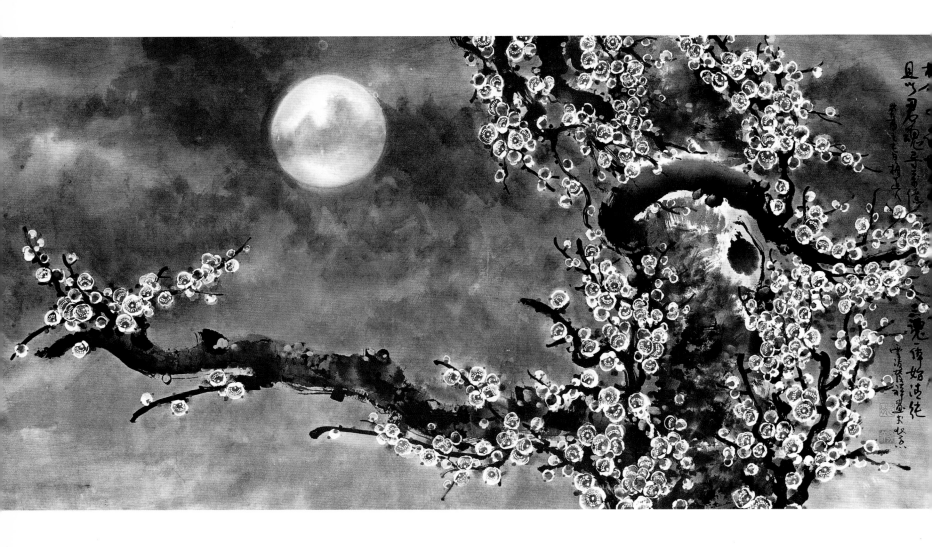

88

月下美人
660mm × 1360mm

Beauty below the Moon
(660mm × 1360mm)

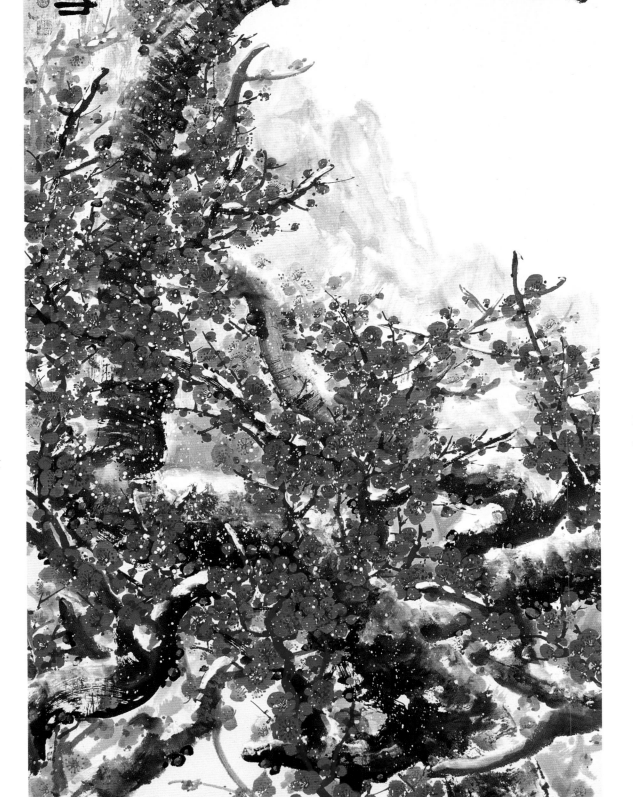

梅花歡喜漫天雪
680mm × 1360mm

Plum Blossom Joys Snow all over
the Sky
（680mm × 1360mm）

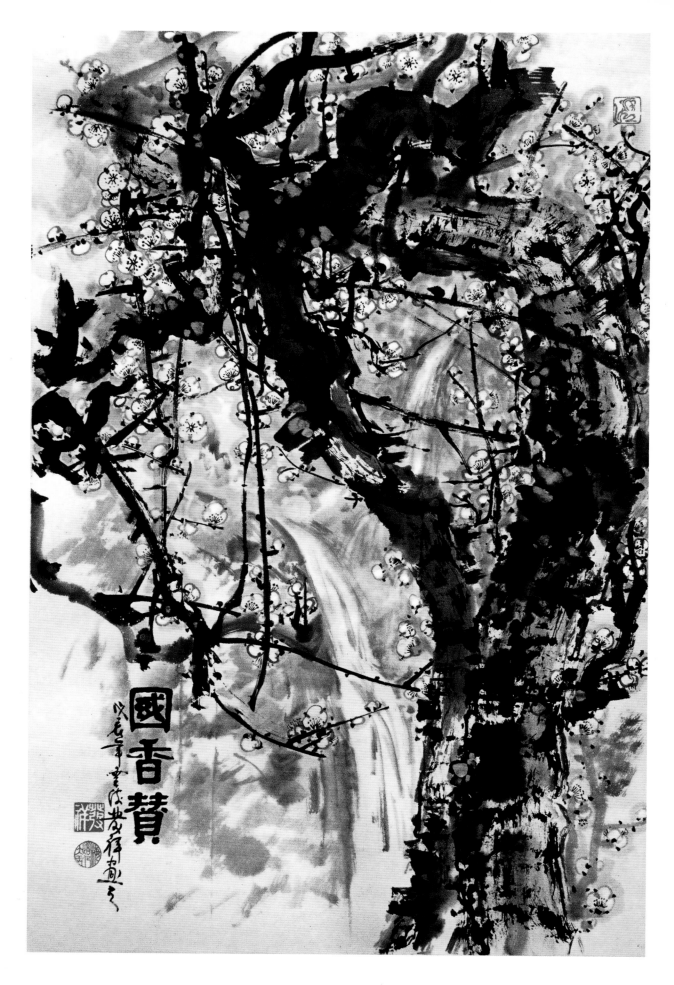

90

國香
330mm × 680mm

National Fragrance
(330mm × 680mm)

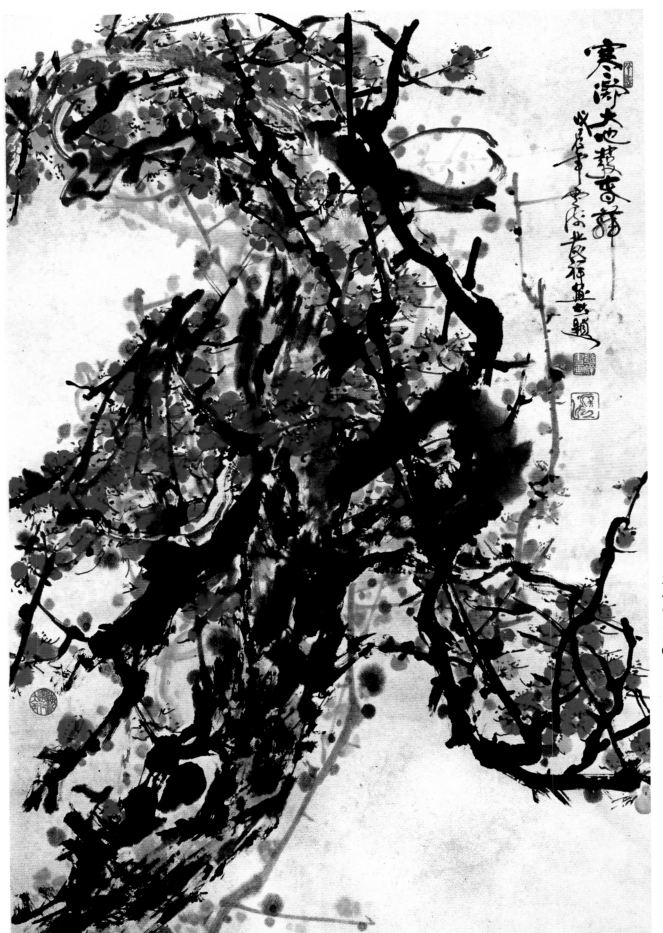

大地發春華

330mm × 680mm

The Earth Produces Glorious
Flowers in Spring

（330mm × 680mm）

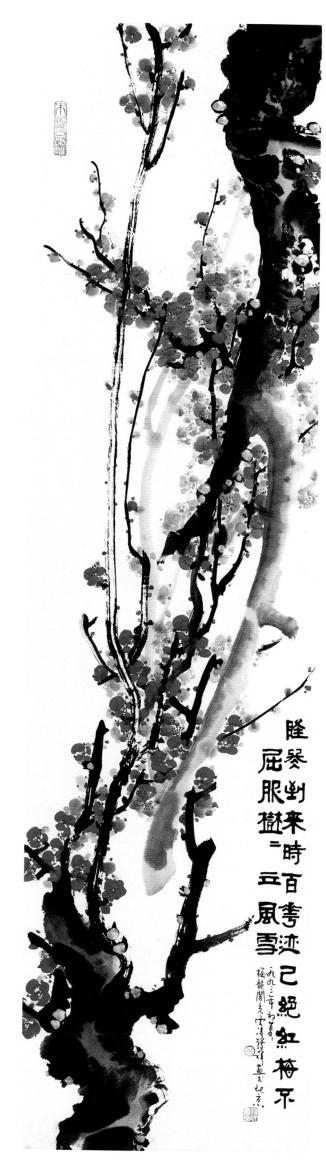

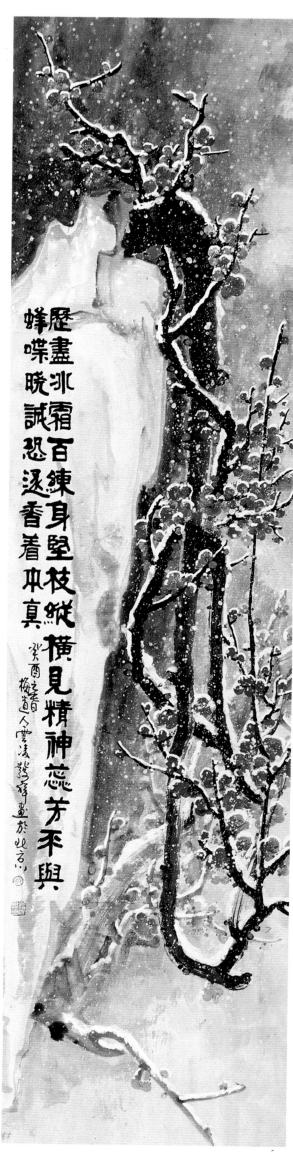

92

歷盡冰霜百練身
240mm × 680mm

Experiencing in Full Ice and
Frost, the Body is Tempered
Thoroughly
(240mm × 680mm)

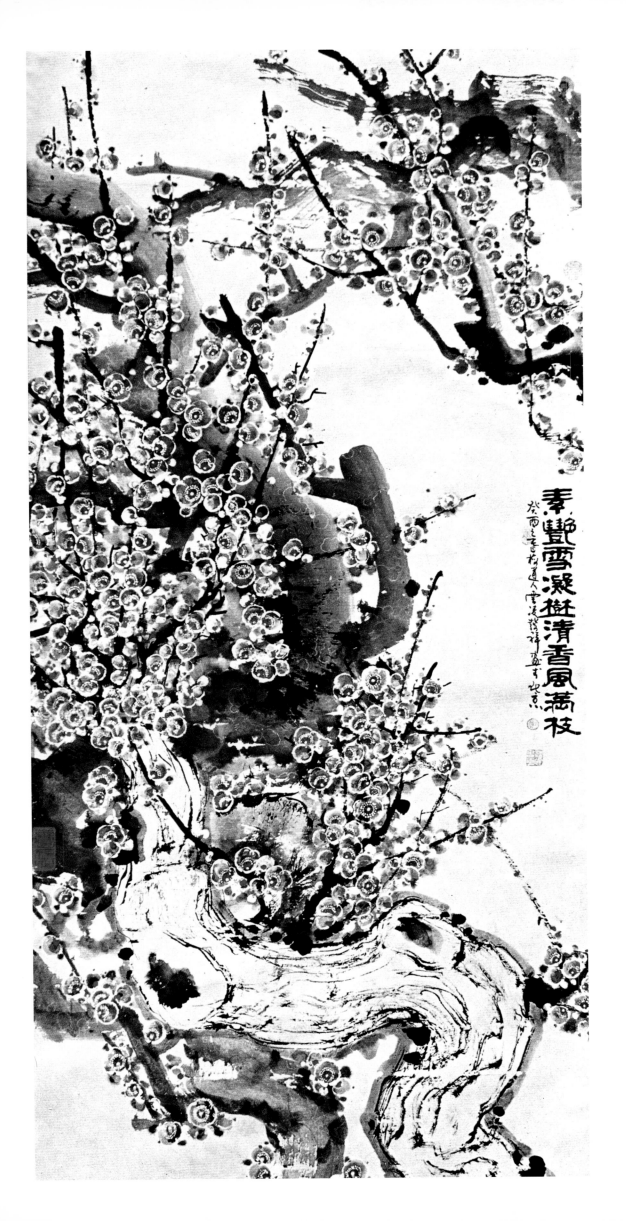

素艷雪凝樹
480mm × 1100mm

White Snow Coagulates Trees
（480mm × 1100mm）

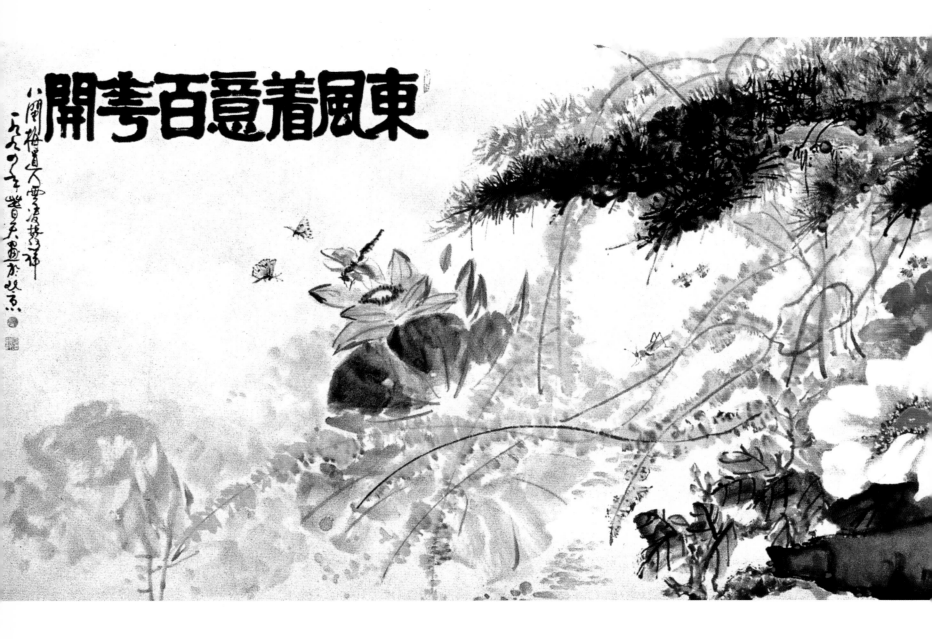

東風着意百花開
1100mm × 3960mm

East Wind Acts Carefully, and Hundreds of
Flowers Are Blooming
(1100mm × 3960mm)

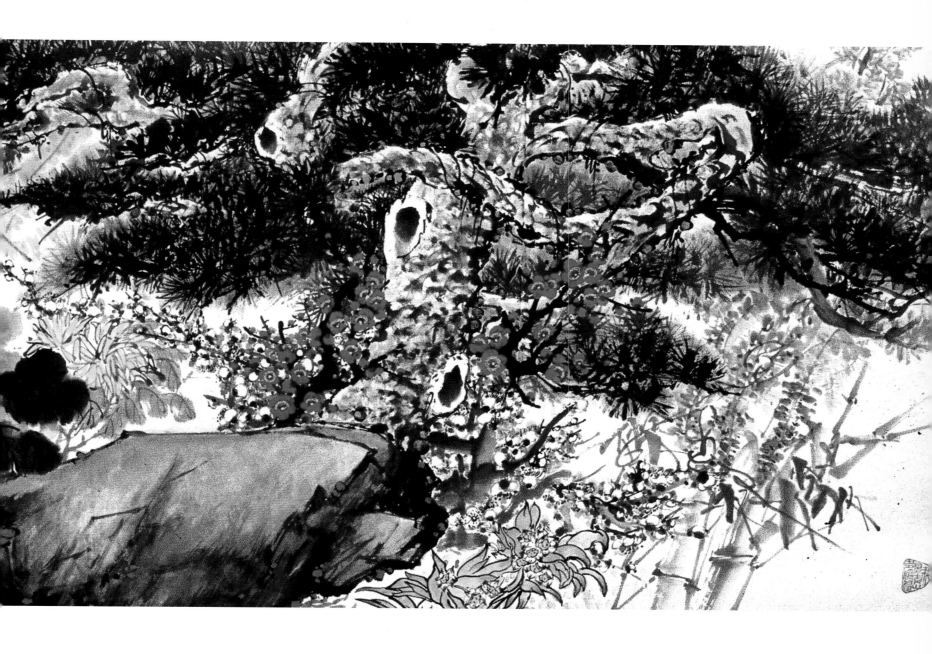

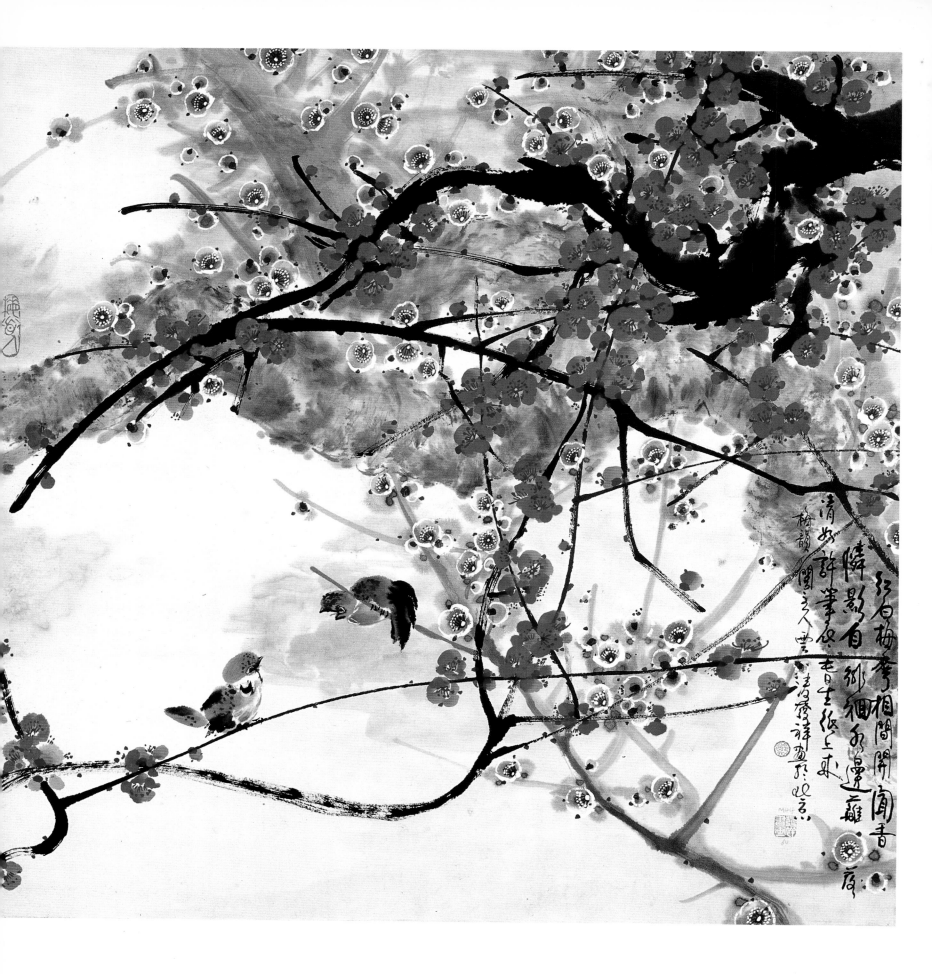

清如許
680mm × 680mm

Freshness is so
(680mm × 680mm)

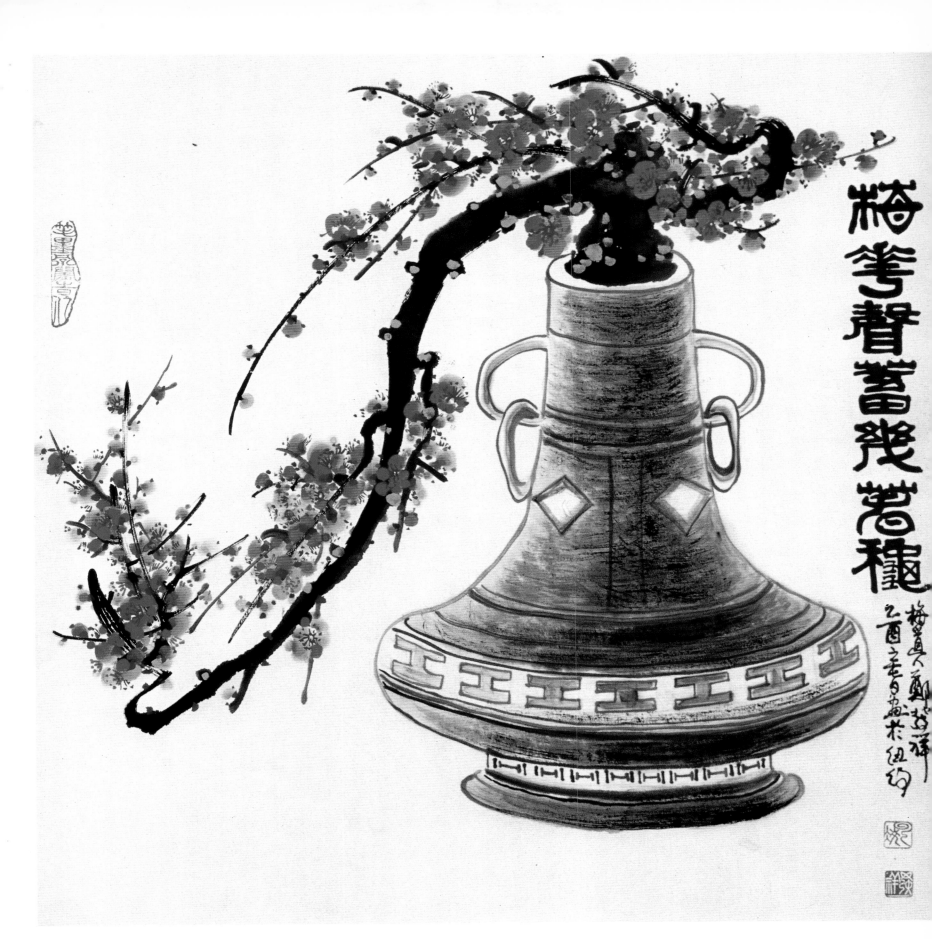

梅花聲蓄幾春秋
680mm × 680mm

Plum Blossom Sound Is Stored
up for a Few Years
（680mm × 680mm）

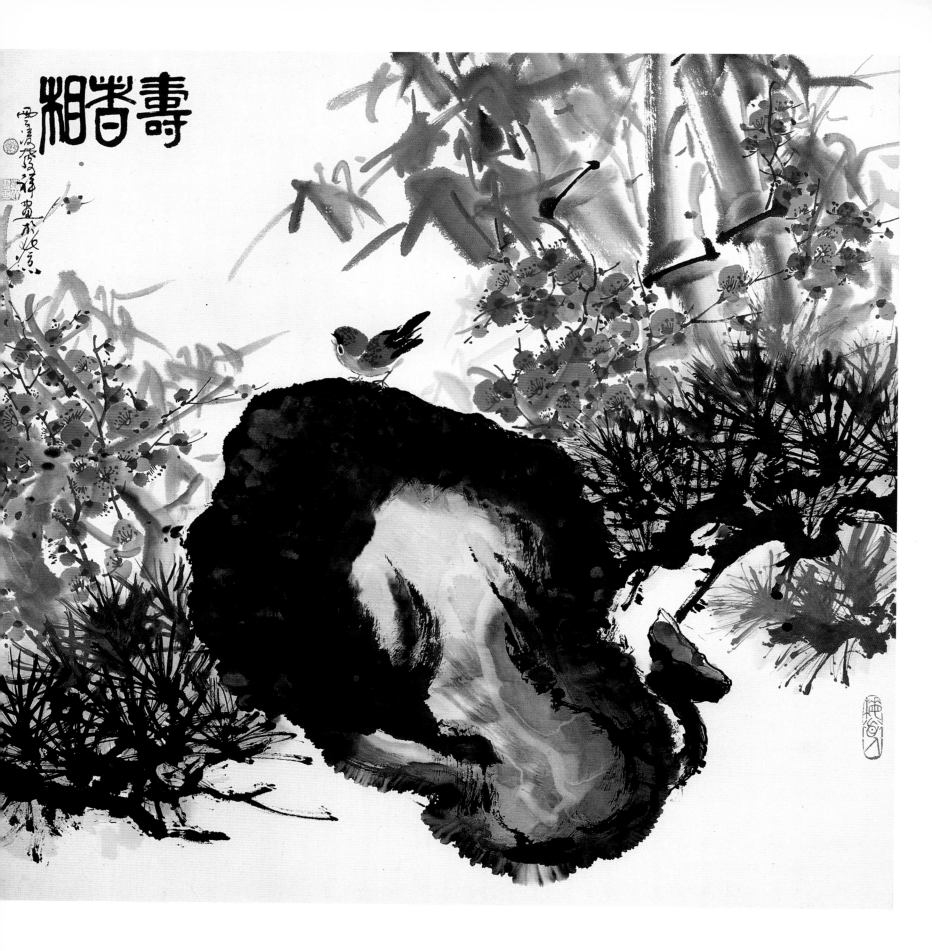

壽相
680mm × 680mm

Looks of The God of Longevity
(680mm × 680mm)

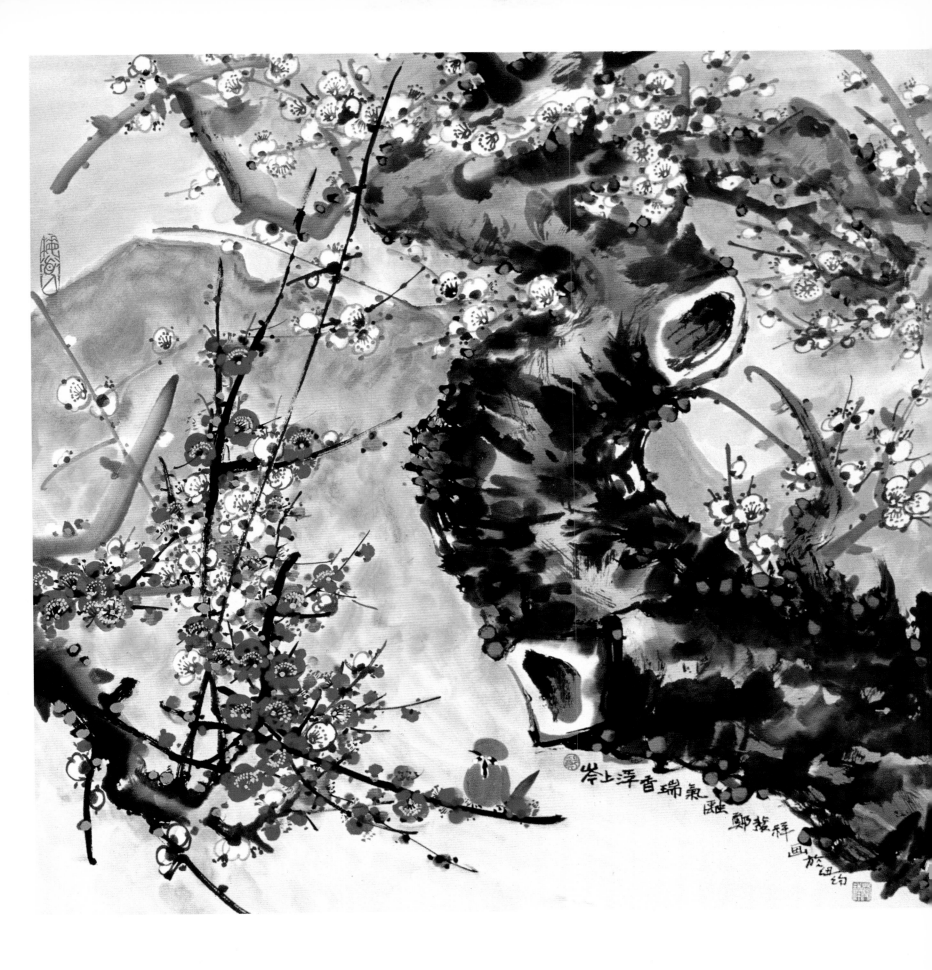

嶺上浮香瑞氣融
680mm × 680mm

Fragrance Floats on Mountain and
Lucky Atmosphere is in
Harmony
（680mm × 680mm）

99

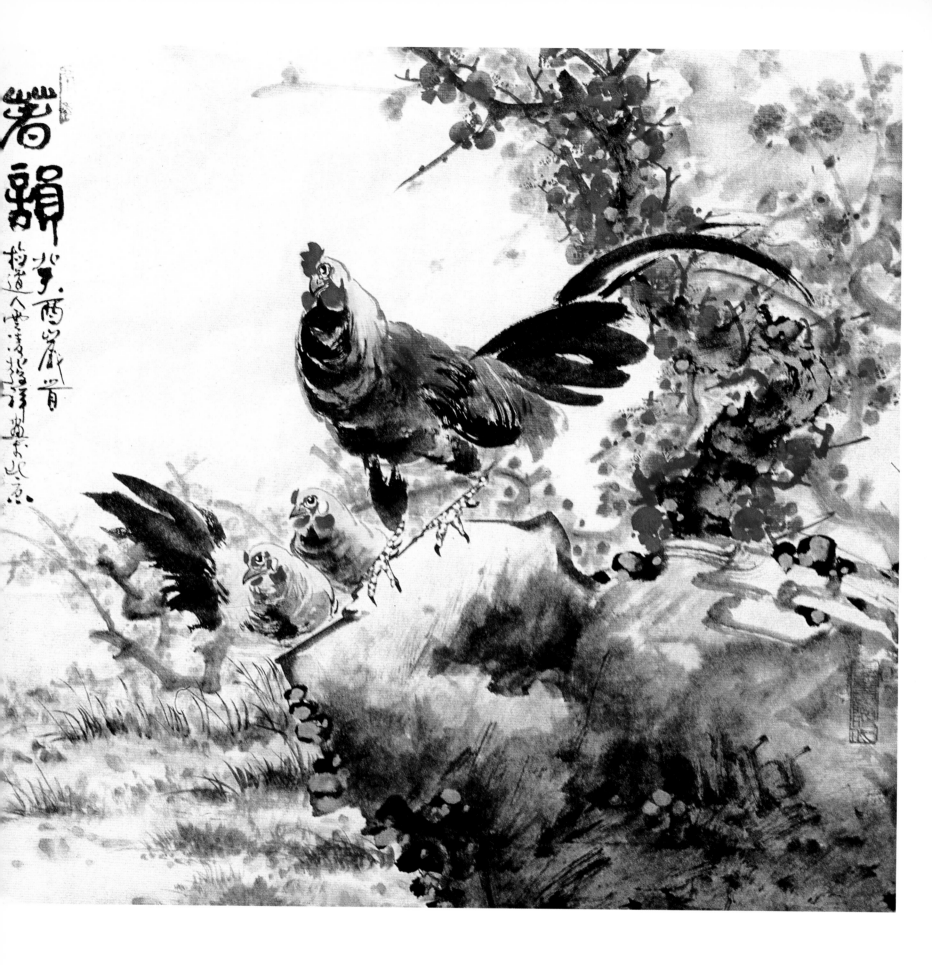

春韵
680mm × 680mm

Spring Rhyme
(680mm × 680mm)

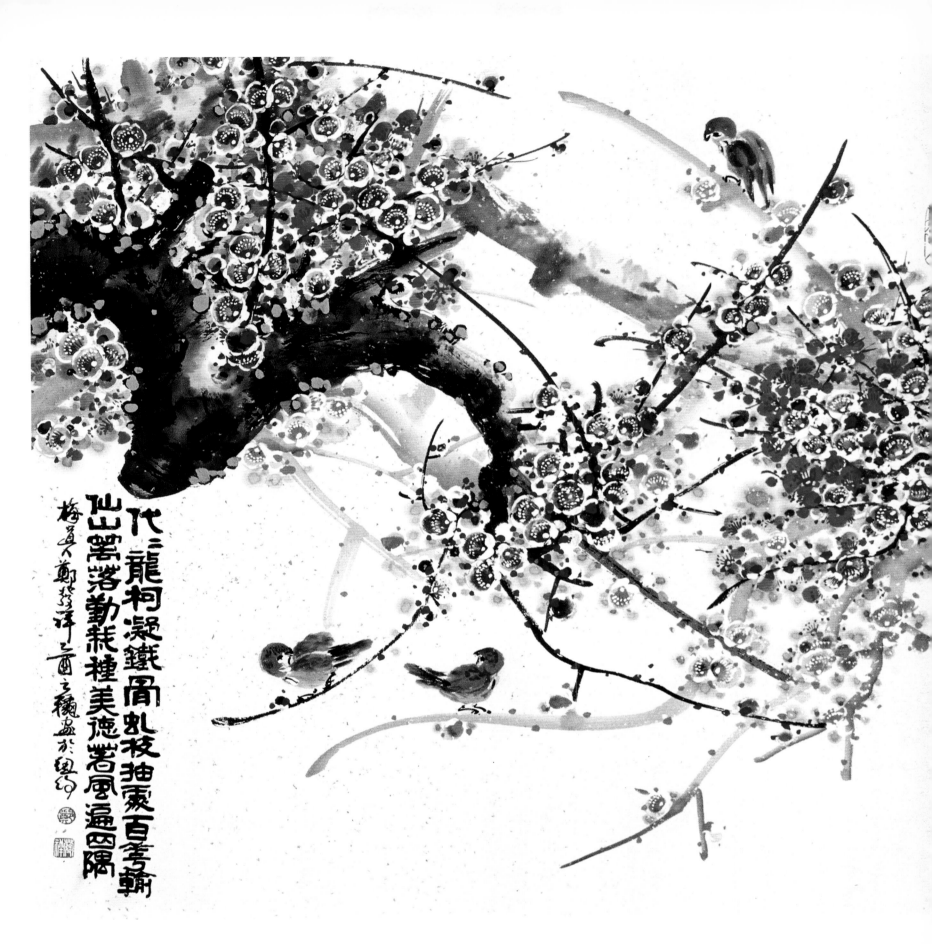

美德春風香四海
680mm × 680mm

Virtue Spring Breeze is Fragrant
all over the World
（680mm × 680mm）

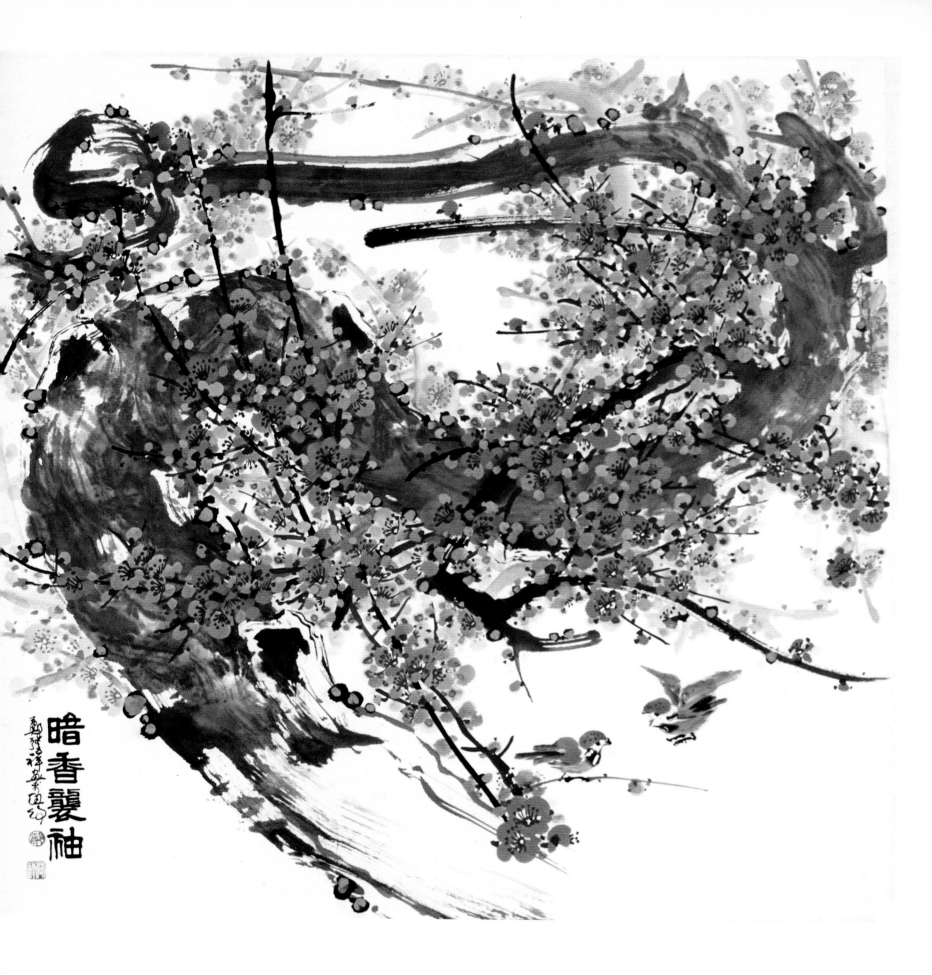

102

暗香裘袖
680mm × 680mm

Darkly Sweet Scent and Fur Sleeve
(680mm × 680mm)

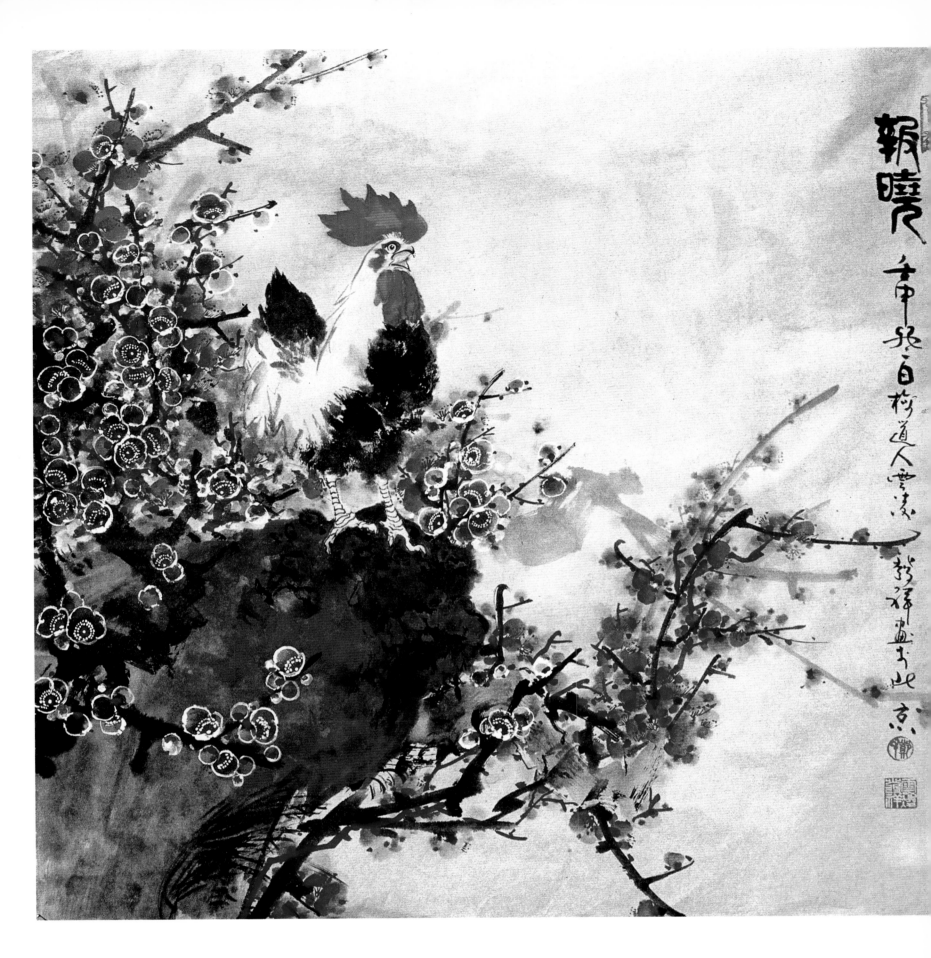

報曉
680mm × 680mm

Heralding the Break of a Day
（680mm × 680mm）

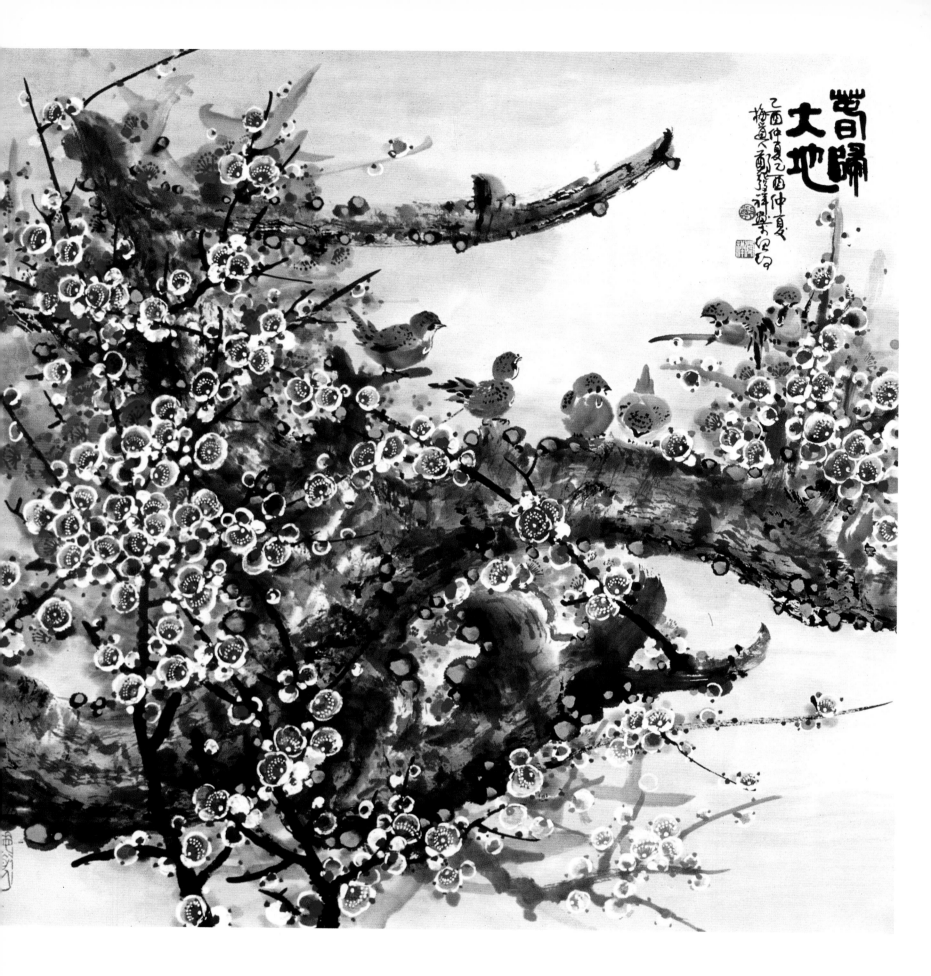

春歸大地
680mm × 680mm

Spring Returns to the Good Earth
(680mm × 680mm)

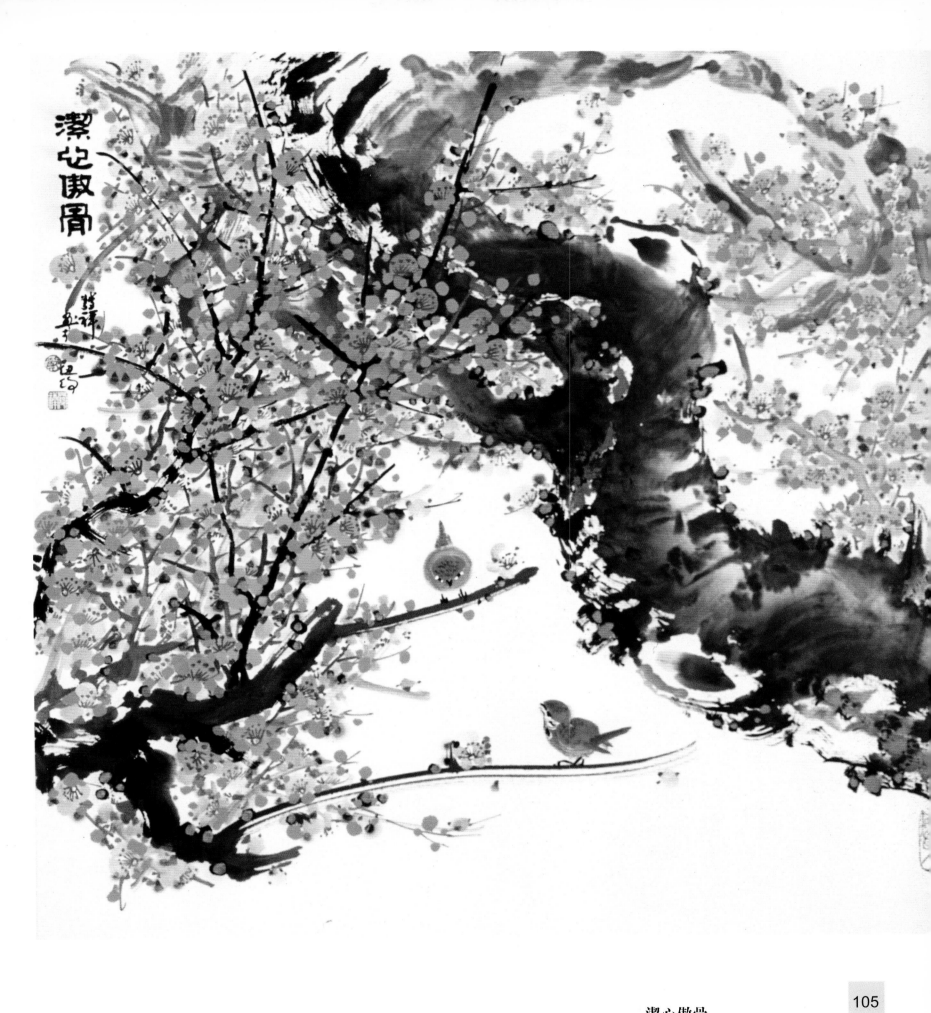

潔心傲骨
680mm × 680mm

Clean Heart and Unyielding
Character
（680mm × 680mm）

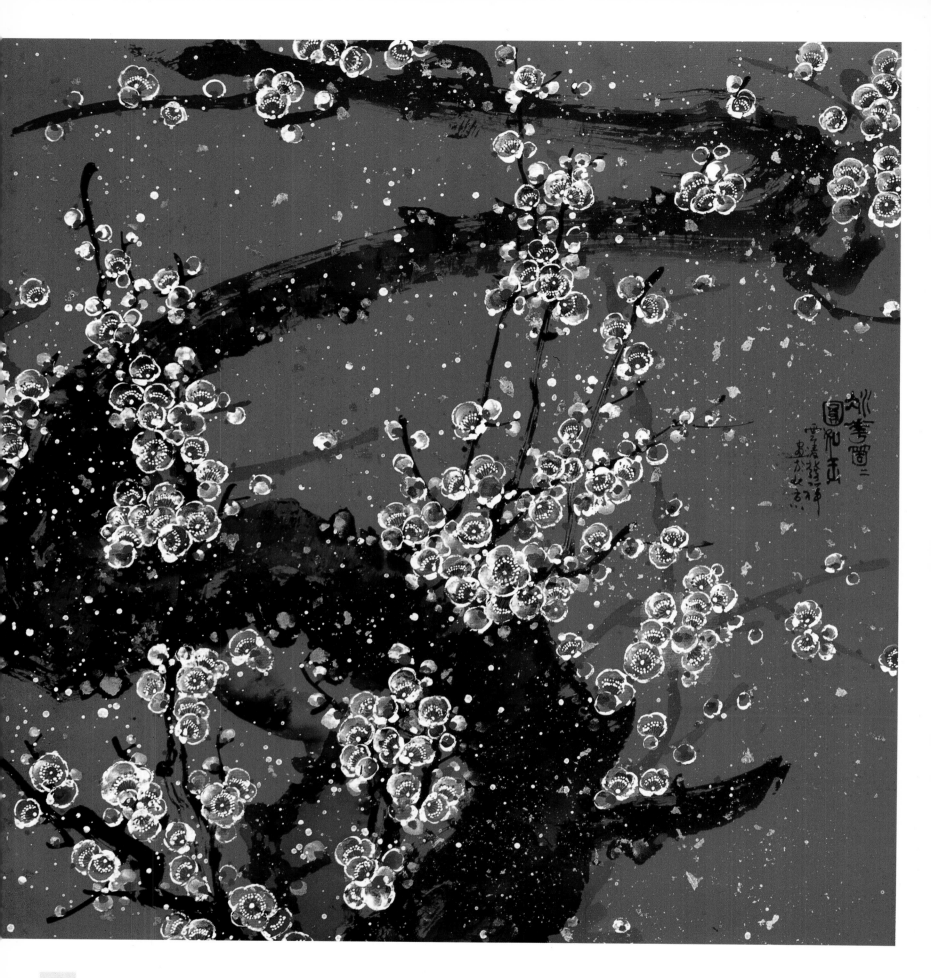

占盡春光
680mm × 680mm

Accounting for in Full Spring Scenery
(680mm × 680mm)

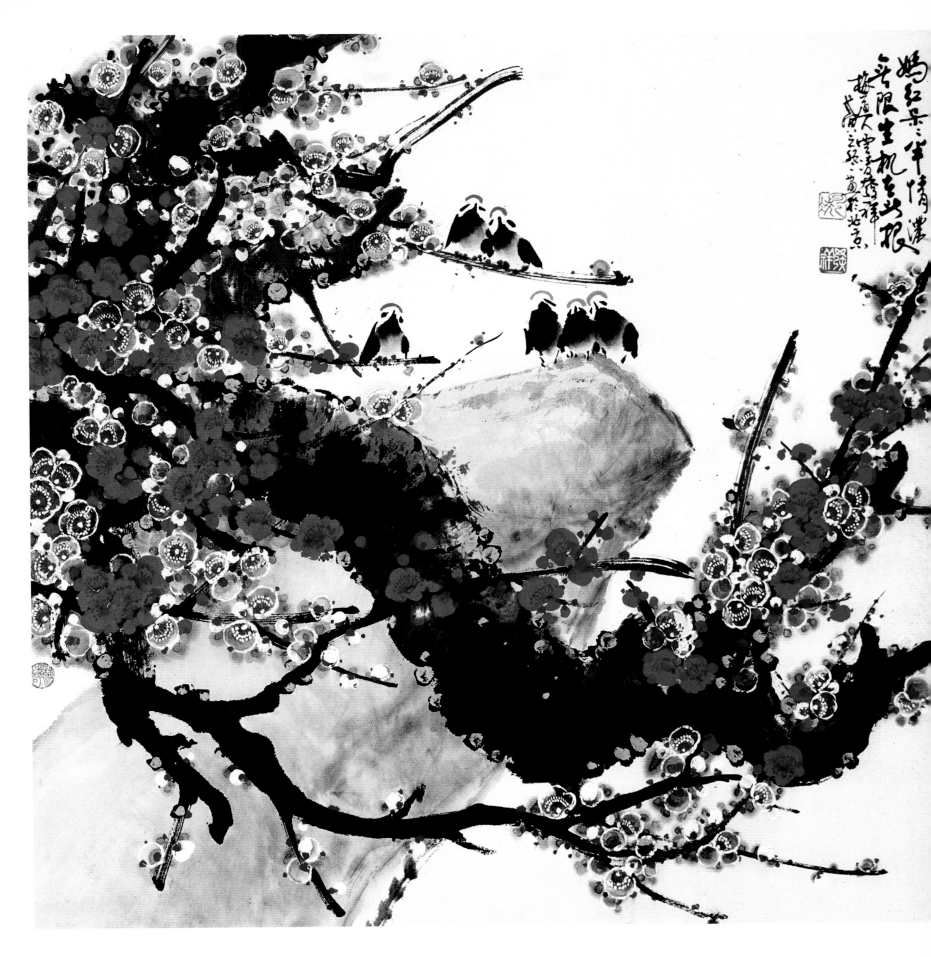

媽紅朵朵伴情濃
無限生機在此根
680mm × 680mm

Bright Red Flowers Accompanies
Thick Affection, and Infinite Vital
Force In Rooted Hereon
（680mm × 680mm）

107

108

迎春曲
660mm × 1330mm

Music to Meet Spring
(660mm × 1330mm)

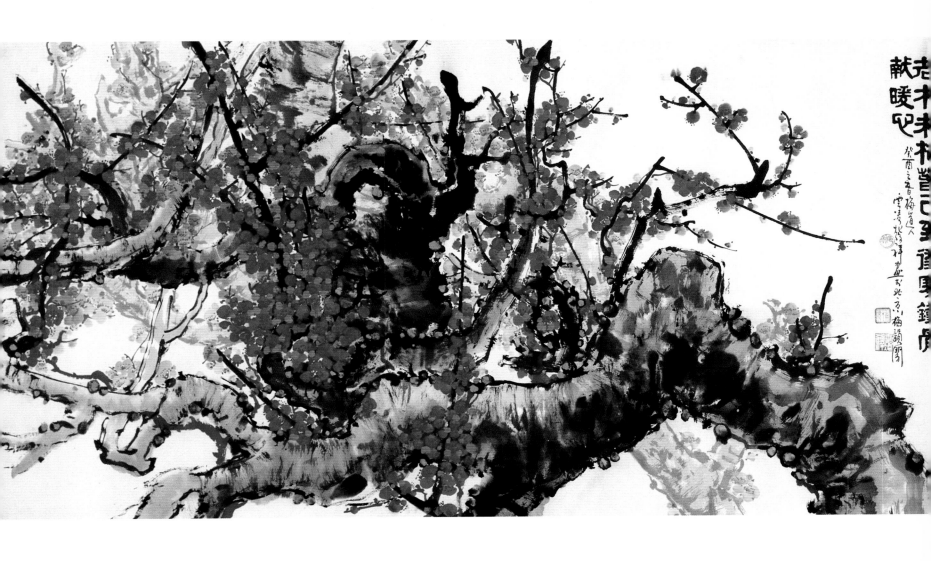

鐵骨獻暖心
680mm×1360mm

Iron Bone Dedicates Warm Mind
（680mm × 1360mm）

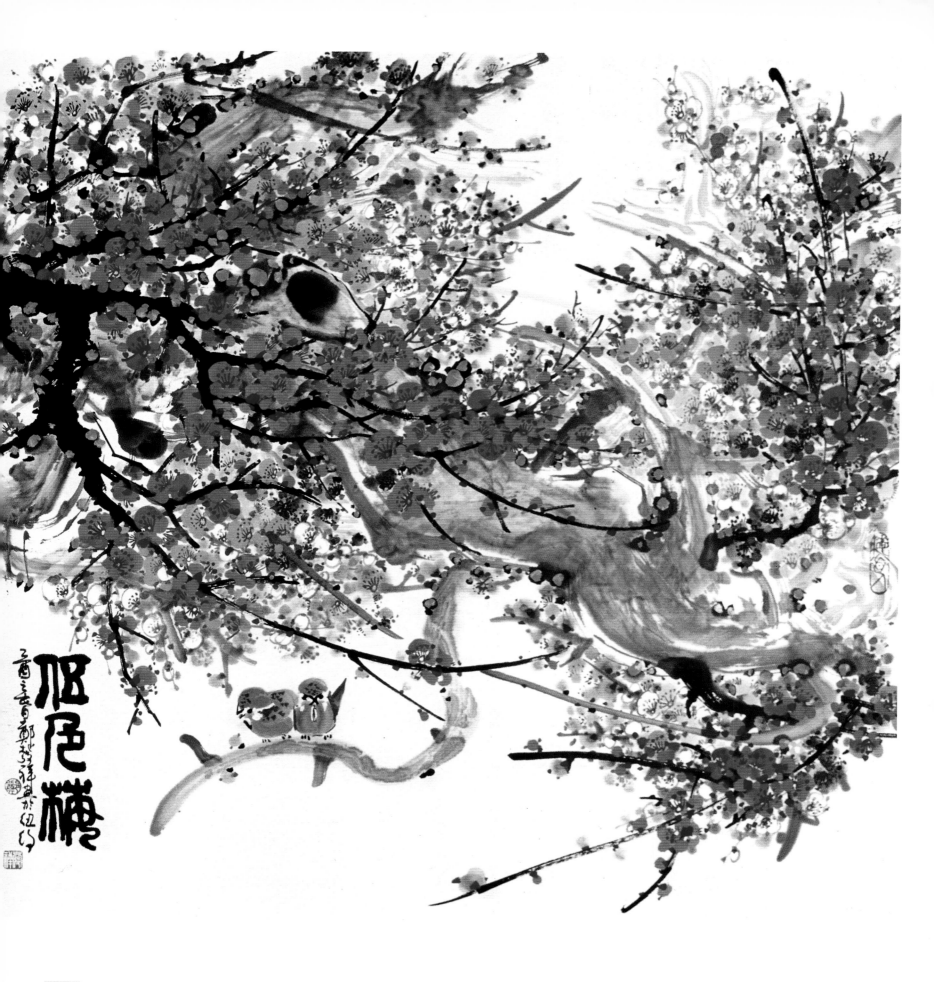

伍色梅
680mm × 680mm

Five Colors Plum Blossom
(680mm × 680mm)

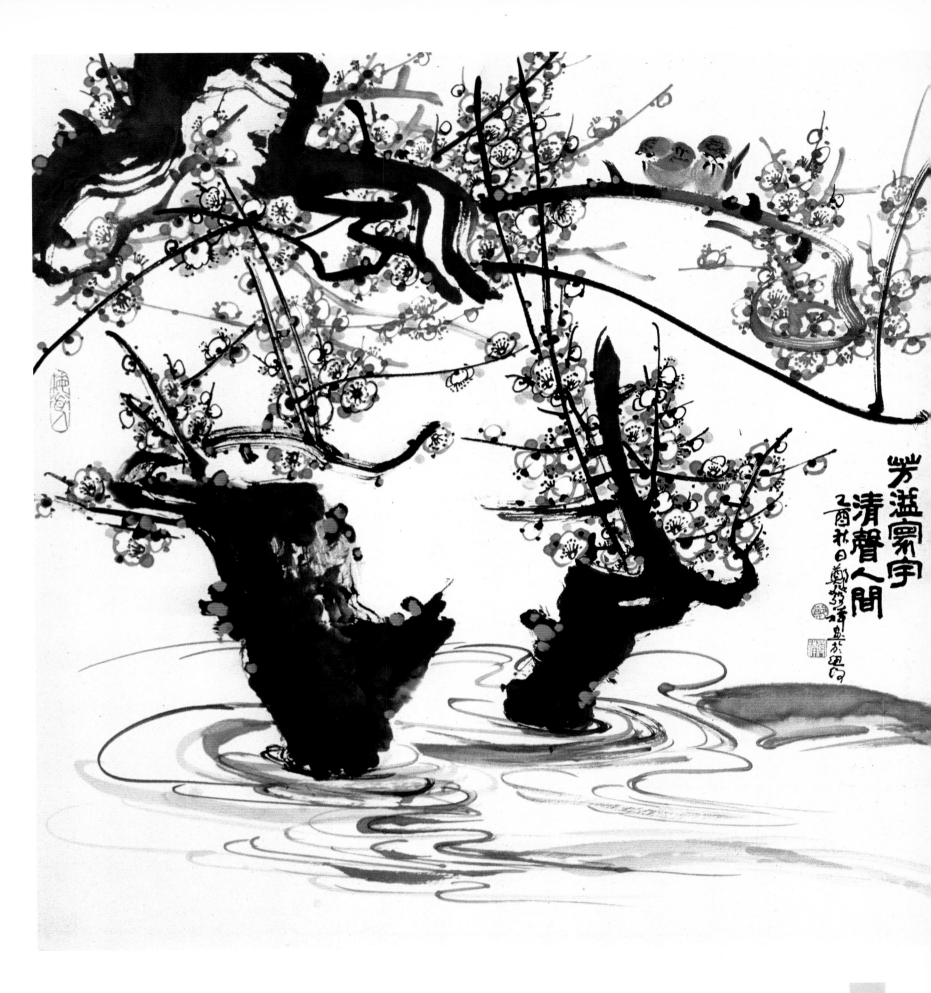

芳溢寰宇　清聲人間
680mm × 680mm

Fragrance Overflows the World,
and Freshness Sounds around the
World　（680mm × 680mm）

111

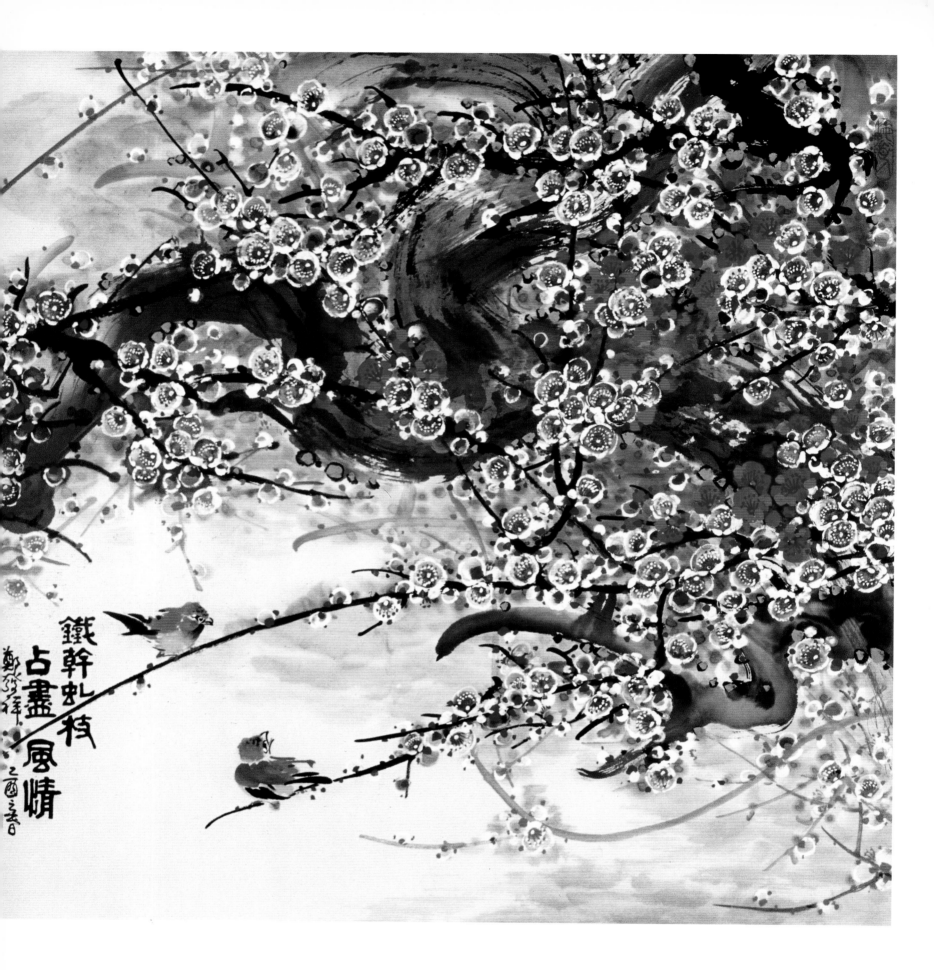

112 鐵幹虬枝占風情
680mm × 680mm

**Iron Trunk and Curly Branches Occupies
Amorous Feelings**
(680mm × 680mm)

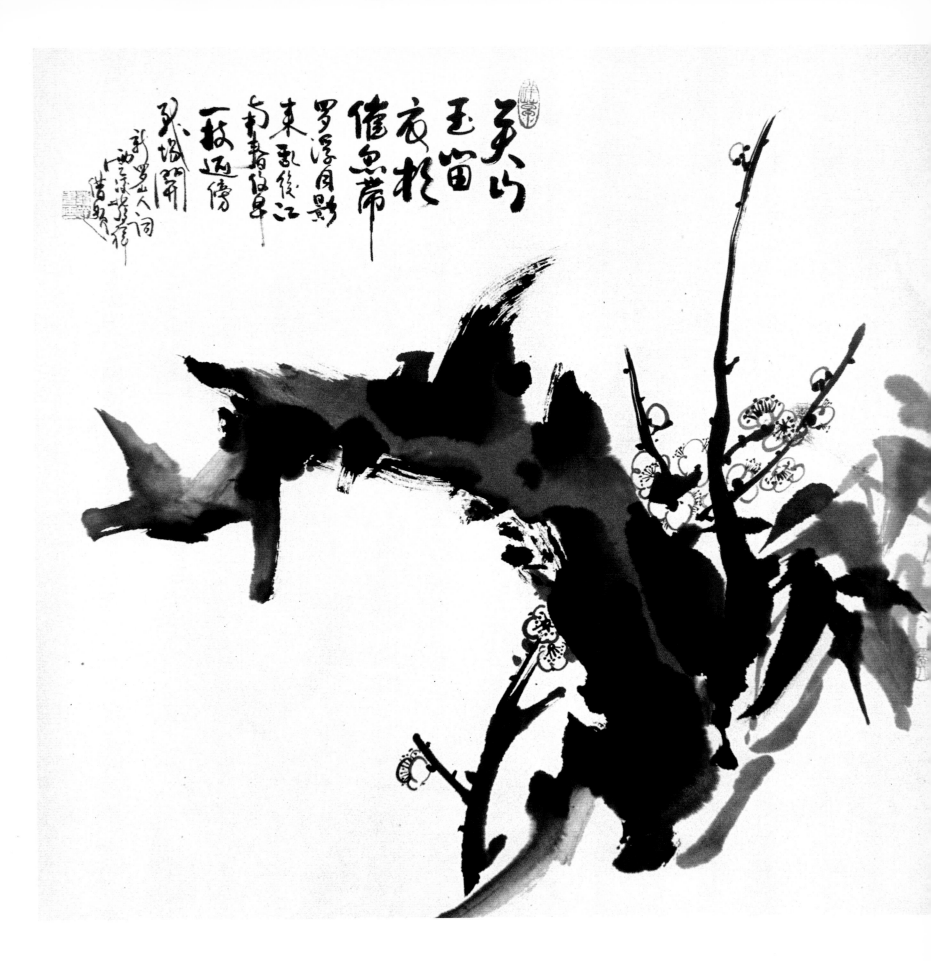

關山第一枝
680mm × 680mm

**First Branches at the Gate and
Mountain**
（680mm × 680mm）

113

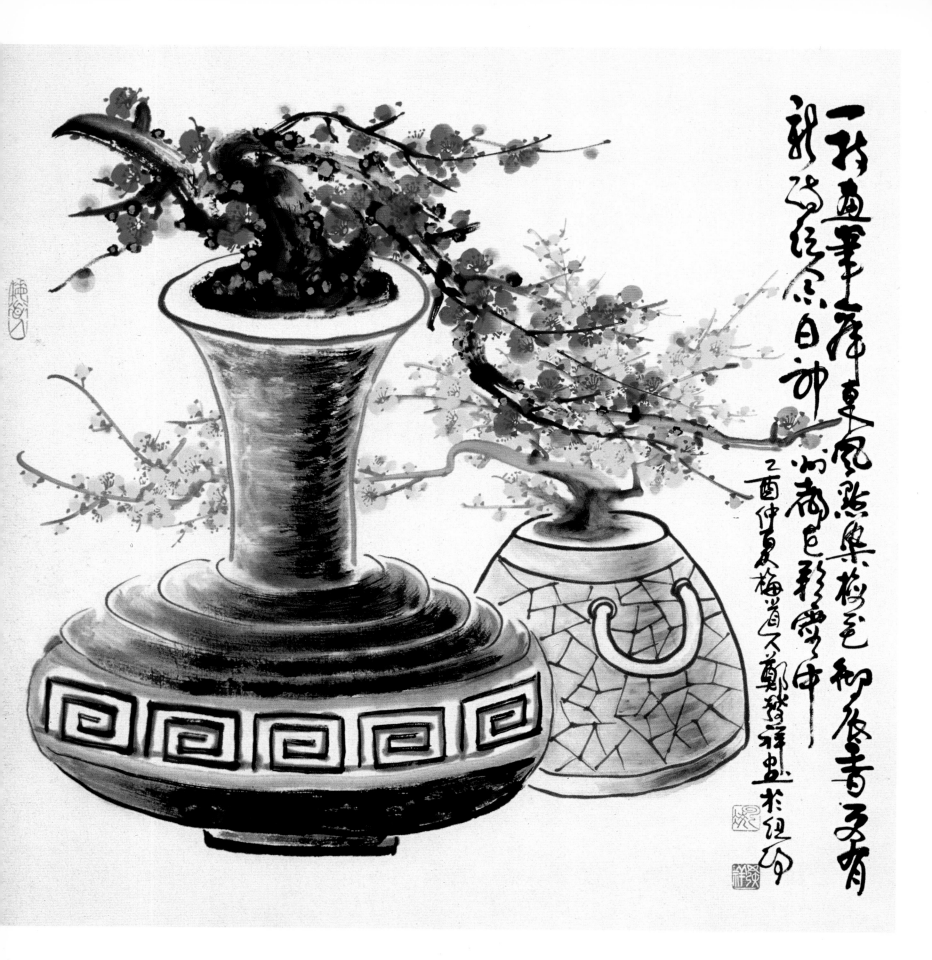

神州點燃梅花香
680mm × 680mm

China Ignites the Plum blossom Fragrance
(680mm × 680mm)

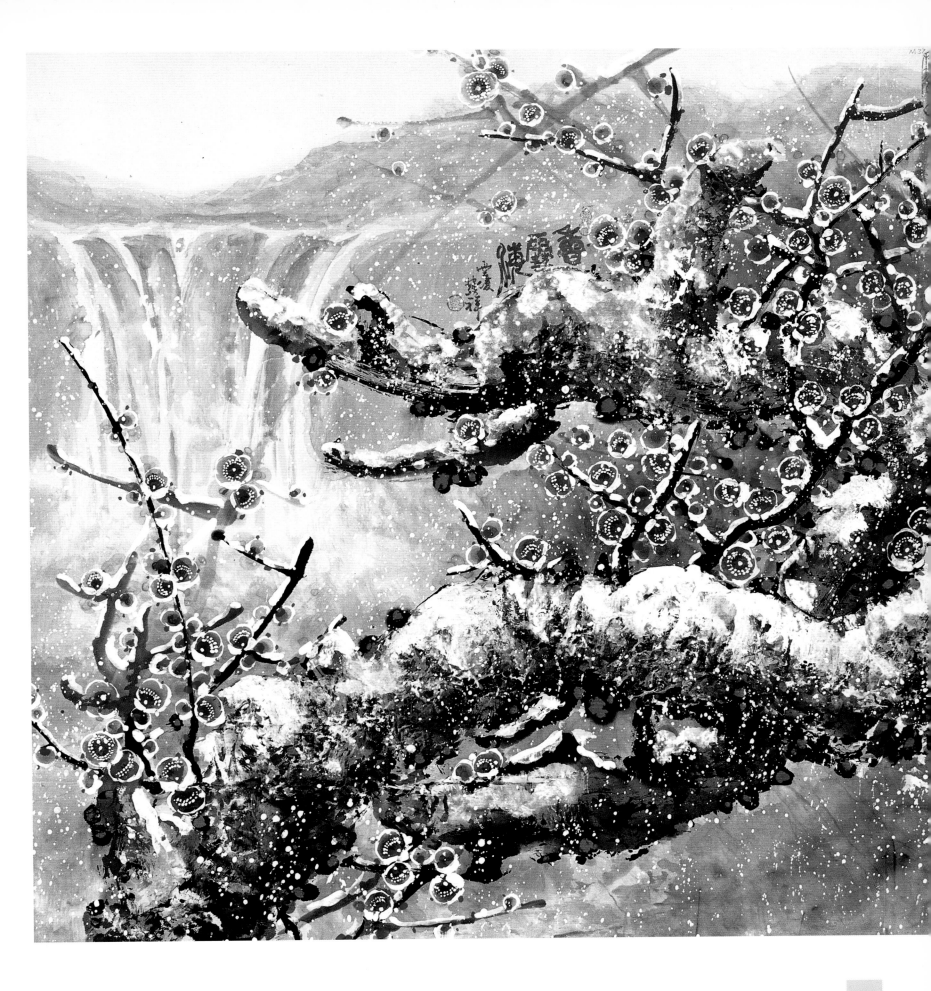

香雪撒河山
680mm × 680mm

**Fragrant Snow Scatters on the
Land**
（680mm × 680mm）

115

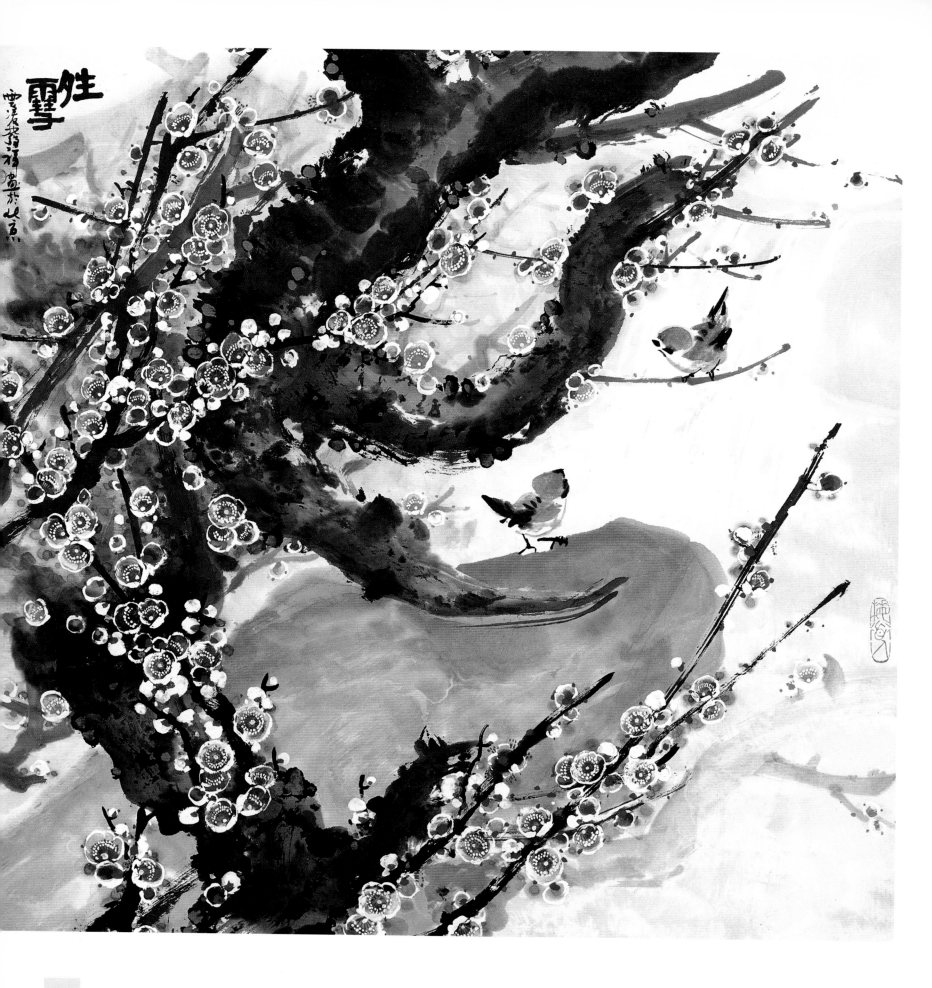

晴雪 680mm×680mm

Fine Snow
(680mm × 680mm)

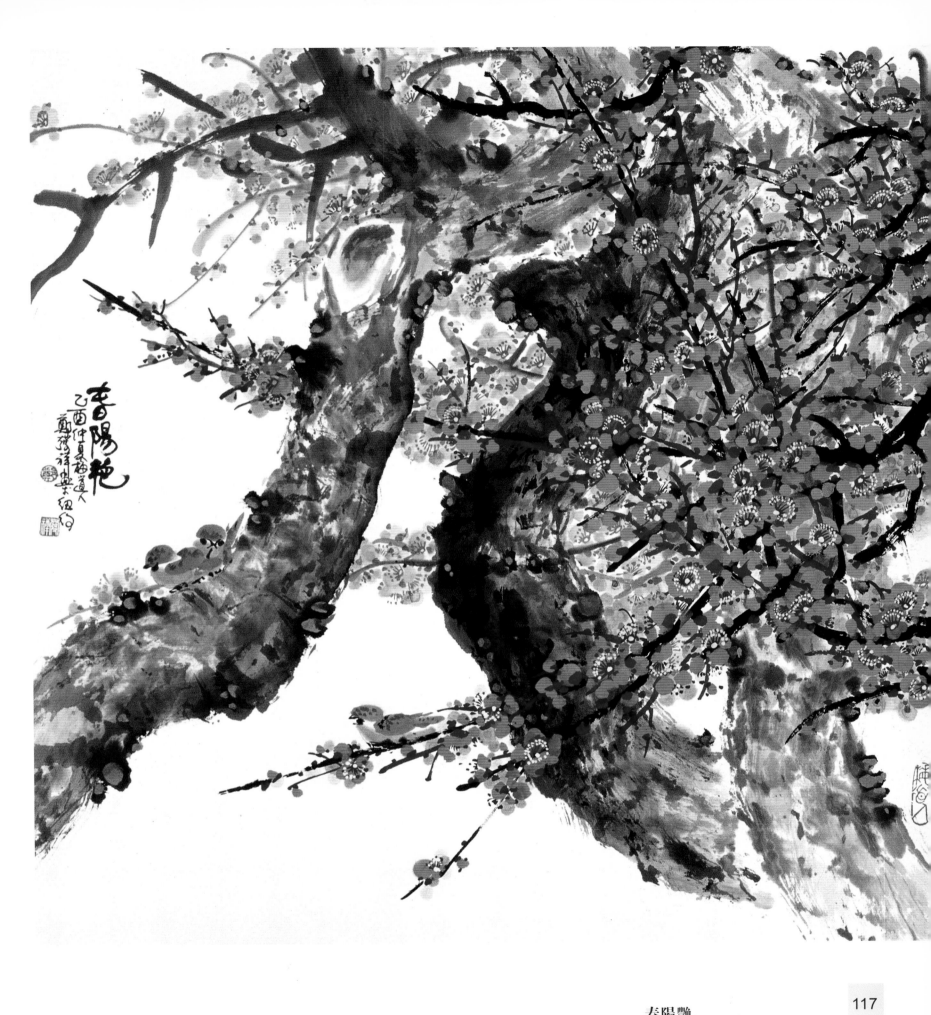

春陽艶
680mm × 680mm

Spring Sun is Gorgeous
（680mm × 680mm）

117

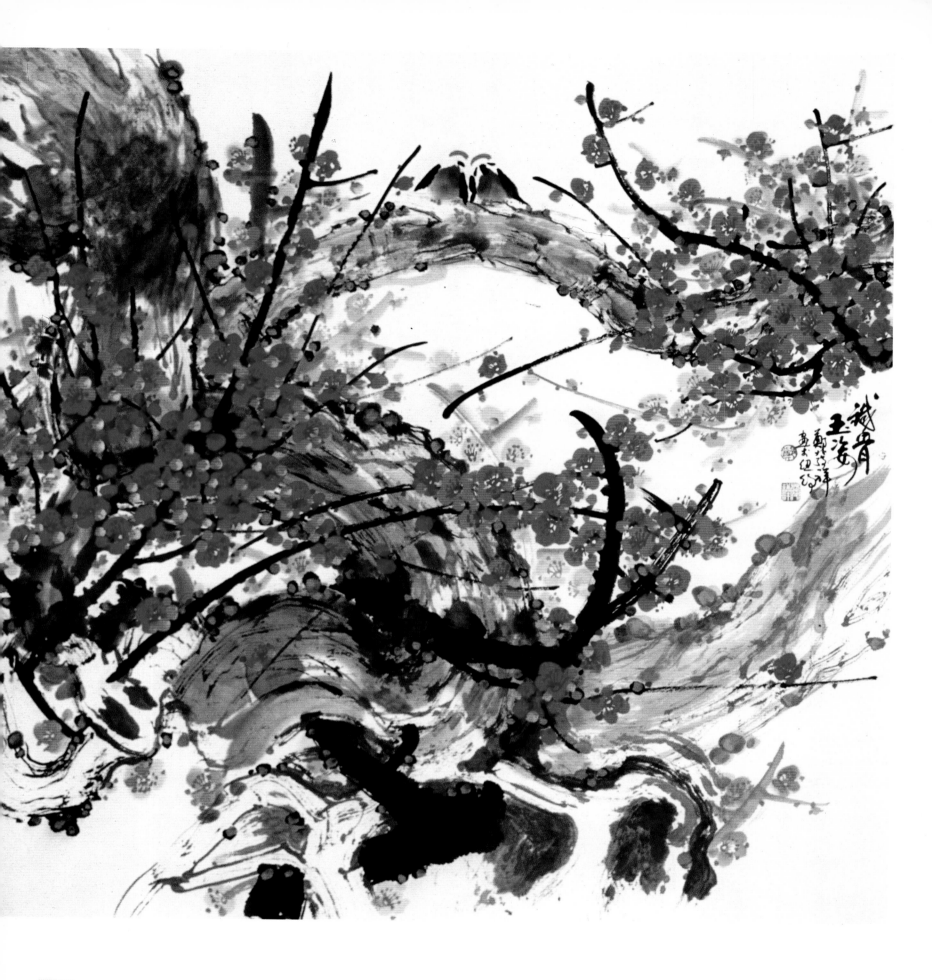

鐵骨玉姿　680mm × 680mm

Iron Bone and Jade Appearence
(680mm × 680mm)

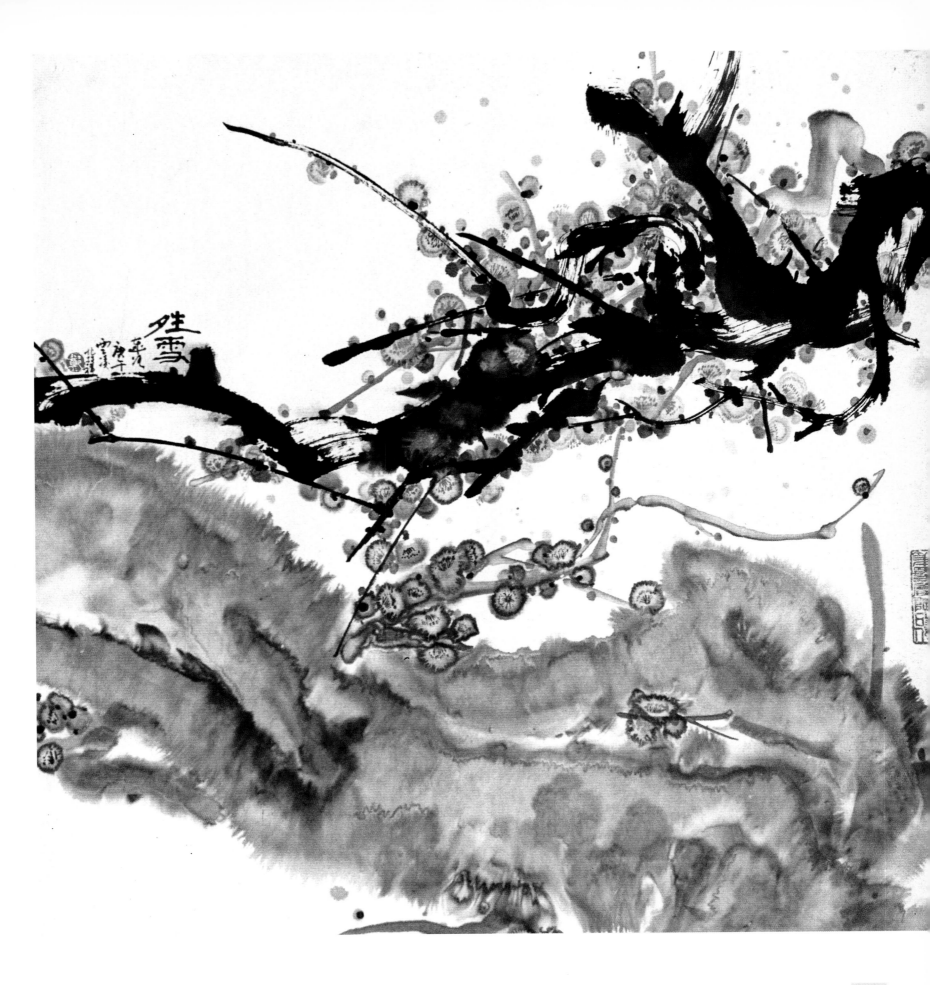

墨梅
680mm × 680mm

Black Plum Blossom
（680mm × 680mm）

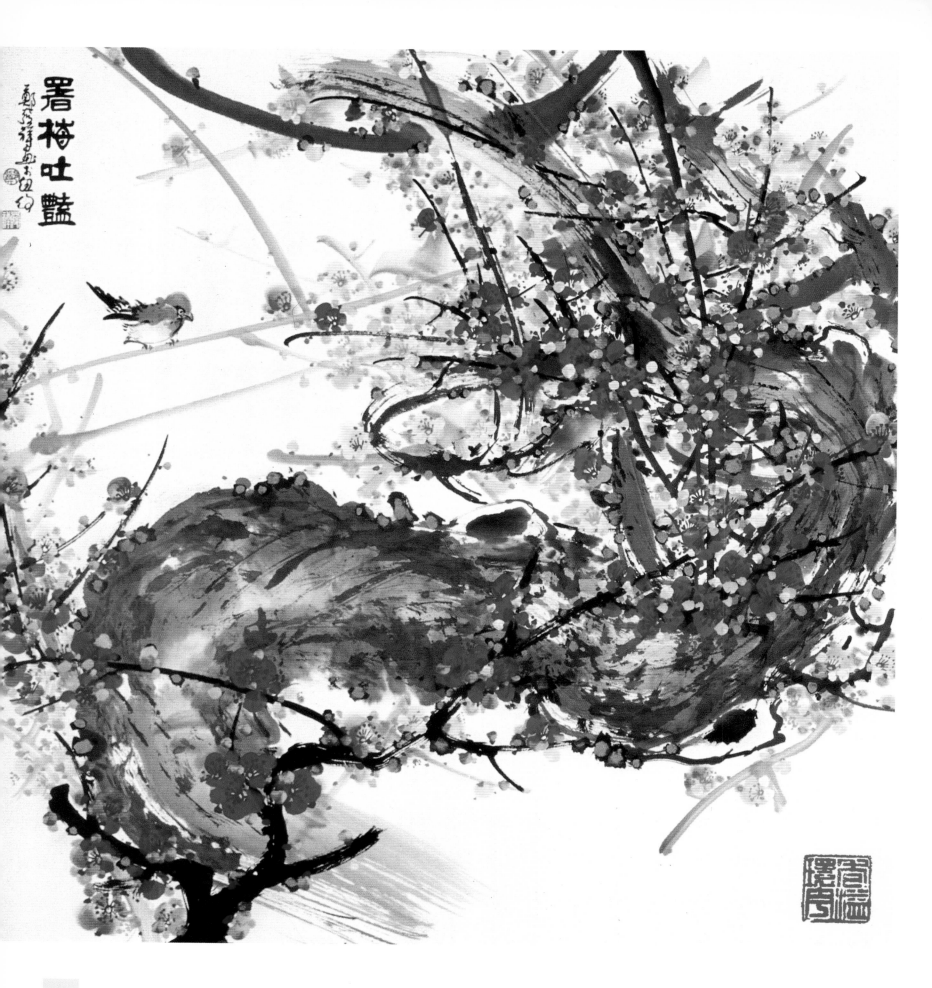

署梅吐豔　680mm × 680mm

White Plum Blossom Spits Beauty
(680mm × 680mm)

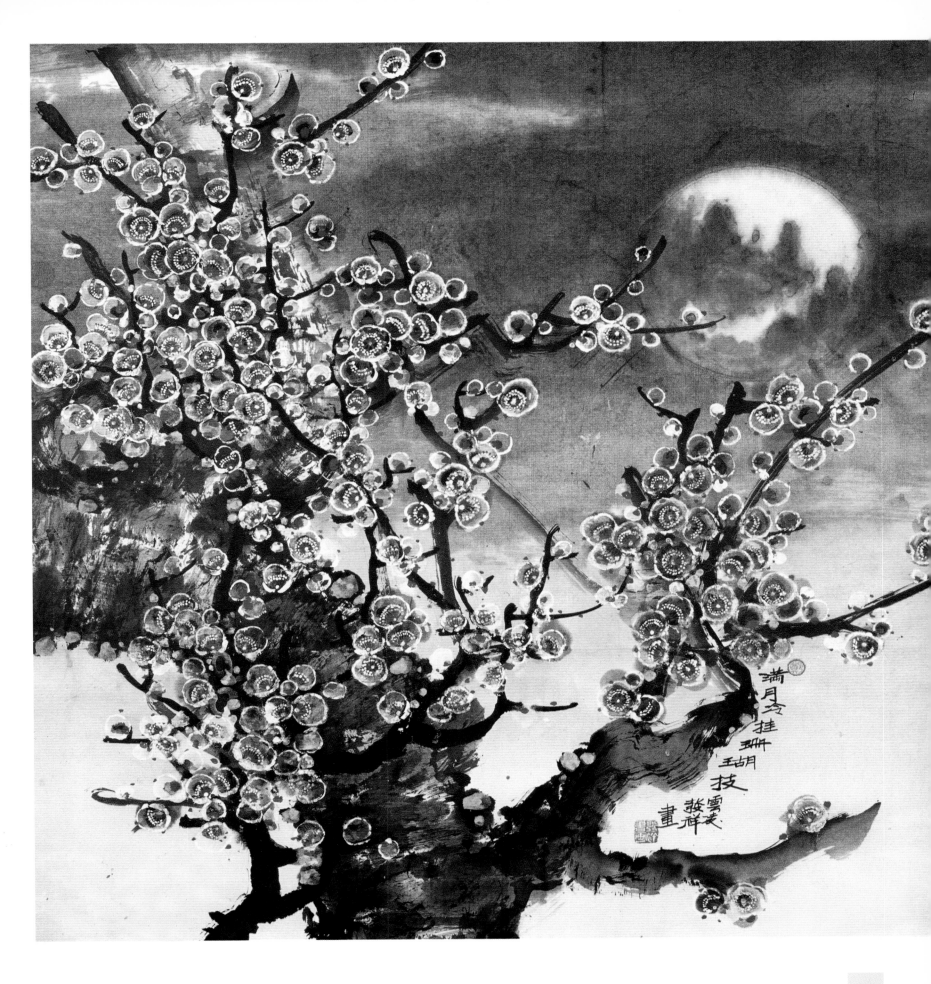

滿月冷挂珊瑚枝
680mm × 680mm

Plenilune Hangs Coldly Coral
Branches
（680mm × 680mm）

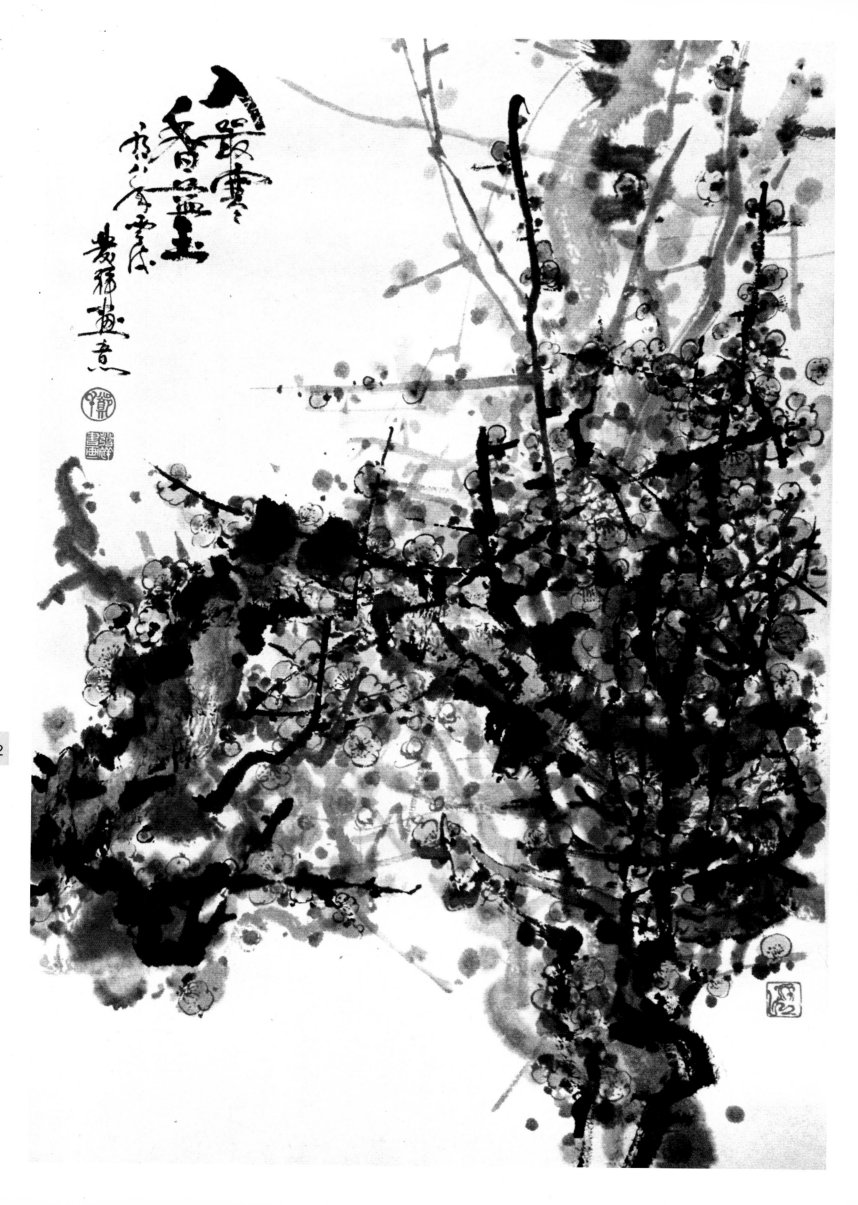

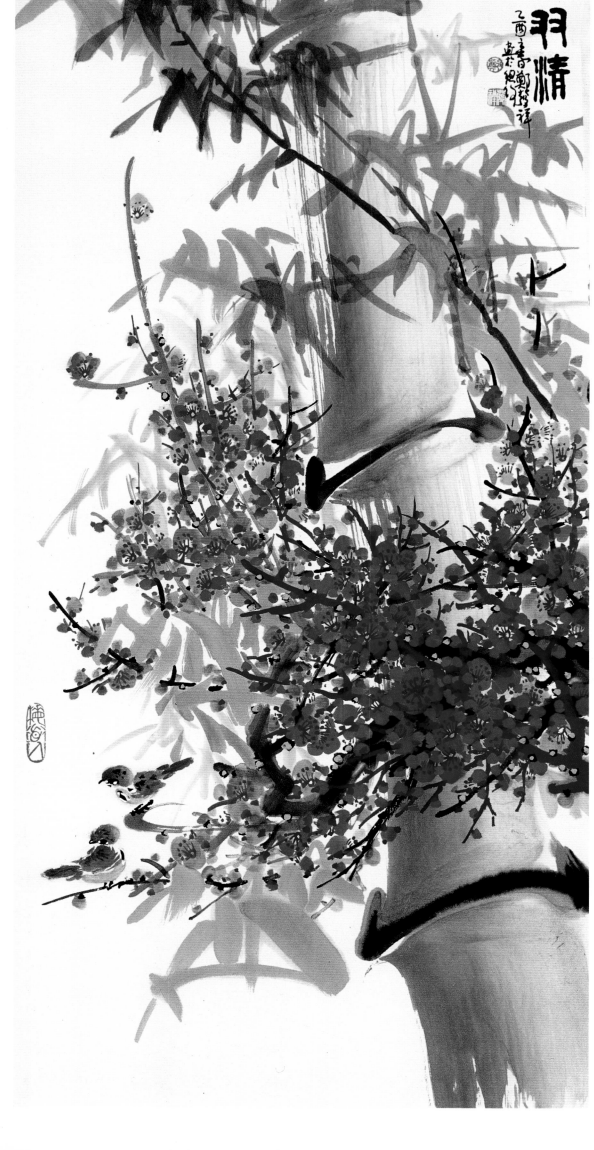

嚴寒香溢（左頁圖）
336mm × 480mm
雙清
460mm × 980mm

Chilliness Fragrance Overflows
(Far right)
（336mm × 480mm）Double
Freshness
（460mm × 980mm）

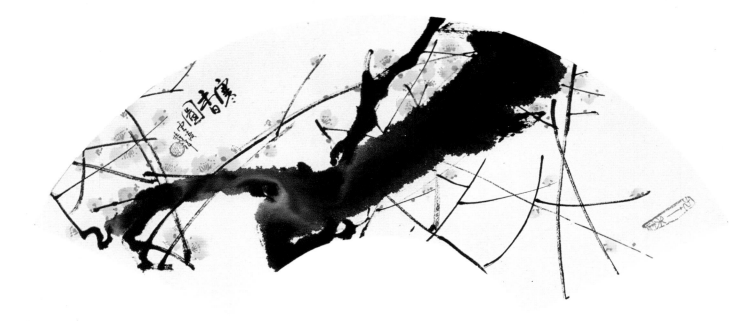

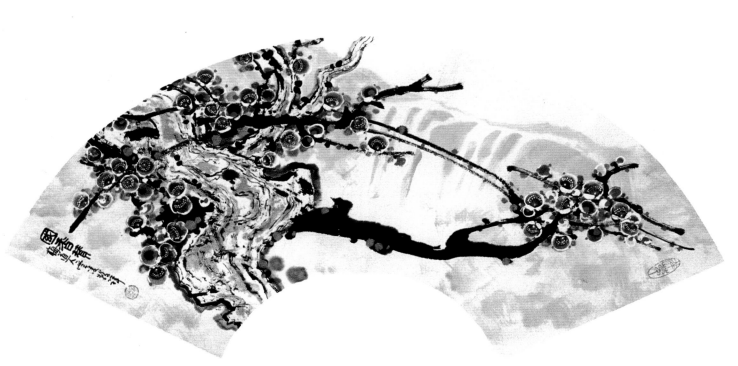

寒香圖、國香、鐵骨春
冷月美人（右頁圖）
330mm × 680mm

124

Cold Fragrance Picture, National
Fragrance, Iron Bone Spring

Beauty of Cold Mooon（detail）(right)
（330mm × 680mm）

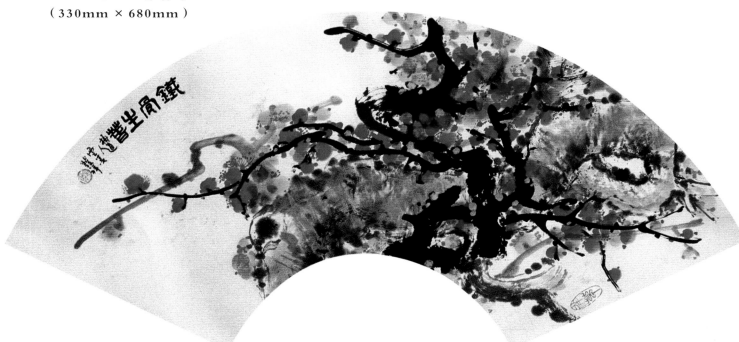

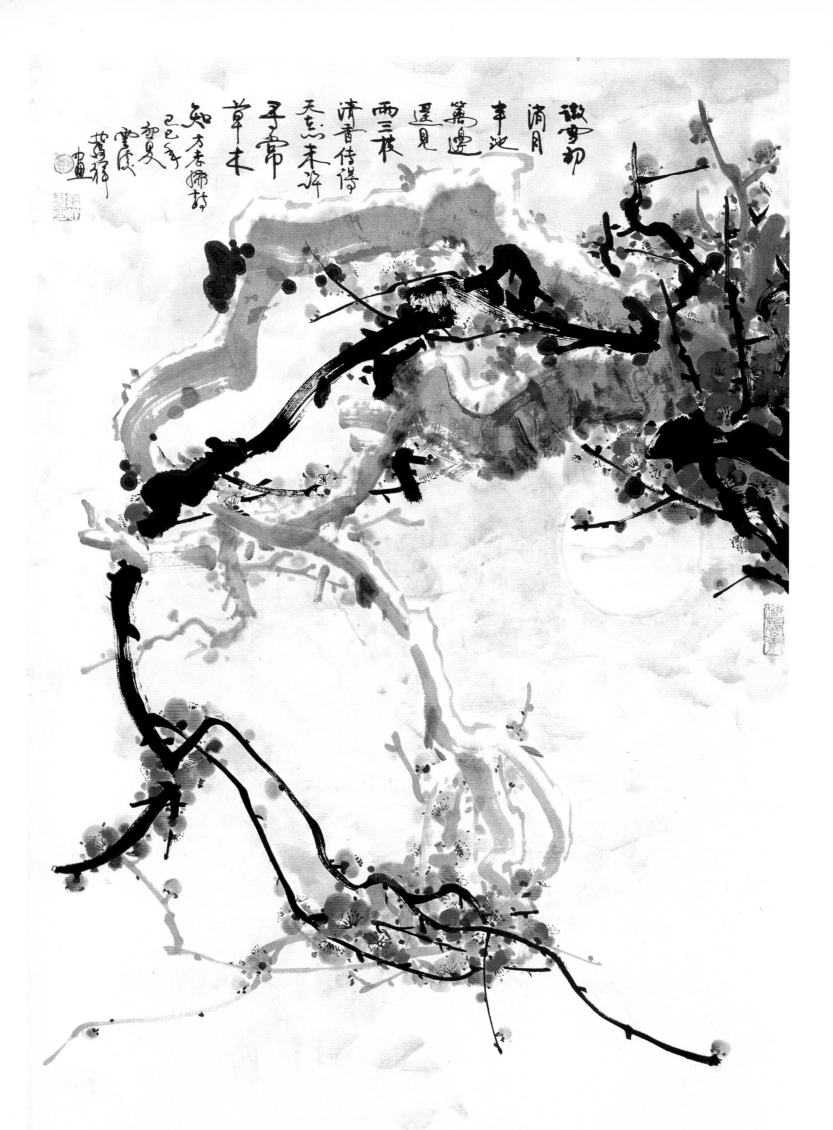

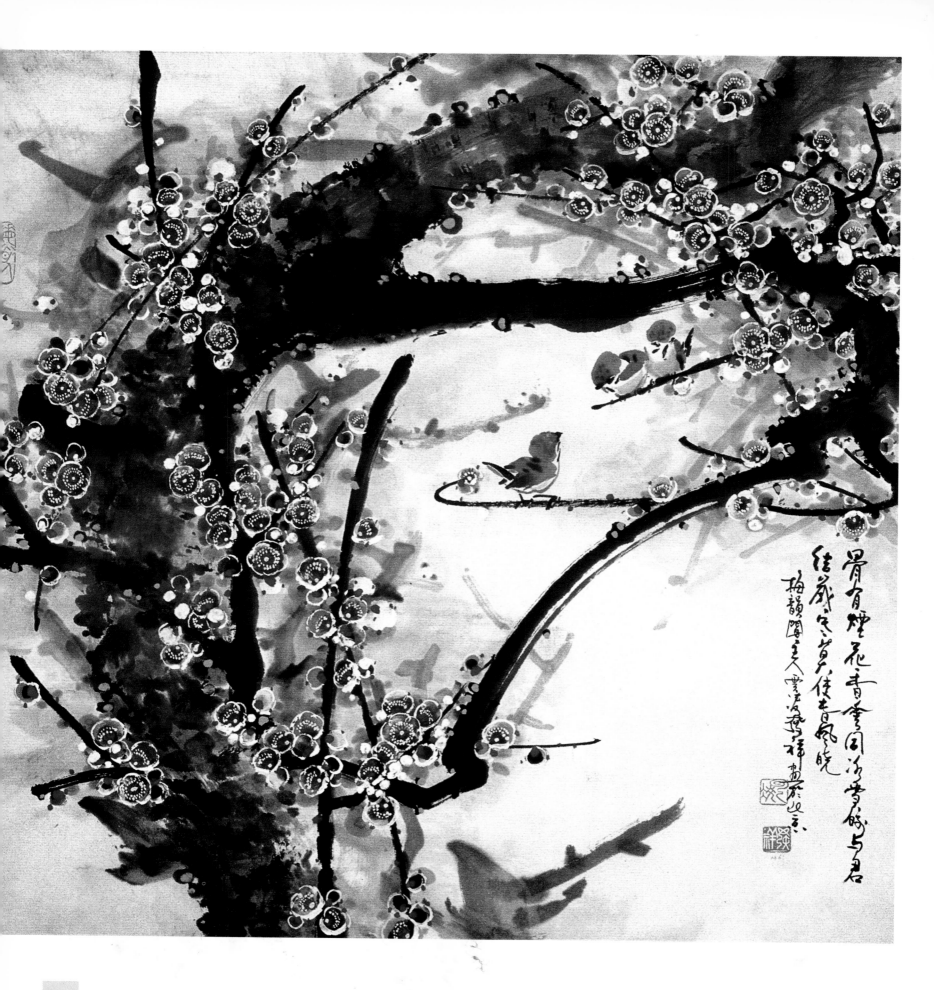

人間春情　680mm × 680mm

Spring Affection all over the World
(680mm × 680mm)

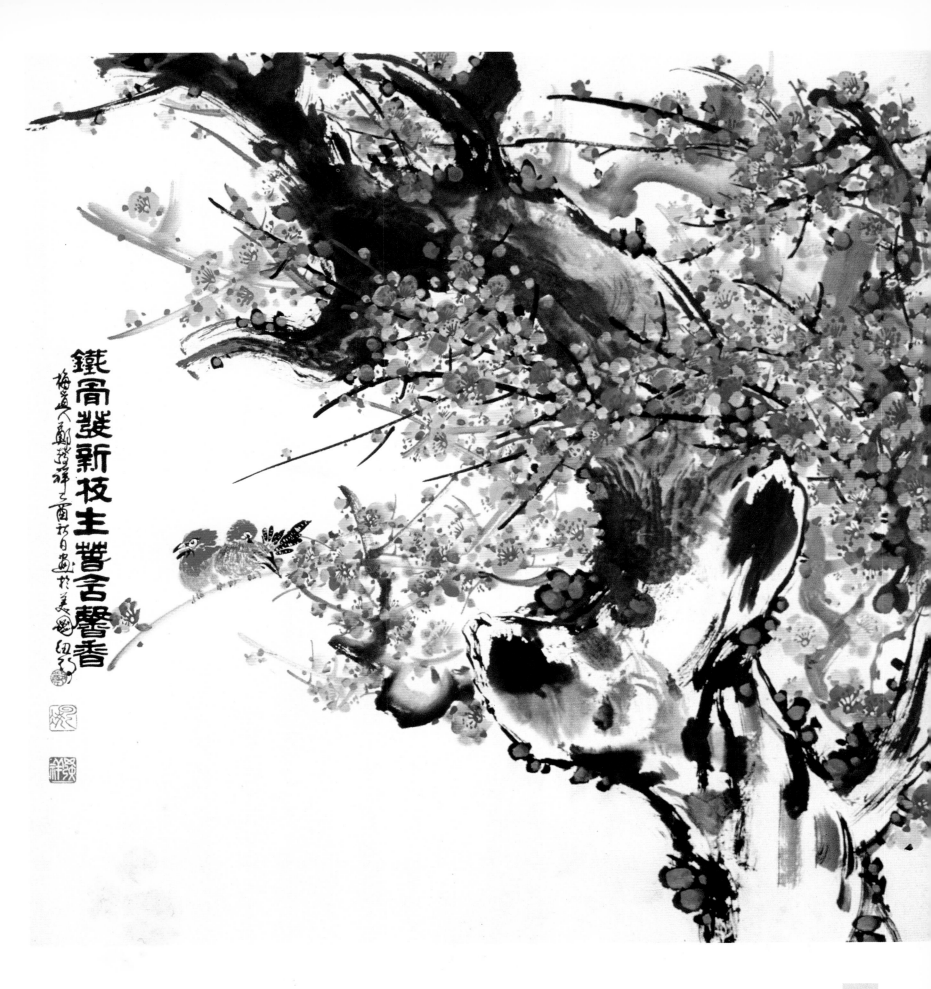

鐵骨發新枝主醬舍馨香
梅氣真人鄭琦祥之畫於美
[落款印章]

鐵骨發新枝
680mm × 680mm

Iron Bone Produces New Branches
（680mm × 680mm）

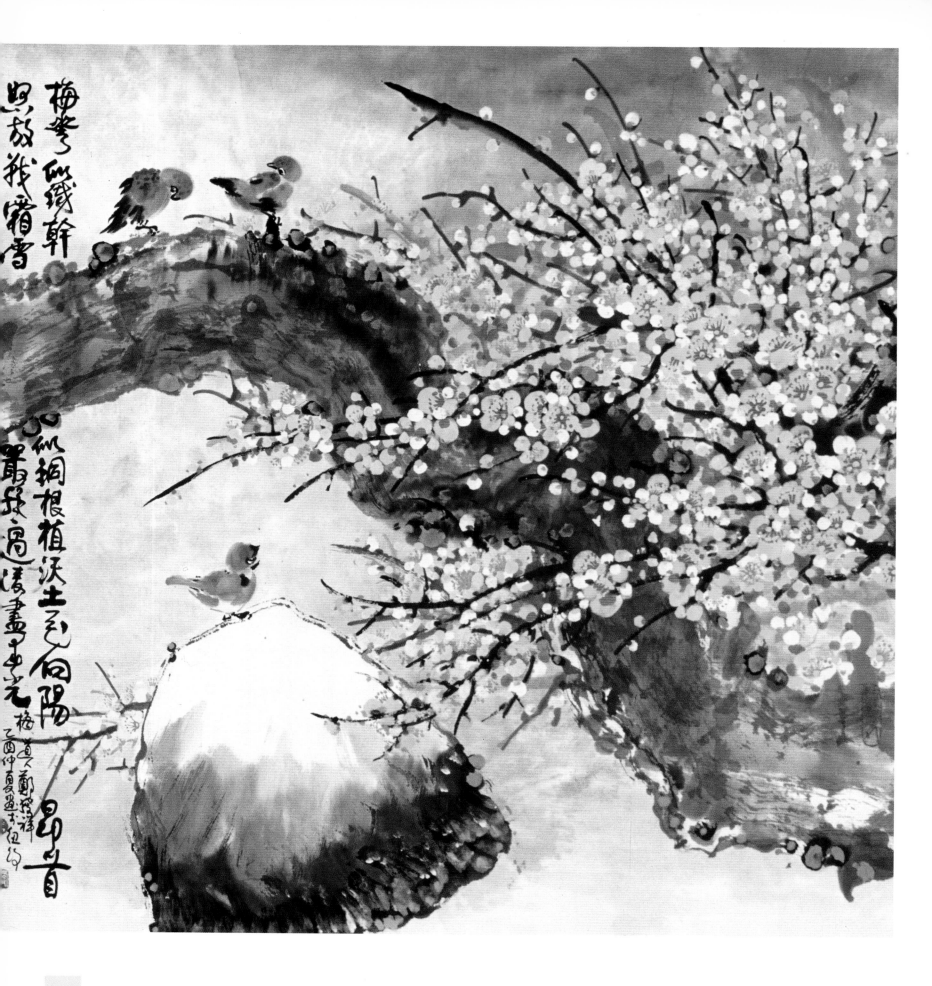

128

怒放 680mm × 680mm

SPlum Blossom is Blooming in Profusion
(680mm × 680mm)

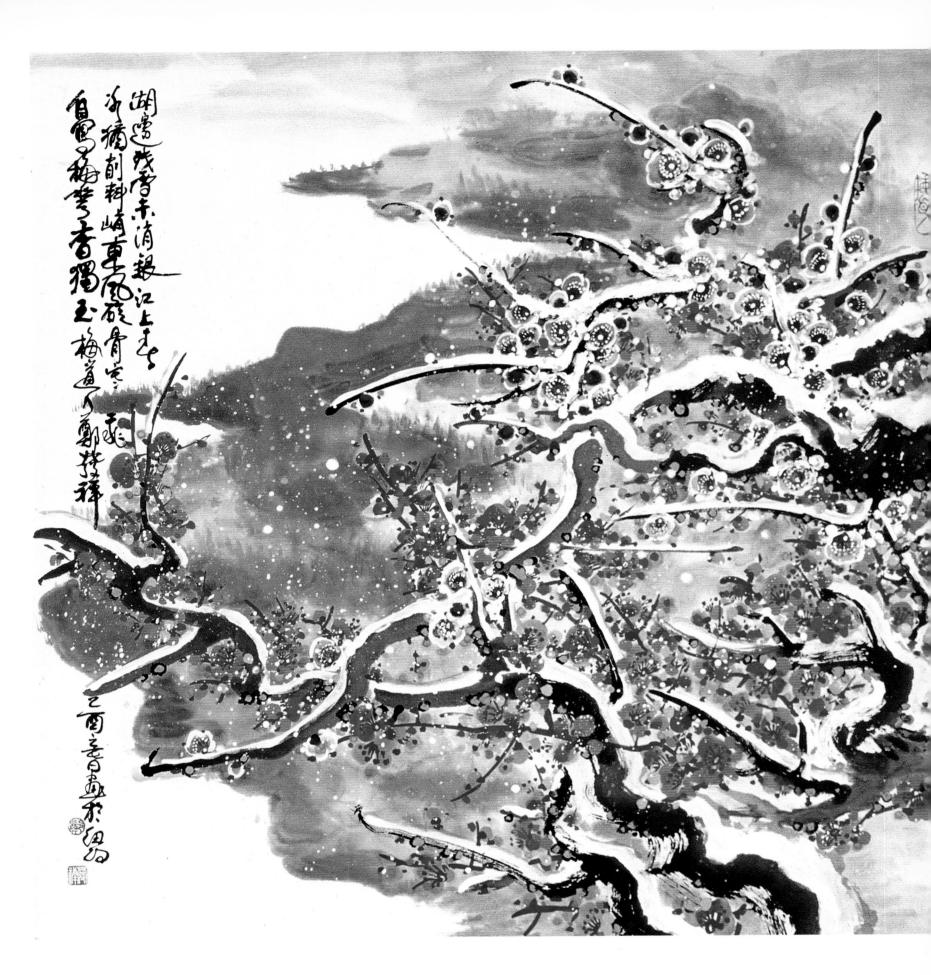

冰魂舞
680mm × 680mm

Icy Soul Dance
（680mm × 680mm）

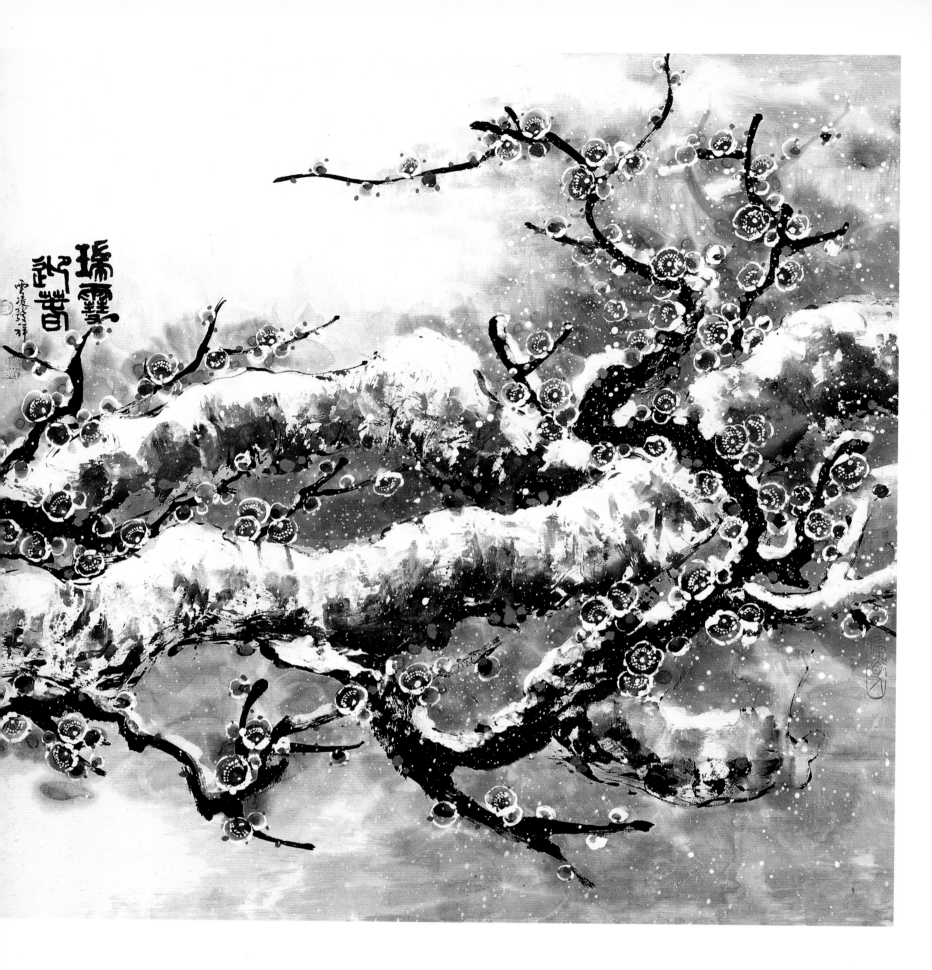

130

瑞雪迎春 680mm × 680mm

Auspicious Snow Welcomes Spring
(680mm × 680mm)

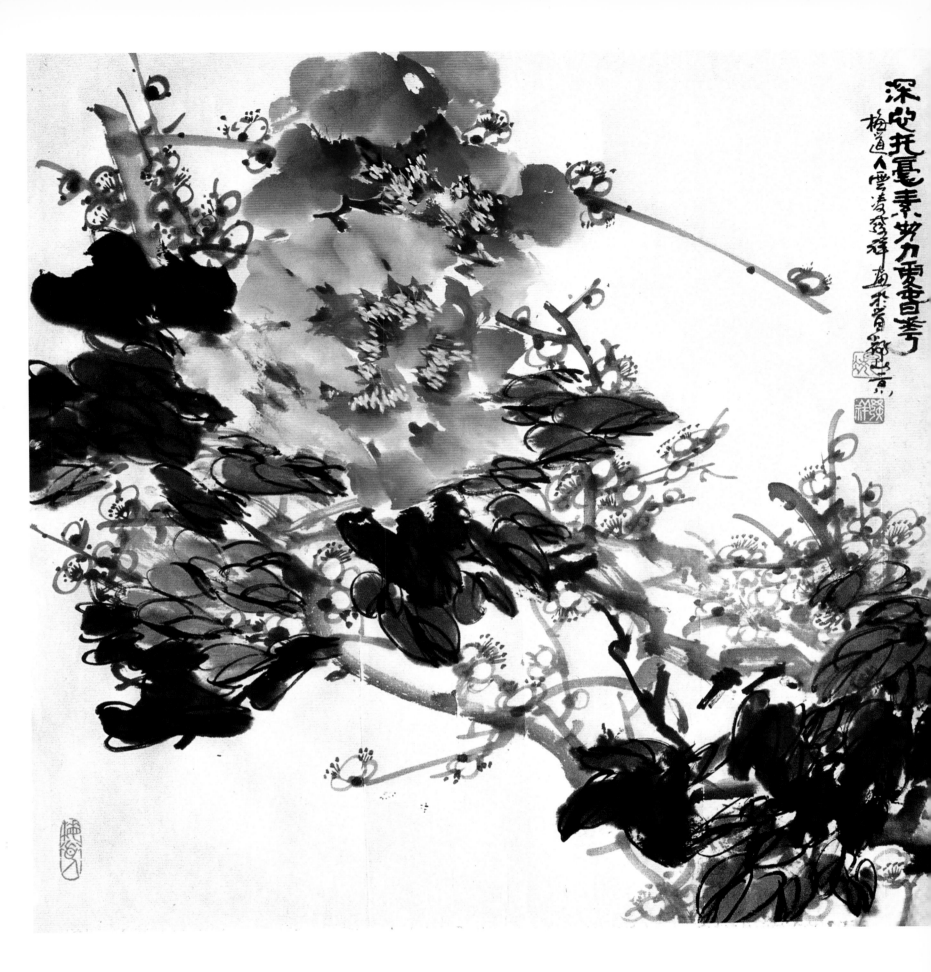

深心托豪情 努力愛春華
680mm × 680mm

Deep Mind Supports Lofty
Sentiments, and Try Hard to
Love Glorious Flowers in Spring
（680mm × 680mm）

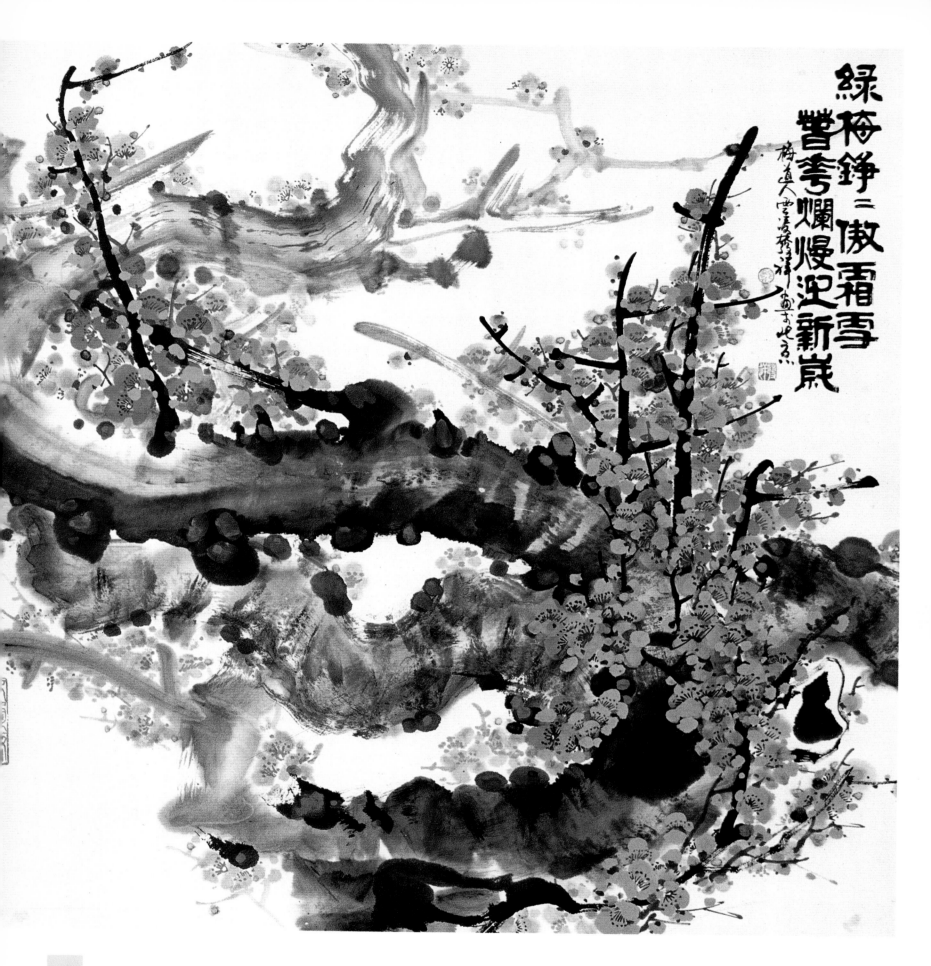

緑梅錚骨傲霜雪

緑梅錚骨傲霜雪
680mm × 680mm

Green Plum Blossom and Glossy Bone are
Proud at Frost and Snow
(680mm × 680mm)

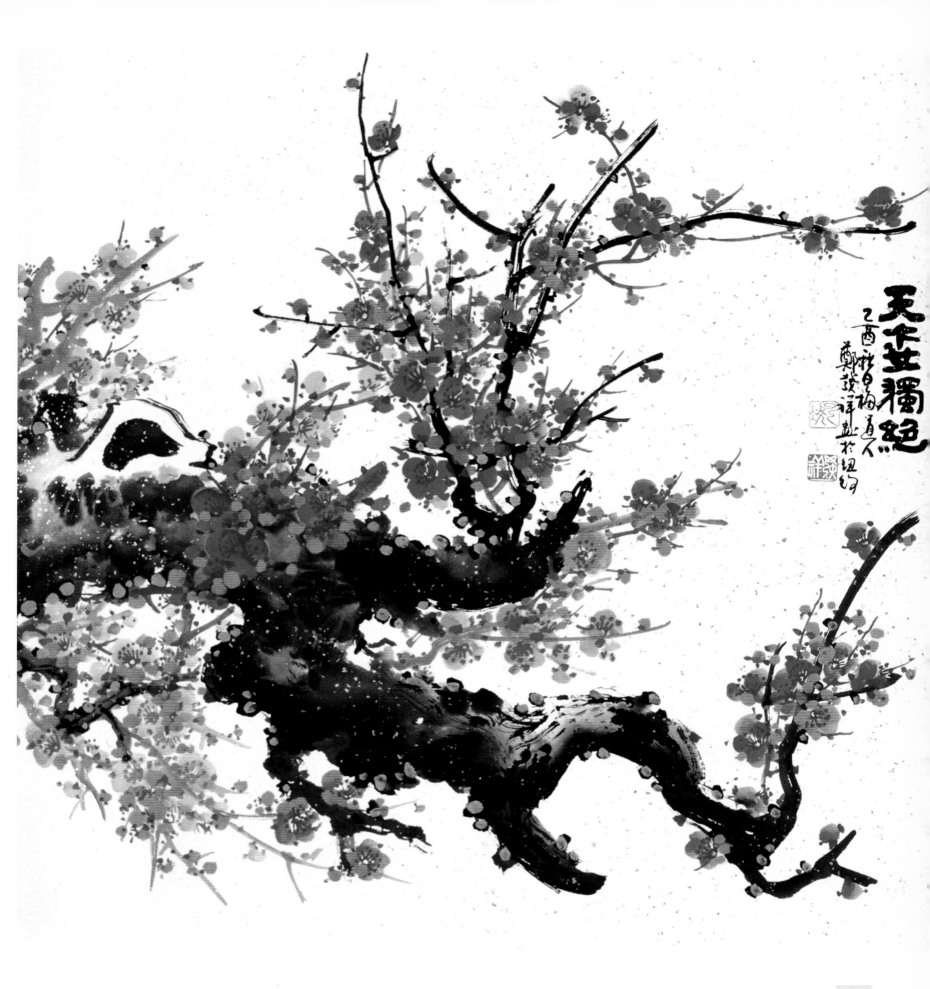

天姿獨色
680mm×680mm

133

Surpassing Beauty and Unique
Color
（680mm × 680mm）

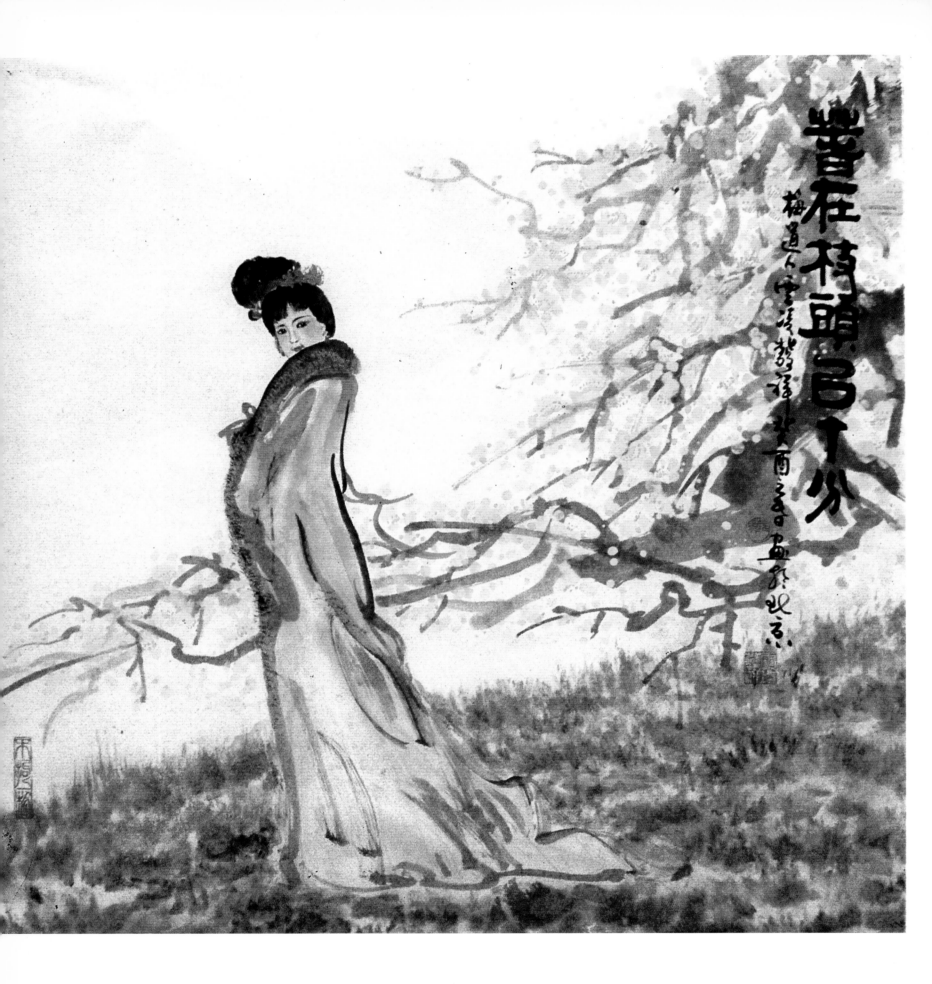

春在枝頭已十分
680mm × 680mm

Spring on Branches is Full
(680mm × 680mm)

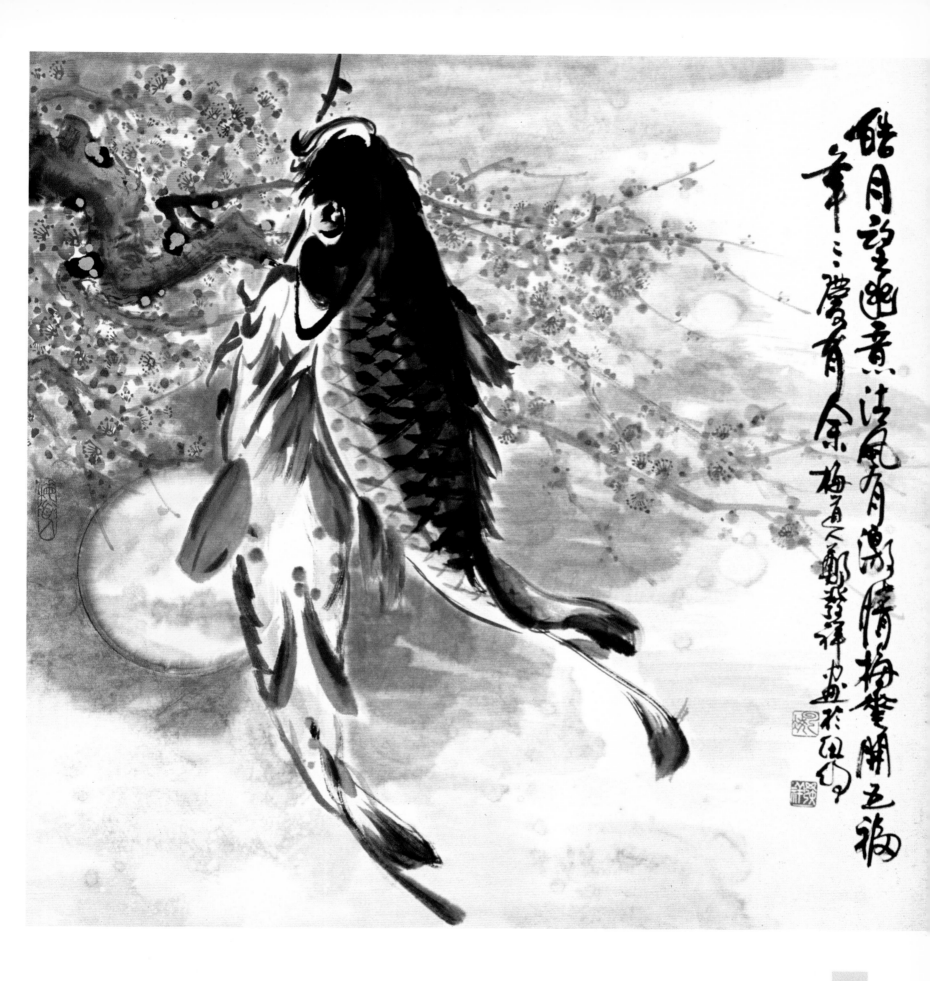

梅開五福，年年餘
680mm × 680mm

Plum Blossom Opens Five
Fortunes and Every Year Has a
Surplus
（680mm × 680mm）

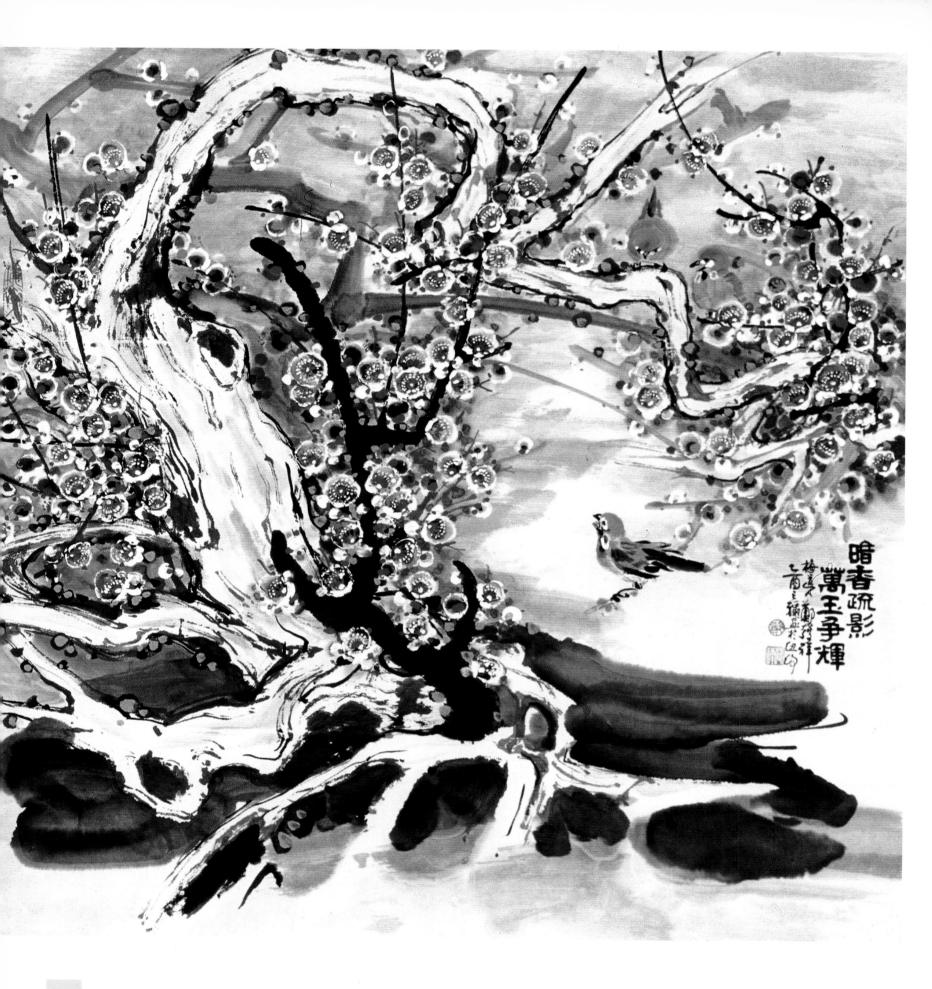

暗香疏影　萬玉争輝
680mm × 680mm

Darkly Sweet Scant and Sparse Branch
Ten Thousand of Jades Vie for Brightness
(680mm × 680mm)

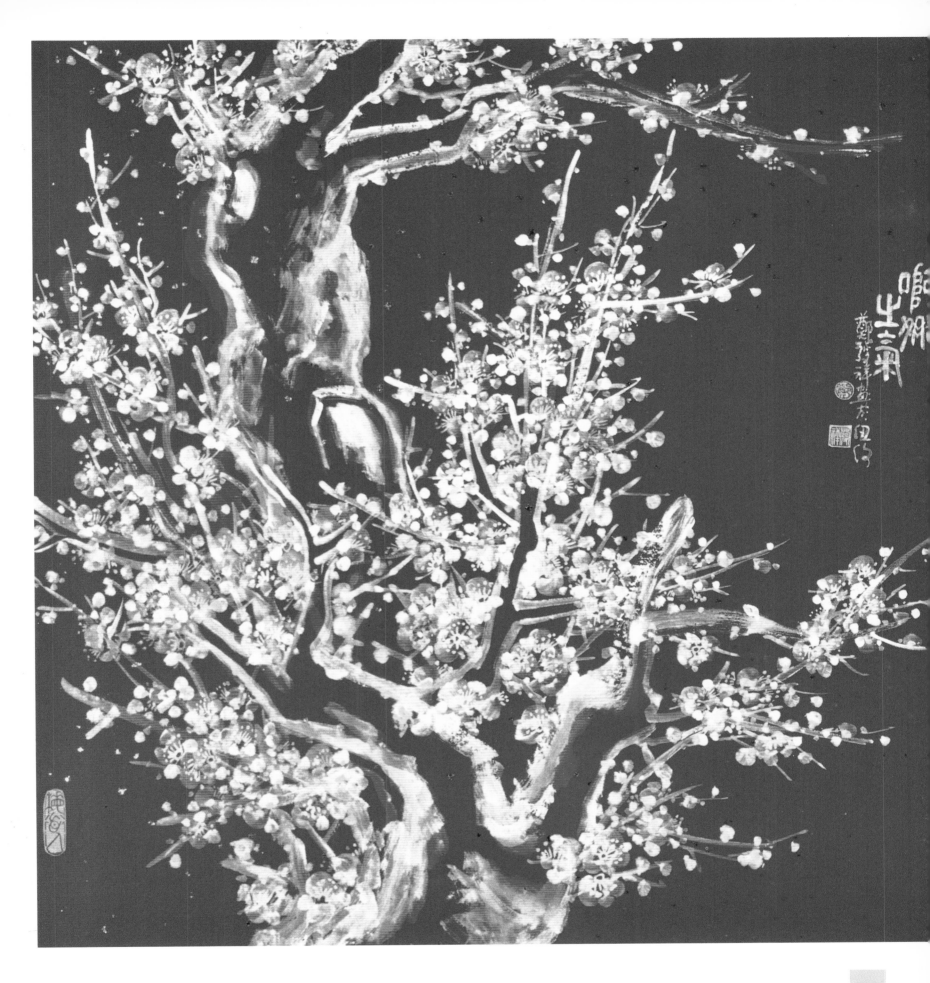

婀娜多姿
680mm × 680mm

Graceful and Varied in Postures
（680mm × 680mm）

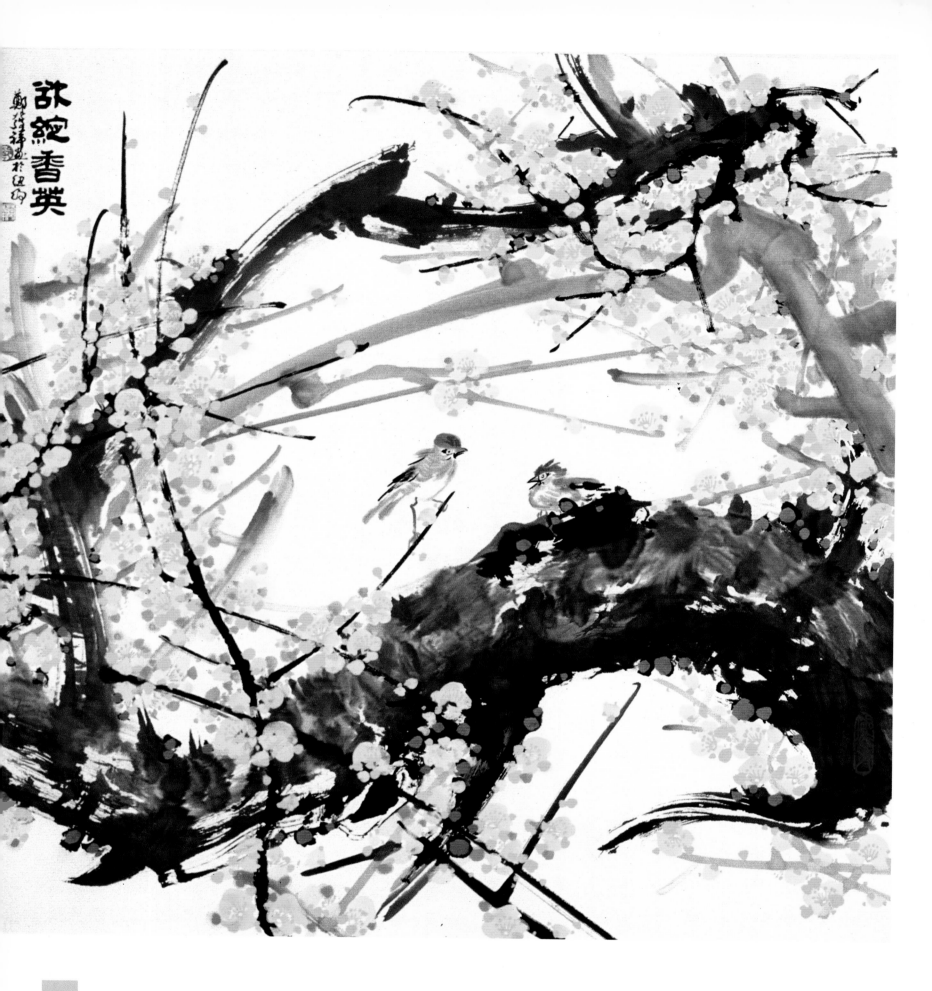

欲綻香英
680mm × 680mm

Wish to Burst Fragrant Hero
(680mm × 680mm)

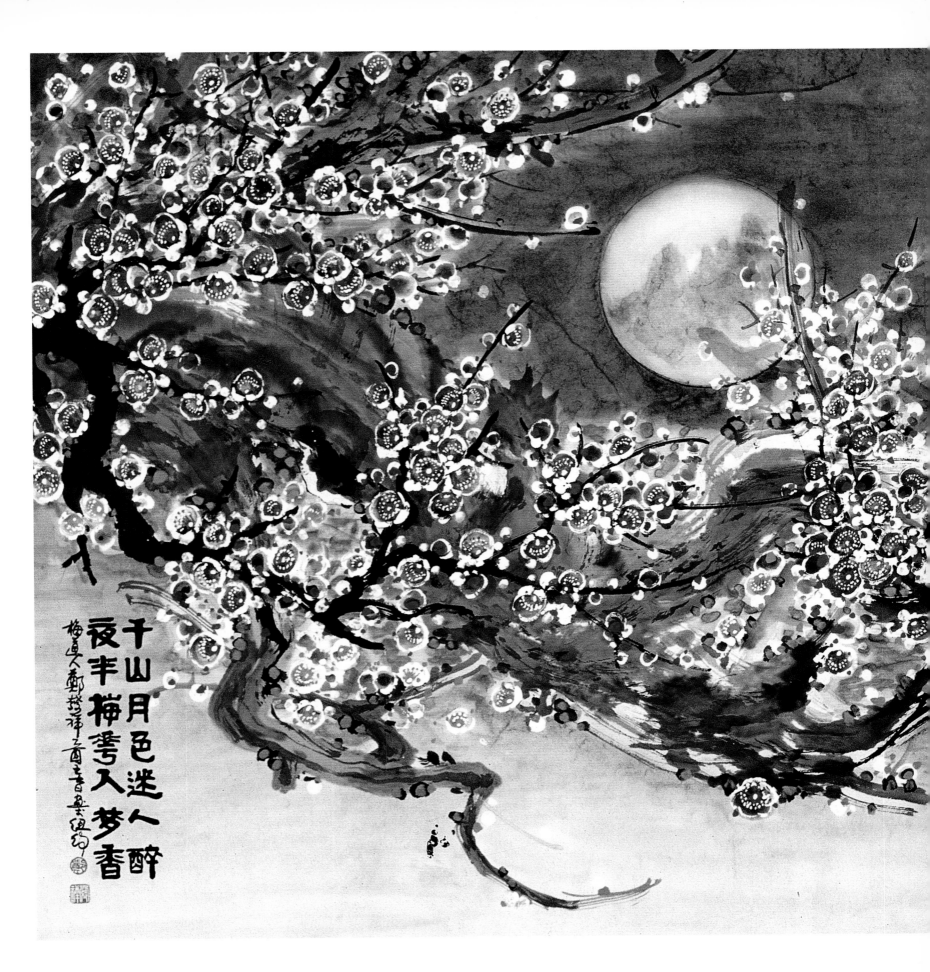

千山月色迷人醉
夜半梅花入梦香

梅里大郑称祥二酉年李素祖绚

139

夜半梅花入夢香
680mm × 680mm

Midnight Plum Blossom Dreams
Fragrance
（680mm × 680mm）

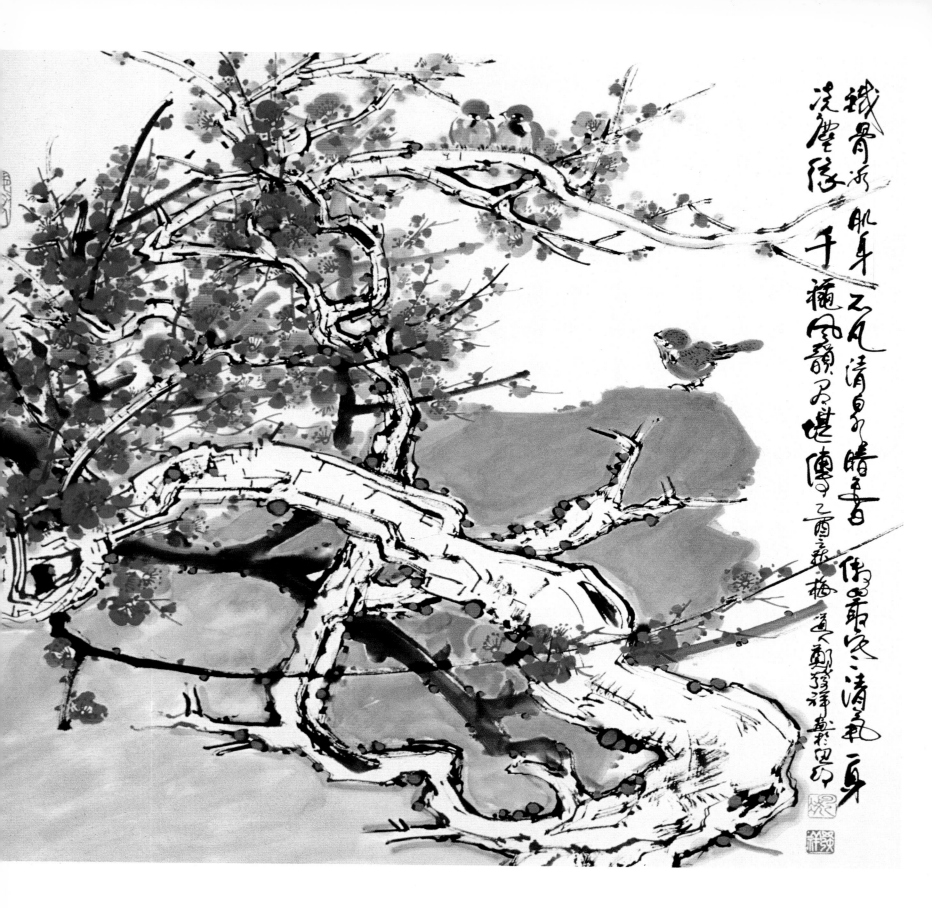

千秋風韵盡堪傳
680mm × 680mm

Charm throughout the Ages is Handed
down
(680mm × 680mm)

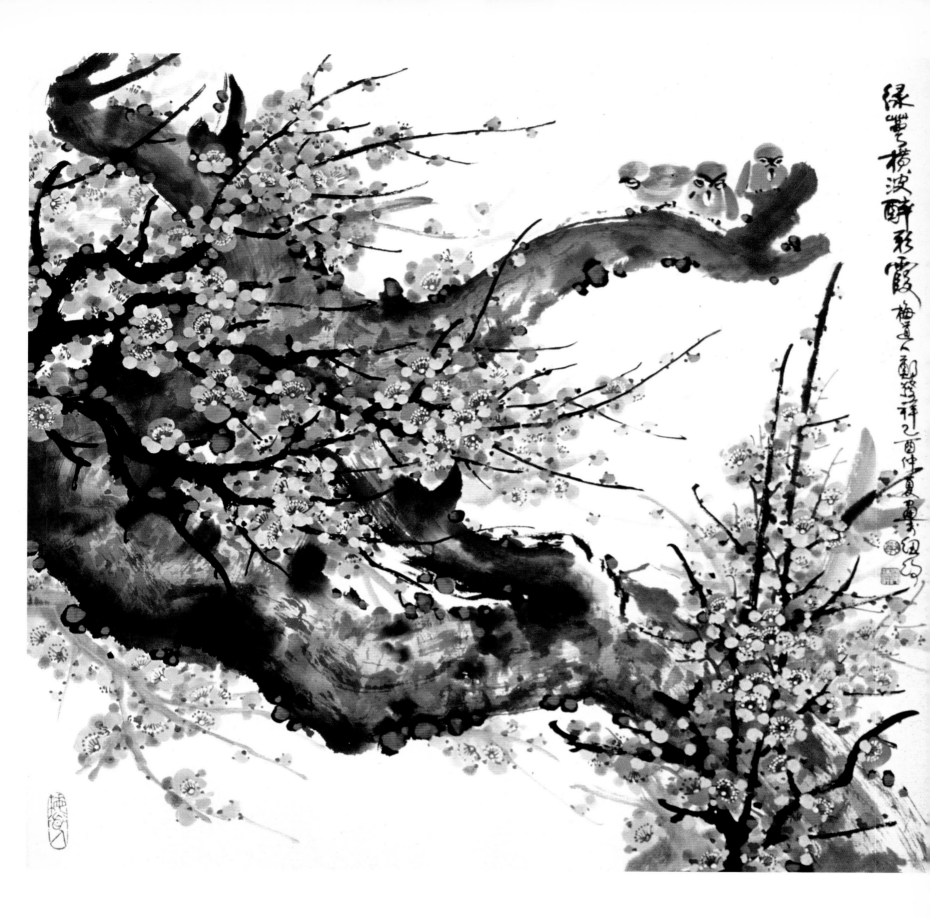

绿萼蔓横波醉彩霞

緑萼蔓橫波醉彩霞
680mm × 680mm

Green Calyxes and Tendril
Transverse Wave Drinks Rosy
Clouds
（680mm × 680mm）

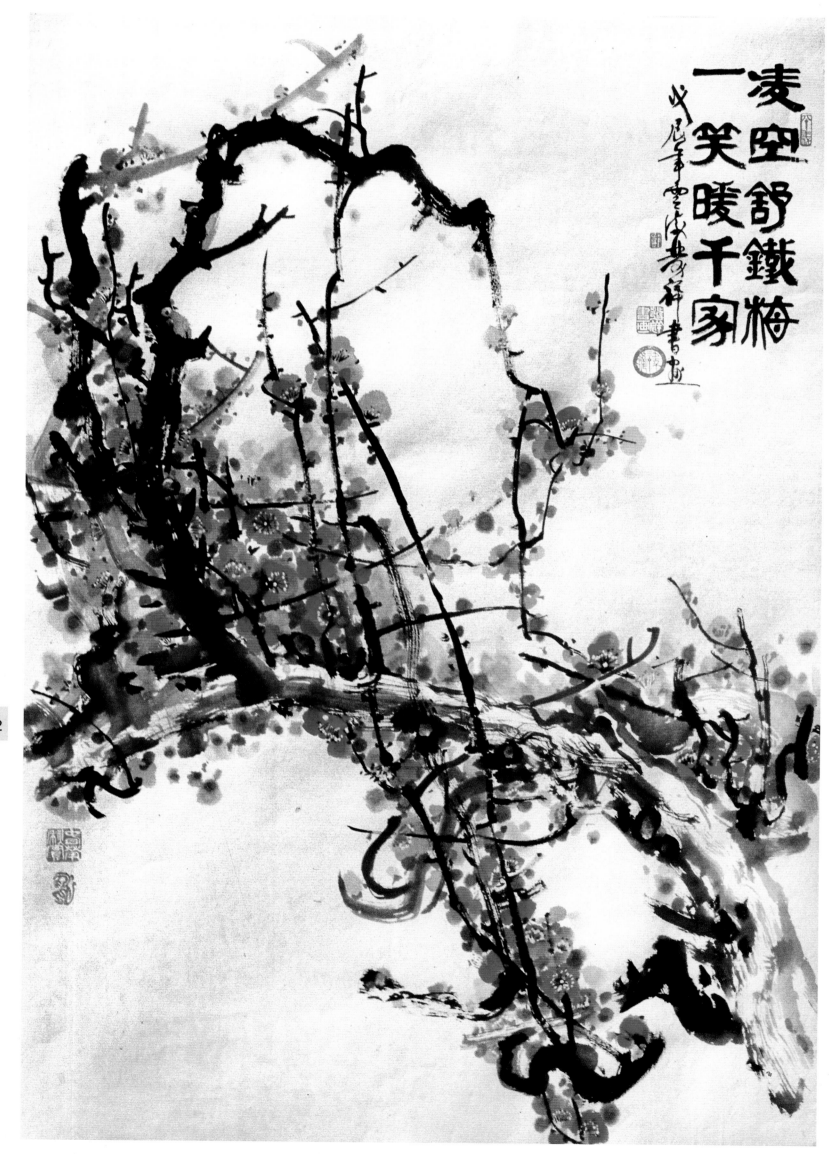

凌空舒鐵梅
一笑暖千家

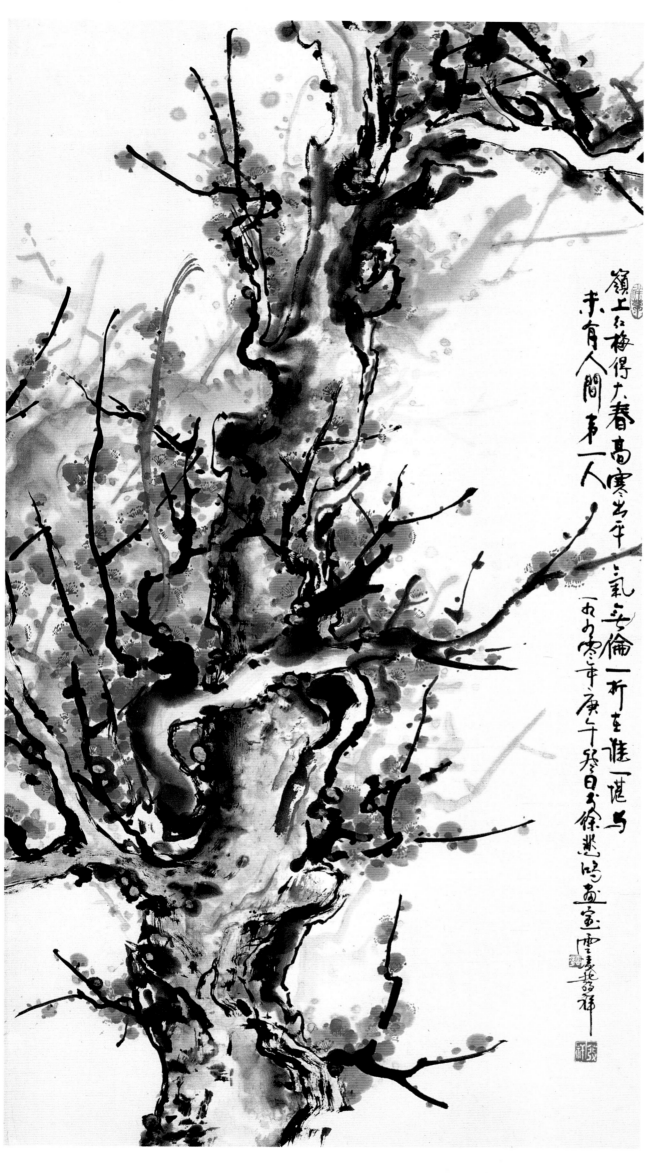

凌空舒鐵梅 （左頁圖）
680mm × 680mm

143

鐵骨丹心
680mm × 680mm

Iron Plum Blossom Stretches in Being
High up in the Air (fat left)
（480mm × 680mm）

Iron Bone and Loyal Heart
（680mm × 680mm）

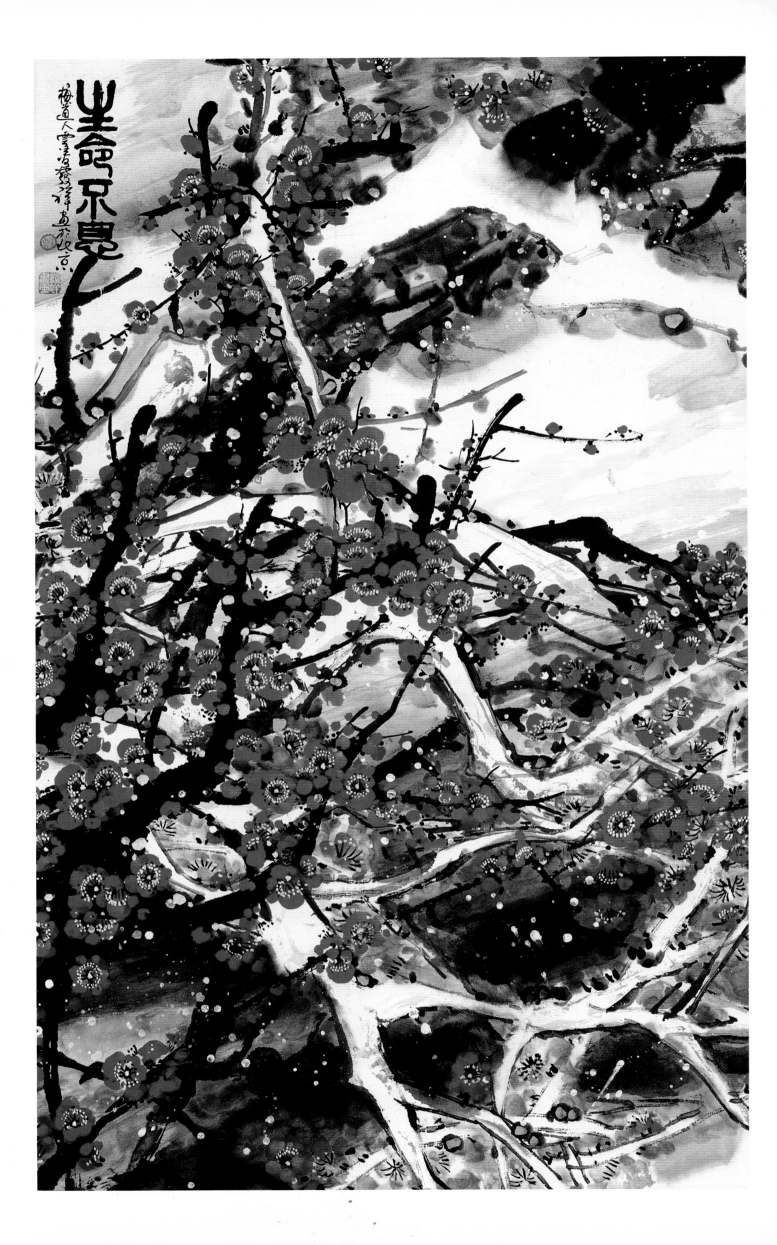

144

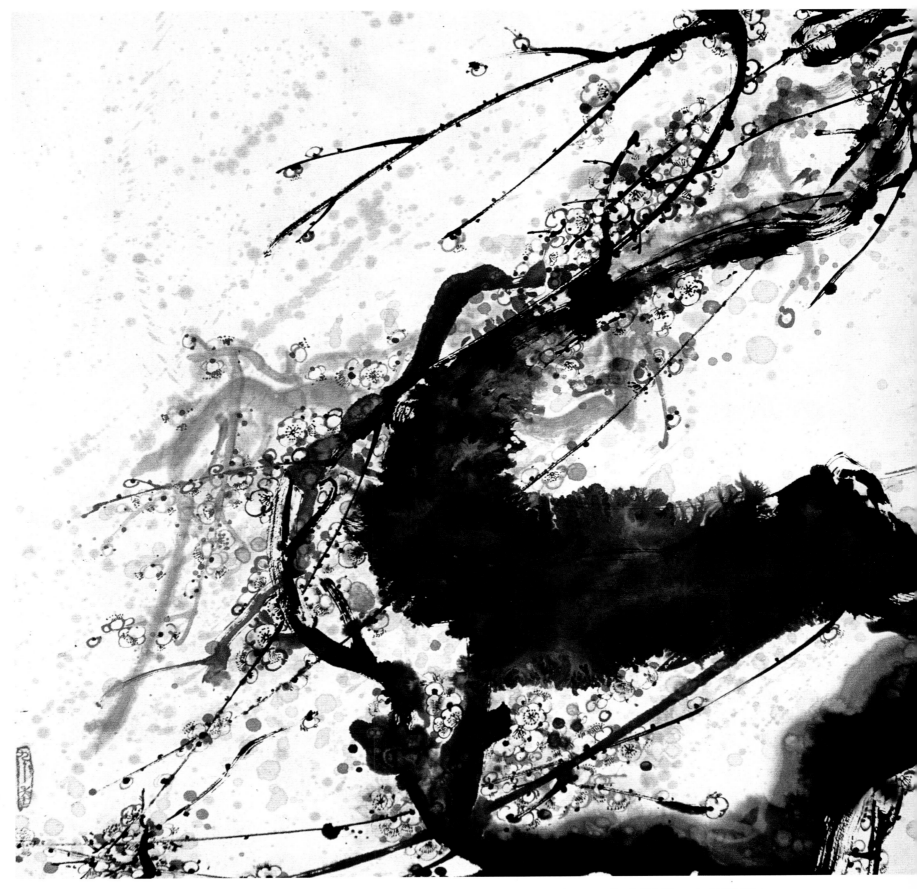

生命不息 （左頁圖）
650mm × 850mm

送春歸
680mm × 680mm

Life Does not Cease (fat left)
（650mm × 850mm）

Seeing Spring Return
（680mm × 680mm）

香溢寰宇

Fragrance Overflows the World down

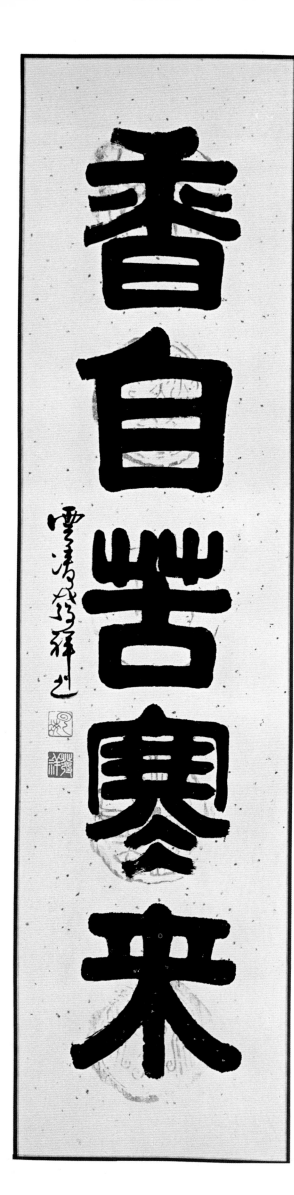

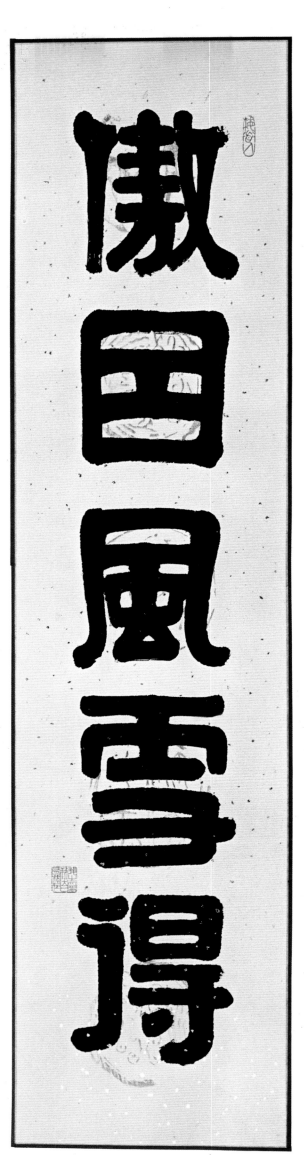

傲因風雪得，香自苦寒來
330mm × 1330mm × 2

Pride is Gained due to Wind and Snow, and Fragrance Comes from the Bitter Cold
（680mm × 680mm × 2）

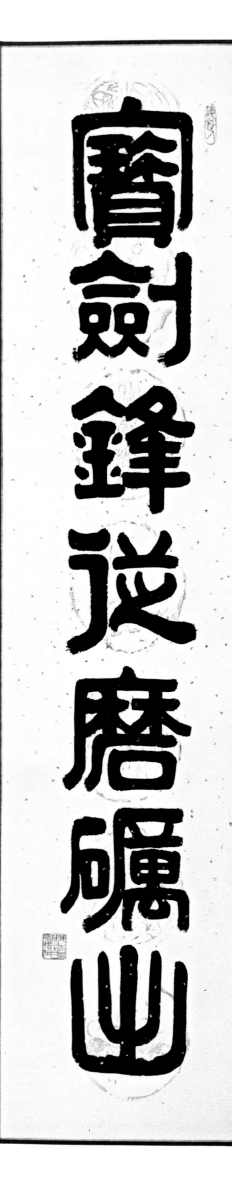

寶劍鋒從磨礪出
梅花香自苦寒來

330mm × 1330mm × 2

Sharp Edge of a Sword Comes out from
Grinding, and Plum Blossom's Fragrance
Comes from the Bitter Cold

(330mm × 1330mm × 2)

148

從來多古意
可以賦新詩
330mm × 1330mm × 2

There Are always Ancient
Meaning, and New Poetry Can
Be Written
（330mm × 1330mm × 2）

149

150

獨傲秋霜
同沾春露
330mm × 1330mm × 2

Being Alone Proud at Autumn Frost,
Together Moisten Spring Dew

(330mm × 1330mm × 2)

山不在高，有仙則名。水不在深，有龍則靈。斯是陋室，惟吾德馨。苔痕上階綠，草色入簾青。談笑有鴻儒，往來無白丁。可以調素琴，閱金經。無絲竹之亂耳，無案牘之勞形。南陽諸葛廬，西蜀子云亭。孔子云：何陋之有？

劉禹錫陋室銘 梅道人鄭發達記於經行

151

陋室銘
650mm × 1330mm

Inscription to the Humble Room
（650mm × 1330mm）

少而好學如日出之陽
壯而好學如日中之光
老而好學如炳燭之明
炳燭之明孰與昧行乎

劉向說苑
650mm × 1330mm

Liu Xiang Saying Garden
(650mm × 1330mm)

152

香溢寰宇　梅開五福
330mm × 1330mm × 2

Plum Blossom Opens Five
Fortunes, and Fragrance Overflows
the World
（330mm × 1330mm × 2）

153

154

妙筆繪香雪　風霜練精神
330mm × 1330mm × 2

Wind and Frost Drills Spirit, and Clever
Brush Paints Fragrant Snow

(330mm × 1330mm × 2)

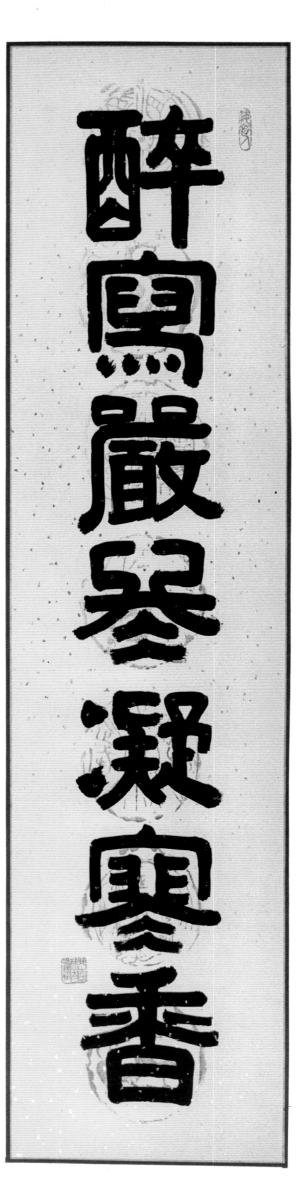

醉寫嚴冬凝寒香
此外評花四海空
330mm × 1330mm × 2

155

Drunk-Writing the Cold Winter
and Coagulating the Cold
Fragrance, and Commenting
herein Flowers for Nothing all
over the World
（330mm × 1330mm × 2）

三國演義開篇詞《臨江仙》

330mm × 1330mm

Introductory Words to The Three Kingdoms' Historical Novel 《River Shoreface Immortal》

(330mm × 1330mm)

滾滾長江東逝水，浪花淘盡英雄。是非成敗轉頭空。青山依舊在，幾度夕陽紅。

白髮漁樵江渚上，慣看秋月春風。一壺濁酒喜相逢。古今多少事，都付笑談中。

臨江仙三國演義開篇詞 乙酉之穢日 梅道人鄭發祥於美國紐約

白香山詩一首

鄭松祥書於邊城

157

白香山詩一首
660mm × 1200mm

One Poetry of White Xiangshan
Mountain
（660mm × 1200mm）

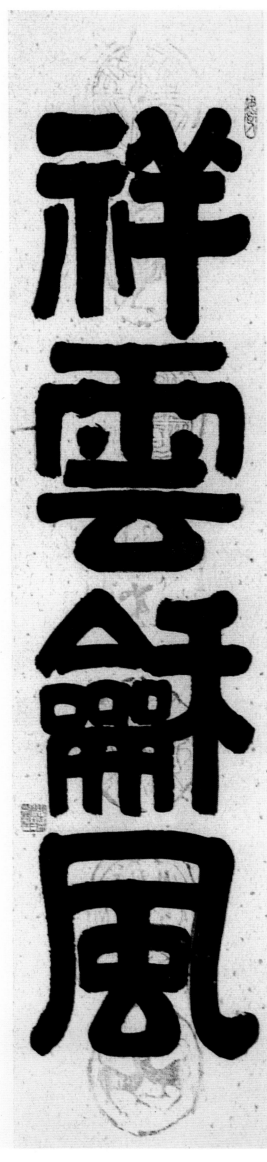

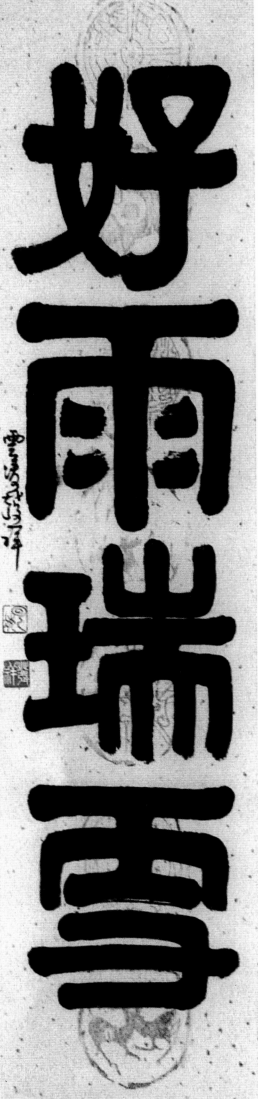

158

祥雲和風
好雨瑞雪
330mm × 1330mm × 2

Lucky Clouds and Moderate Breeze, Fine
Rain and Auspicious Snow
(330mm × 1330mm × 2)

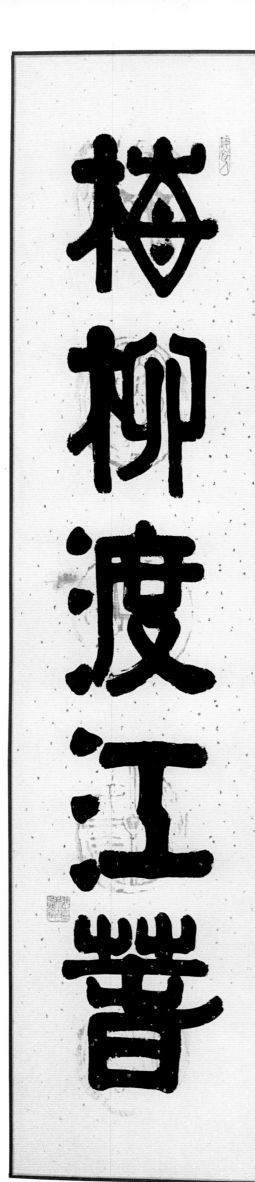

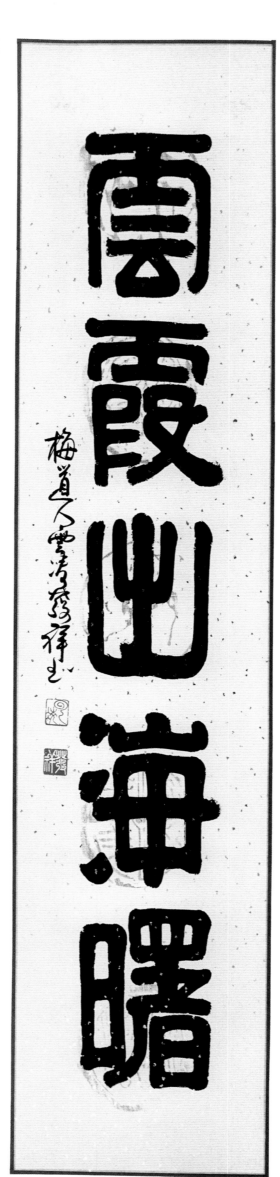

梅柳渡江春　　159
雲霞出海曙
330mm × 1330mm × 2

**Plum Willow Crosses River
Spring, and Rosy Clouds
Produces Sea Dawn**
（330mm × 1330mm × 2）

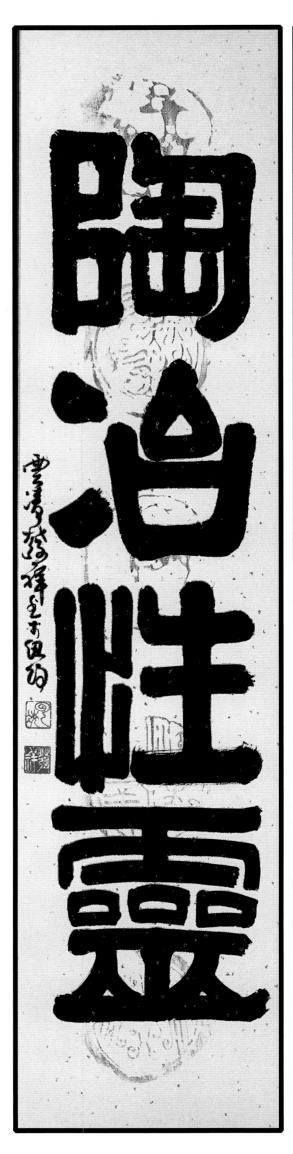

160

陶冶性靈　變化氣質
330mm × 1330mm × 2

Nurturing Character and Soul, to Change
Temprament
(330mm × 1330mm × 2)

161

唐詩
660mm × 1330mm

Poetry of the Tang Dynasty
The Full Front and Back Twine
Jade green Scallion
（660mm × 1330mm）

蘇軾　念奴矯一首
650mm × 1200mm

Su Shi　One Ci　Nian Nu Jiao
(650mm × 1200mm)

大江東去，浪淘盡，千古風流人物。故壘西邊，人道是，三國周郎赤壁。亂石穿空，驚濤拍岸，捲起千堆雪。江山如畫，一時多少豪傑。

遙想公瑾當年，小喬初嫁了，雄姿英發。羽扇綸巾，談笑間，檣櫓灰飛煙滅。故國神遊，多情應笑我，早生華髮。人生如夢，一尊還酹江月。

蘇軾念奴嬌赤壁懷古　梅道人鄭榮祥書於鯉魚約

會當凌絕頂

一覽眾山小

杜少陵詩句 梅道人鄭雅祥乙酉之穐於迴幻

會當凌絕頂，一覽眾山小
630mm × 1100mm

Gathering to Approach the Tiptop, Generally Viewing that the Crowd of Mountains Are Small
（630mm × 1100mm）

164

霜毫總寫波濤賦
素練長引壯士歌

333mm × 1330mm × 2

Frost Writing Brush Writes always the
Wave Odes, and Usually Training Often
Cites Hero Song

(333mm × 1330mm × 2)

江山麗詞賦
冰雪净聰明
330mm × 1330mm × 2

The Land Makes Ci and Ode Beautiful, and Ice and Snow Cleans Cleverness

（330mm × 1330mm × 2）

165

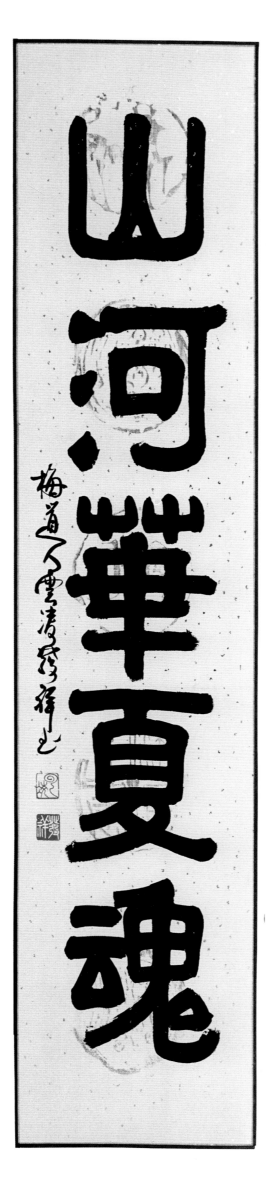

166

梅花炎黄瞻
山河華夏魂

330mm × 1330mm × 2

Plum Blossom is the Yellow Emperor's
Looking up, and the Land of Country
Huaxia's Soul

(330mm × 1330mm × 2)

大江歌罷掉頭東，邃密群科濟世窮。

面壁十年圖破壁，難酬蹈海亦英雄。

周恩來總理詩

乙酉之秋梅道人鄭碩禪書

周恩來詩一首
660mm × 1330mm

One Poetry of Zhou Enlai
（660mm × 1330mm）

劉長卿詩彈琴
660mm × 1330mm

Playing Qin of the Ancient
Poetry of Liu Changqing
(660mm × 1330mm)

169

董必武詩一首
630mm × 1100mm

One Poetry of Traveling Boat of
Dong Biwu
（630mm × 1100mm）

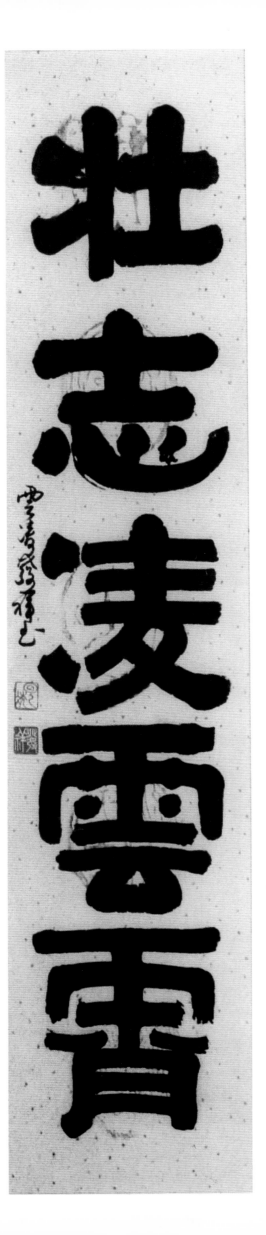
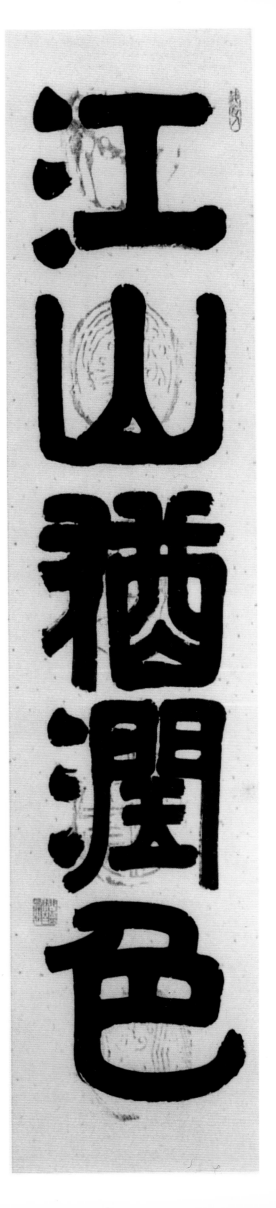

170

江山猶潤色
壯志凌雲霄

330mm × 1330mm × 2

The Landscape still Embellishes, and Lofty
Ideal Reaches the Sky

(330mm × 1330mm × 2)

詞賦動陽春
健融偏湖海
330mm × 1330mm × 2

Ci and Ode Moves Spring, and
Healthy Harmony Spreads all
over the lake and Sea
（330mm × 1330mm × 2）

171

172

幾身修得到梅花
妙筆繪成香雪海
333mm × 1330mm × 2

Cultivating and Gaining Plum Blossom,
Clever Writing Brush Paints the Fragrant
Snow Sea
(333mm × 1330mm × 2)

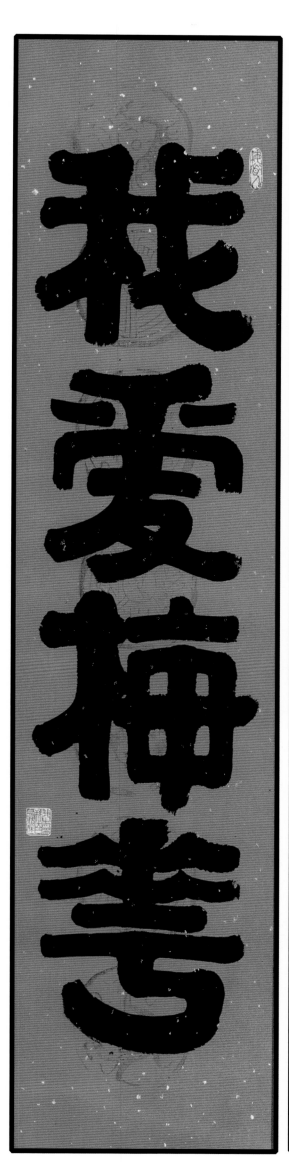
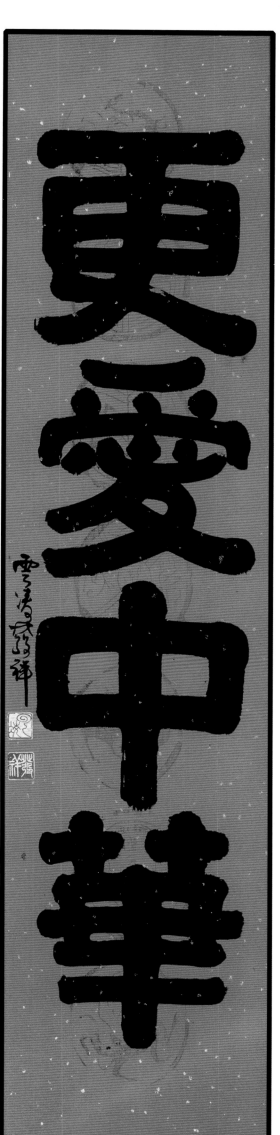

我愛梅花　更愛中華
333mm×1330mm×2

I Love Plum Blossom, but even
more Love China
（333mm × 1330mm × 2）

祥雲和風
海納百川
歲月流韻

333mm × 1330mm × 3

Lucky Cloud and Moderate Breeze, Sea
Accepts all Kind of Rivers, and Yeas Flows
Charm

(333mm × 1330mm × 3)

174

真諦
660mm × 1330mm

Essence
（660mm × 1330mm）

新鬆恨不高千尺
惡竹應須斬萬竿
333mm × 1360mm × 2

New Pine Hates not Being High to
Thousand of Chi, and Bad Bamboo Shall
Cut Ten Thousand of Poles
(333mm × 1360mm × 2)

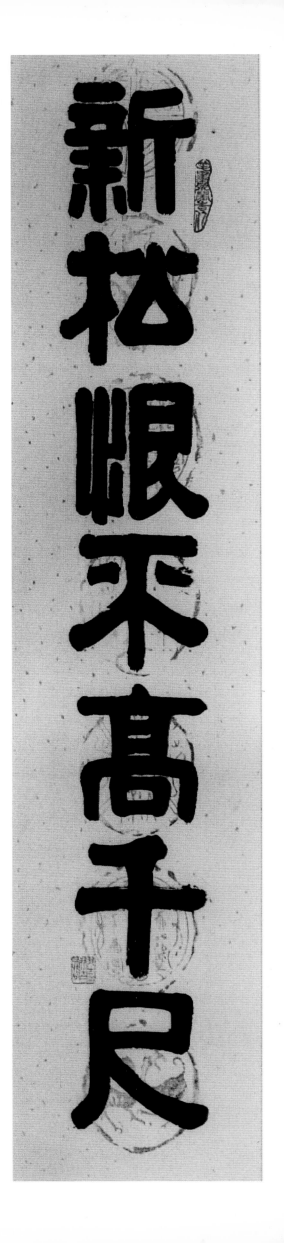

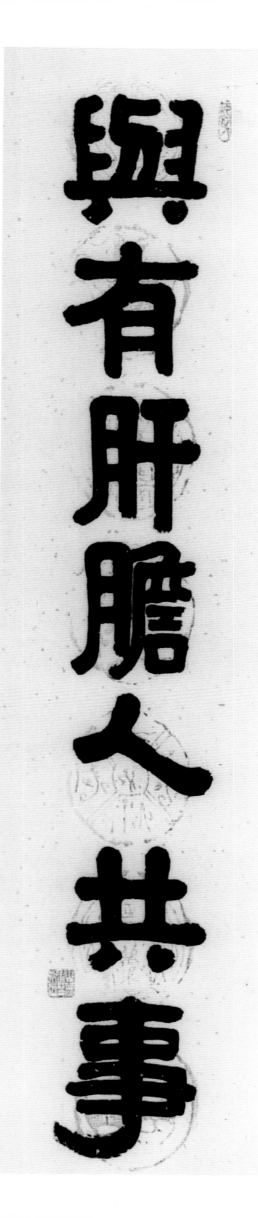

與有肝膽人共事
從無字句處讀書

330mm × 1360mm × 2

177

Working together with People with Courage, and Read Book From Place without Word and Phrase

（330mm × 1360mm × 2）

滾滾長江東逝水，浪花淘盡英雄。是非成敗轉頭空。青山依舊在，幾度夕陽紅。

白髮漁樵江渚上，慣看秋月春風。一壺濁酒喜相逢。古今多少事，都付笑談中。

三國演義開篇詞

鄭榮祥

178

三國演義開篇詞（行草）

660mm × 1390mm

Introductory Words to The Three Kingdoms' Historical Novel (Running Hand, Grass Writing)

(660mm × 1390mm)

一花一世界，一葉一如來。鑑筆鋒舞，須臾成畫，有如歌如泣，會當神馳，相雪飛雪清，冲都霞歌。

梅道人雪清齋拜手

179

梅花詩一首（行草）
660mm × 1360mm

One Poetry of Plum Blossom
(Running Hand, Grass Writing)
（6600mm × 1360mm）

畫梅聖手鄭發祥

偶觀中央電視臺"祖國各地"藝術專題片《一剪寒梅》

近年來，電視專題中有一些以畫家爲題材的作品，其中也不乏畫梅者，但中央電視臺1993年元月11日"祖國各地"欄目播出的"一剪寒梅"在短短的10分鐘時間裏以凝重的基調，舒緩的節奏，多側面多角度刻畫一位著名青年藝術家，給人以心靈的震撼。

尤其片中的主人公當代畫梅聖手鄭發祥先生，于"而立"之年，敢在萬花競開的梅林中另辟蹊徑一枝獨絶。其才，其勇令人振奮。

鄭發祥畫梅，不論在立意上還是技法上，較之前人(尤其是歷代文人畫)都有鮮明的突破。在他筆下，一反古人借梅花抒發孤芳自賞，淡泊明志，感傷時世的思路，而是着力營造氣勢雄勁，生機勃發的意象。誠如他的條幅"鐵石梅花氣概，山川香草風流"所言，極爲突出梅花内在的陽剛之美，洋溢出一股奮發進取的氣韵和力量。其中尤以爲國家文物局、中國美術館、人民大會堂、天安門城樓、中南海、中國軍事博物館所繪制的春韵、國香贊、紅梅贊等巨幅精品，被譽爲"時代大寫意"，"人格精神與繪畫技法的結晶"。

發祥畫出的梅花，飽蘸濃烈的時代與個性的頌揚之情，這是賞畫者所不難感受到的。

發祥畫梅之所以不同凡響，就在于他對梅花具有獨特的觀察，感知和審美意識。他説過：梅花體現了"萬花敢向雪中出，一樹獨先天下春"的精神，這是人的一種品格與境界。古人筆下的梅花，往往"雅氣有餘而生氣不足，給人一種雪壓冬雲之感"，而追求意境上的出新，則是他畫梅的主旨。正是在這樣藝術見解的指引下，我們在他的作品中看到了色彩强烈的紅、藍、緑、黄、白各异的梅花；看到了帶有篆刻情致，魏碑風骨的梅花；看到了將没骨畫法與骨墨混寫的梅花；看到了用墨濃而潤的意趣盎然的梅花以及那一系列在冰雪裏獨傲群芳月光下芳姿各异的梅花……總之，在技巧與技法上，他既吸取、師承了傳統繪畫中豐富的遺産，又不拘泥于法度，揮灑自如，處處給人以新意，給人以獨特的藝術個性，真是應驗了石濤大師"我之爲我，自有我在"這句名言。

鄭發祥的成功絶非偶然。人才學家、社會學家、文藝心理學家可以從不同的視點作多角度的探討。僅就他的創作道路來看，首先他身體力行"師造化"這條古訓。"讀萬卷書，行萬裏路"，鄭發祥在"行萬裏路"中，還包含着遍賞大江南北梅林的閲歷。蘇州的香雪海，無錫的梅園，南京的靈峰園，成都的青羊宮到浣花溪……無不留下他的足迹，更留下他的痴迷、感悟與思考。發祥戲稱自己爲"梅道士"，正是他以梅爲友，"我"梅合一，聯想妙得的生動寫照。

在師造化的同時，發祥還虔誠地拜師求藝。他先後向家鄉的林葆生、章友芝兩位名畫家和國内名家學藝討教，後來拜著名藝術家董壽平先生爲老師博采衆長，熔于一爐，使其在"而立"之年就成長爲從藝術觀念到創作實踐都蜚聲海内外的名畫家。他自幼家境清寒，求學謀生坎坷，在上述種種追求過程中經歷的磨礪和艱辛，自然是可以想見的。其間所揭示的成才之路及其真諦，足以發人深省。

中國傳媒大學教授　葉家錚
一九九四年七月二十八日
（轉載《中華兒女》雜志第32期）

Zhengfaxiang

A young master in plum painting in china

Plum, blossoming in severe winter, is always the eternal theme of scholars' and painters' works. Numerous people of all ages have expressed their admiration for it. The exquisite work of art is bright and beautiful. In recent years, there have been some TV programs about painters including plum painters. With an imposing keynote and leisurely rhythm, the CCTV program "A Spray of Winter Plum Blossoms" in "Every Place in China" on Nov. 11, 1993, introduced a young painter from various angles. This made people greatly excited.

Mr. Zheng Faxiang, the hero of this program, is known as a young talented plum painter of our time. He dares to find a new way in the plum blossoming trees in his thirties. Both his ability and courage make people inspired. In the aspect of conception and artistry, Zheng's plum painting effects an obvious breakthrough as compared with those predecessors. Not like the ancients using plum blossoms to express their sadness for the current situation at their time, Zheng's paintings are full of vigor and enterprising spirit. His paintings, especially "Spring Thyme", "Clear Sky after Snow". "Ode to the National Fragrance ", and "Ode to the Red Plums ", which are exhibited in the People's Great Hall, Tiananmen Gate—tower, Zhongnanhai, and China Art Gallery, are famous for the vivid expression of our time, and the crystallization of personality and drawing skill.

Faxiang's plum paintings are praises of our time and individual character. People do enjoy them.

Faxiang studies the plum blossoms in his unique style. He has his own aethetic idea. He said, plums' spirit, blossoming in winter and noting on forthcoming spring, is a kind of personality of human beings. So we can see intensely coloured plums, red, blue, green, yellow, white we can see the plums with the feature of seal cutting and style of tablet inscriptions of the Northern Dynasties. We can see the plums painted with different skills. We can see the plums in dark and smooth ink as well as the quietly elegant plums under the moon. In a word, he has not only assimilated traditional painting heritage but also brought forth new idea.

Zheng Faxiang's success is not accidental. The talentists, sociologists and art psychologists may discuss the phenomenon from different points. In the way of his creating, he has followed the ancient model, "Nature— as a teacher". Just like the motto "Read millions of books and travel over numerous places", Zheng Faxiang traveled over many plum gardens from north to south in China, such as Xiangxuehai in Suzhou, Meiyuan Park in Wuxi, Lingfengyuan Park in Nanjing, of human beings. So we can see intensely coloured plums, red, blue, green, yellow, white we can see the plums with the feature of seal cutting and style of tablet inscriptions of the Northern Dynasties. We can see the plums painted with different skills. We can see the plums in dark and smooth ink as well as the quietly elegant plums under the moon. In a word, he has not only assimilated traditional painting heritage but also brought forth new idea.

Zheng Faxiang's success is not accidental. The talentists, sociologists and art psychologists may discuss the phenomenon from different points. In the way of his creating, he has followed the ancient model, "Nature— as a teacher". Just like the motto "Read millions of books and travel over numerous places", Zheng Faxiang traveled over many plum gardens from north to south in China, such as Xiangxuehai in Suzhou, Meiyuan Park in Wuxi, Lingfengyuan Park in Nanjing, Qingyanggong Palace and Huanhua brook in Chengdu. etc. Where he went, where he left his infatuation, comprehension and thoughts. So Zheng Faxiang calls himselft "Meidaoren", and the plums are good friends to him.

While Faxiang took nature as his teacher, he learned from other people sincerely, including two famous painters in his home town and Mr. Dong Shouping, an art master in China, so that he became famous for his art sense and creating practice in his thirties. Faxiang was born in a poor family. We can easily image the difficulties and hardship he experienced. Asamatter of fact, the true meaning of his road to success is enough to call for deet thought, Written by Ye Jiazheng, professor of Academy of Belling Broadcasting, critic.

燃燒生命的激情

記旅美著名藝術家畫梅聖手鄭發祥

被新聞界譽為"梅花奇才"、"梅聖"的旅美著名藝術家鄭發祥先生 2003 年 9 月，在孫中山先生創立的有 100 多年歷史的中華公所藝術廳，舉辦了一個紐約華阜空前盛大的個人藝術展。各社團贈送的幾十盆鮮花和參加畫展開幕式的觀眾擠滿了寬敞的大廳。這個名為"鄭發祥《梅之韵》"的紐約藝術大展，不僅在華人圈內引起轟動，就連崇尚西方藝術的美國本土藝術專家也紛紛前往參加。參觀者無不贊不絕口。短短五天時間，展會便接待了參觀者數萬人之眾。在這次個展上，時任紐約市市長彭博、中華公所主席伍庭典以及紐約議員高頓先生為鄭發祥頒發功勛證書。鄭發祥先生的梅花作品《冰魂皓態古今頌》和《香雪海》分別以每幅 12.86 萬美元的高價被僑團買家收藏。

鄭發祥福州人。幼年時因家境的貧困和生活的磨難，造就了他不屈不撓的性格和堅忍不拔、不達目的誓不罷休的精神。而這種性格和精神亦成為他後來在繪畫藝術上取得成功的堅實基礎和寶貴財富，翻開他不算太長但却充滿坎坷的經歷不難發現，從閩江邊的沙灘上用樹枝畫日落，到去日本舉辦個人畫展，再回北京全面發展以及最終成為定居美國的旅美著名藝術家。可以說，他的每一個脚印都滲透着艱辛和甘苦，亦折射着他的努力和勤奮。

發祥畫梅，淵于他對梅花的酷愛。他愛梅花清麗、灑脱、超逸的風姿，更愛梅花傲霜鬥雪、不畏嚴寒的品性。他把自己的才華和情感全部寄予了梅花。古人稱：作畫是"借物以寫胸中之所有"。而鄭發祥常說："梅花是中華民族的一個民族精神的象徵。他不畏冷風和嚴寒，笑傲群芳，具有鬥雪傲霜的精神，它的香是從苦寒中來的。梅花高潔，化作泥土也依然香如故，而且還具有高尚的情操，祗是為了報春而不與群花爭艷。我以為對于一個有心的人來說，站在咏梅的詩書畫面前，使人的性靈起到了一種激勵和净化作用。"發祥畫梅，正是透過梅花那獨有的風韵和品性來抒發他胸中的獨愛和追求。透過筆下一幅幅清麗、高雅、氣勢蓬勃的梅花作品，盡情贊美梅花那種在逆境中頑强拼搏，在世俗中一塵不染的品格精神。正是由于他準確地把握了畫梅的精髓，所以他筆下的梅花圖才會令人怦然心動。國畫大師關山月觀其畫後給鄭發祥的來信中贊曰："功底深厚，創新出奇；梅家一派，非同流俗。"

鄭發祥先生的作品涉獵甚廣。除梅花外，他的人物、山水、鳥獸、以及書法篆刻等都頗其功底。尤其是他的篆隸書法，那雄沉、圓轉、道勁中透射出的奔放、灑脱和超逸受名家的肯定。發祥深明"書畫同源"的真諦，因而在筆墨技法上，他將中國書法淋漓痛快及流暢神動的精髓與大寫意繪畫的技巧融會貫通，力求書中有畫意，畫中有書魂。這種書與畫的協調與互補使其相得益彰，達到了藝術上的真正和諧統一，收到了攝人魂魄的藝術效果。

鄭發祥經常被邀為紐約大學、哥倫比亞大學、曼哈頓大學講授神奇的東方藝術。海外僑胞和國際友人購買和收藏他作品更是比比皆是。在這些友人中，蔣緯國先生、陳香梅女士、馬英九先生更是對鄭發祥先生的梅花贊不絕口。我親眼目睹蔣緯國先生、陳香梅女士、馬英九先生給鄭發祥的親筆信。從他們那熱情及贊美的話語中不難看出。鄭發祥先生的作品在他們的心目中是多麼的完美。

應該說，做為藝術家的鄭發祥絕對是一位成功者。但成功了的鄭發祥并沒有沾沾自喜。他告訴我，他現在最大的壓力便是感到藝術創作的重新突破。為此。他除了更加努力地創作外，還把"弘揚梅花人文精神，振興華埠文化經濟"作為已任。近年來，他頻繁穿梭于世界各地，為華夏文化的傳播起到了積極的作用。2005 年在河南鄭州的春拍會上一幅"香雪海"梅花作品以 65 萬元的高價拍出，被加拿大收藏家收藏。今年秋拍會上一幅四尺整張作品以 12 萬元人民幣定錘，又創鄭州書畫作品秋拍會的最高價。此外，鄭發祥先生還十分熱心于公益事業，在福建長樂市他的出生地，由他發起成立的"發祥教育基金會"是一個扶持家鄉教育事業的資助機構這個機構是長樂市繼冰心教育基金會後第二個長樂籍藝術屆名人為家鄉設立的教育基金會。他還被中華愛國工程聯合會授予"杰出愛國人士"榮譽稱號

撰稿：今傳（中國藝術家學部委員會副秘書長）
地址：北京市 226 信箱
郵編：101101

182

Enthusiasm that burns the Life

Notes of Faxiang Zheng, a Chinese nationals residing in USA, famous artist, plum blossom painting saint

Mr. Faxiang Zheng, a praised by the press circle as "plum blossom wizard" and "plum blossom saint" Chinese nationals residing in USA, famous artist, held in September 2003, a New York China Town unprecedented grand individual art exhibition in the art hall of the established by Mr. Zhongshan Sun China Mansion with more than 100 years' history. The presented by various communities a few tens of pots of fresh flowers and audiences who attended at the opening ceremony of the arts exhibition, crowded the hall. This named "Zheng Faxiang 'Plum Blossom Rhyme'" New York Arts Exhibition, not only aroused stir in overseas Chinese circle, but also the American art experts, who advocate western art, went up to participate in one after another. Visitors, all without exception, were full of praise. In the short 5 days, the Exhibition received visitors of a few tens thousand people. On this Individual Arts Exhibition, Mr. Pengbo, mayor of New York, Mr. Tingdian Wu, president of China Mansion and Mr. Dunxian Gao, councilor of New York awarded Mr. Faxiang Zheng the feats certificate. Mr. Zheng's plum blossom works: "Ode to the Past and Present with Icy soul and Bright Posture" and "Fragrant Snow Sea" were collected by buyers of overseas Chinese group at a high price of $128600 per piece respectively.

Mr. Faxiang Zheng, native place Fuzhou. In petticoats, the poverty-stricken family circs and existence's crucifixion trained him with a dauntless character and persistent spirit of not stopping until reaching the goal. And such character and spirit have become into a solid base and invaluable fortune for him to achieve successes in the painting art. In his not too long but full of frustrations experiences, it is not difficult to discover that from painting of the sunset with branch on the sand beach beside the Minjiang River, to going to Japan for holding the individual art exhibition, again returning to Beijing for overall development and finally turning into a Chinese nationals residing in USA famous artist, his every footprint was infiltrated by hardships, sweetness and bitterness, and also refracted his endeavor and diligence.

That Faxiang paints the plum blossom is originated from his being wrapped up in the plum blossom. He loves the plum blossom's delicate and pretty, free and easy, unconventionally graceful charm, and even more loves character for the plum blossom to brave snow, struggle against frost and not fear chilliness. He place his own artistic talent and sensibility all on the plum blossom. The ancients saying, painting is "writing the possession in one's mind, relying on substance". Mr. Faxing Zheng often says, "The plum blossom is symbol of an ethos of Chinese Nationality. She does not fear the cold wind and chilliness, laugh at and brave fragrant flowers, having a spirit to struggle against snow and brave frost. Her fragrance comes from the bitter coldness. The plum blossom is noble, and although turning into clay, still the same old fragrant. Furthermore, the plum blossom, having the high-minded sentiment, blossoms only for reporting the spring and not contending the amorous with other flowers. I think, for a minded man, standing before the poetry, painting and calligraphy of ode to the plum blossom, for the hominine character and soul, an inspiration and purification effect is aroused." That Faxing paints the plum blossom is namely to express his unique love and pursue in his mind by permeating the plum blossom's particular charm and character permeating more and more pieces of delicate, pretty, elegant and vigorous plum blossom works, admiring as much as he likes the character and spirit for the plum blossom to indomitably struggle in adversity and to be stainless in common customs. Just due to that Mr. Zheng grasps exactly the kernel to paint the plum blossom, the plum blossom picture under his brush makes people palpitating with excitement eager to do sth. Mr. Shanyue Guan, a traditional Chinese painting, commended in the sent to Mr. Faxiang Zheng letter after having looked at the painting, "Skill is profound, and innovation unusual. Being a unique school of painting the plum blossom, it isn't the same as current fashion."

Mr. Faxinag Zheng's works dabble very broadly. Except the plum blossom, his paintings of character, landscape, birds and animal, as well as calligraphy and seal cutting etc. all are rather skilful. Especially, his seal cutting and calligraphy, are affirmed by masters in their moving and forcefulness, being free and easy, and unconventionally graceful, transmitted from their vigorousness, firmness, roundness, rotation and forcefulness. Mr. Zheng deeply knows essence of "The calligraphy and painting have the same source." so in brush and ink skill, he digests the most incisive, joyful, fluent and lively expressive kernel of Chinese calligraphy with the skill of great freehand brushwork in traditional Chinese painting, and strives "There is the painting meaning in the calligraphy, and there is the calligraphy soul in the painting". Such harmony and complementation of the calligraphy with the painting achieved the exact harmony and unification in art, and received an artistic effect to shake the soul.

Mr. Faxiang Zheng was often invited to lecture the supernatural oriental art in New York University, Colombian University and Manhattan University. Overseas Chinese and international friends who purchase and collect his works, can even more be found everywhere. Among these friends, Mr. Weiguo Jiang, Ms. Xiangmei Chen and Mr. Yingjiu Ma are full of praise on Mr. Faxing Zheng's plum blossom painting. I saw with my own eyes the autographic letters to Mr. Faxiang Zheng from Mr. Weiguo Jiang, Ms. Xiangmei Chen and Mr. Yingjiu Ma. From their ardor and laudatory words it is not difficult to see, how perfect are Mr. Faxiang Zheng's works in their mind.

It is supposed to say, as an artist, Mr. Faxiang Zheng is absolutely a successful personage. However, the successful Mr. Faxiang Zheng is not pleased with himself. He told me, his present supreme press is tasting the renewed breakthrough in artistic creation. Therefore, except much more endeavoring the creation, he takes the "carrying forward the plum blossom's humanist spirit, to re-energize China Town culture and economy" as his personal responsibility. In recent years, he shuttled frequently places all over the world, and played an active role to spread abroad Chinese culture. In 2005, on Zhengzhou Springtime Auction Meeting, Henan Province, a piece of "Fragrant Snow Sea" plum blossom works was auctioned at a high-price of ￥650000, and collected by a Canadian collector. On the Autumn Auction Meeting in this year, a piece of 4chi whole sheet works was auctioned at ￥120000, and again set up a ceiling price on the Zhengzhou Autumn Auction Meeting of Calligraphy and Painting Works. Furthermore, Mr. Faxiang Zheng is very bound up in commonweal cause. In Changle City, Fujiang Province, his homeplace, he sponsored and established the "Faxiang Education Foundation", which is an aided financially institution to support his hometown's education cause. This Institution is the second education foundation, established in Changle City by the Changle native celebrity in the art circle, following Bing Xin Education Foundation. Mr. Faxiang Zheng was also awarded by the China Patriotic Project League as the honor title of "Outstanding patriotic personality".

Writer: Jin Chuan (Deputy secretary-general of China Artists Academic Committee)
 Address: Mail Box 226, Beijing City
 Postal code: 101101

天下道長皆為我師

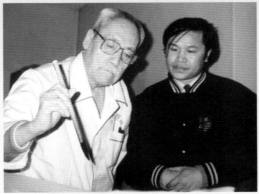
董壽平大師　Dong Shouping Master

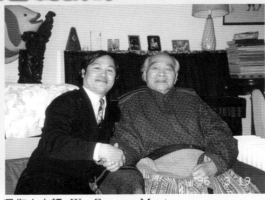
吳作人大師　Wu Zuoren Master

啓 功大師　Qi Gong Master

沈 鵬大師　Shen Peng Master

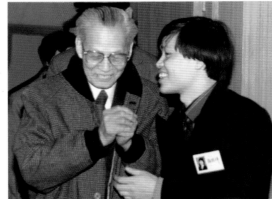
全國人大副委員長程思遠
Cheng Siyuan Vice officer of China
people delegate council committee

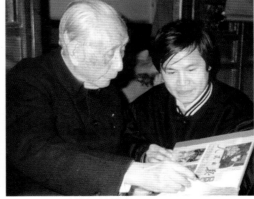
全國人大副委員長楚圖南
Chu Tunan Vice officer of China
people delegate council committee

天下道長皆吾師

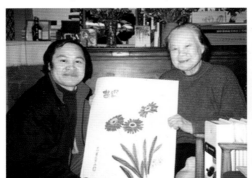
蕭淑芳大师　Xiao Shufang Master

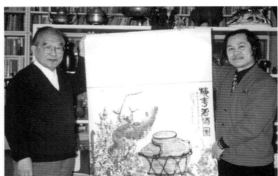
周巍峙大师　Zhou Weizhi Master

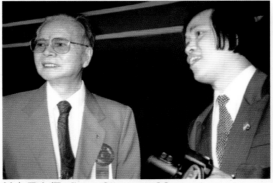
关山月大师　Guan Shanyue Master

冰心大师　Bing Xin Master

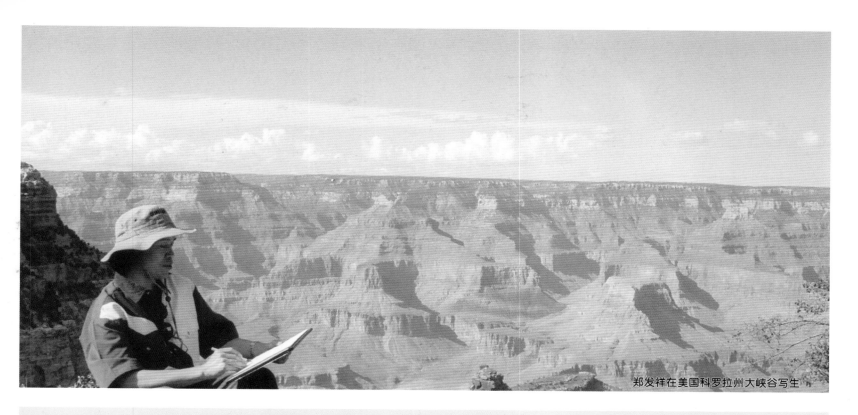

郑发祥在美国科罗拉多州大峡谷写生

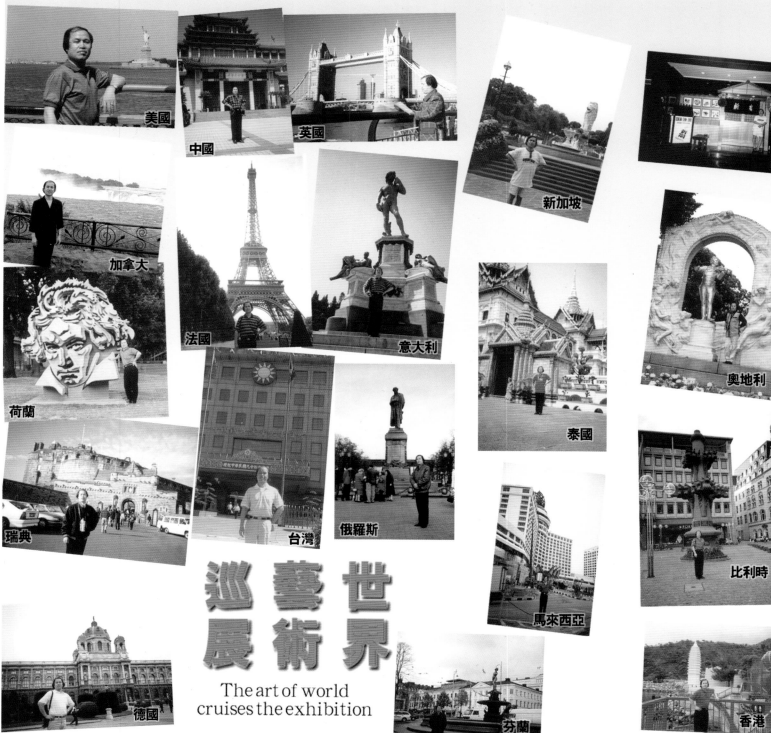

美國

中國

英國

新加坡

日本

加拿大

荷蘭

法國

意大利

奧地利

泰國

瑞典

台灣

俄羅斯

馬來西亞

比利時

巡藝世
展術界

The art of world
cruises the exhibition

德國

芬蘭

香港

185

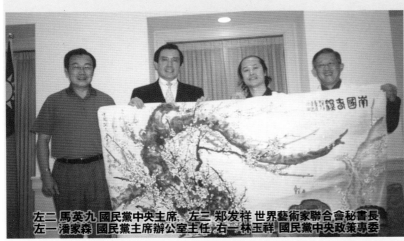

左二 馬英九 國民黨中央主席，左三 鄭发祥 世界藝術家聯合會秘書長
左一 潘家森 國民黨主席辦公室主任，右一 林玉祥 國民黨中央政策專委

時任中華公所主席伍廷典先生與衆僑領親臨梅之韻畫展剪彩

鄭發祥在台北三軍軍官俱樂部與梅花之友會同仁進行梅花藝術交流

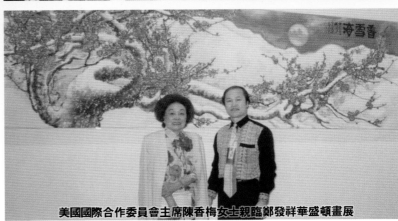

美國國際合作委員會主席陳香梅女士親臨鄭發祥華盛頓畫展

劉陽先生先生（梅花推廣委員會總干事）

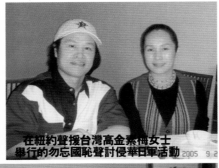

在紐約聲援台灣高金素梅女士
舉行的勿忘國恥聲討侵華日軍活動

中國駐聯合國全權大使王光亞先生

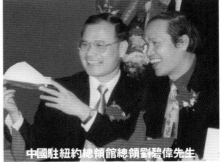

中國駐紐約總領館總領劉碧偉先生

186

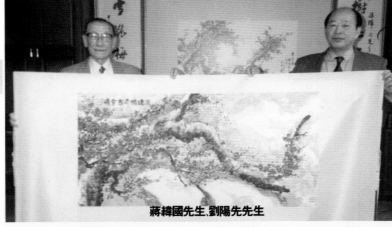

蔣緯國先生、劉陽先生先生

聯合國總部留影

重要活動照片

中華人民共和國文化部証書

中國國家文物局收藏証書

中國文學藝術界聯合會証書

中華全國歸國華僑聯合會証書

中國國家文化網証書 　中國駐英國大使館証書 　中國駐美國大使館証書

中國美術館收藏証書

權威代表性證書

人民大會堂管理局收藏証書

天安門城樓管理局收藏証書

THE CHINA PRESS

社址:839 Cowan Road,
Burlingame, CA 94010
電話(TEL): (650)652-0588
傳真(FAX): (650)652-0586
INTERNET ADDRESS:
WWW. THECHINAPRESS. COM.
E-MAIL ADDRESS:
CPRESS@ ECHONYC. COM.
COPYRIGHT © 1998
THE CHINA PRESS

零售:三藩市 40¢
訂閱 三個月 $55
半年 $80
全年 $130

2001 年 10 月 30 日（星期二）

人物春秋

（原版刊出）

「梅聖」——記畫家鄭發祥

梅，一直是中國畫的藝術大師們的目標和熱點，古往今來從王冕、馬遠、沈周到石濤八大的終生所追求的佳境，今天終被鄭發祥先生所突破，跨過了歷史的條條大河和崇山峻嶺，不溫不火，不拘一格，創造出自己溫文爾雅的自己風格，波瀾不驚，意境無垠的自己風格。

鄭發祥先生的藝術生涯，正如中國中央電視台的專題片中所說：「鄭發祥出生在福建一個普通農民家裡，他的童年在美麗的「神筆馬良」的影響下帶著重重的困難，拍了1000多幅不同時令的梅花，過訪了中國梅園，植物照片，他做了雄厚的物資基礎和精神力量。

技術不負苦心人，歷經不懈的奮鬥，發祥先生一步高人一等從梅痴、梅魂、梅道人，走向萬萬千千個畫中的姣姣者，被稱爲「梅聖」可謂發現了梅的真諦，被廣大愛梅者和藝術界書界名流藝術大師劉海粟爲其題寫書名，書畫界名家劉海粟爲其題寫書名，啓功、劉開渠、冰心、周巍峙、廖靜文、齊良遲、高占祥、沈鵬等爲其題詞祝賀。同時他先後進入中央美術學院、中國藝術研究院進行系統的學習和深造，這使他更上一層樓，鍛鑄了他對梅花深邃的內涵的感悟和對梅賦于了強大的民族信息和時代的華廈文明的崇高品格。鄭發祥的藝術生涯和他所創出新時代的梅，受到海內外一致的好評和熱愛，各種報刊：人民日報、光明日報、中國日報、文藝報、新華社、海外美國、日本、新加坡、泰國、港、澳、臺好評如潮，各種獎項的冠軍數不勝數，國家級、亞洲級、全球、個展幾乎遍及全球，在他的個展上，引起江澤民主席、李鵬、劉華清等國家領導人的驚嘆之妙，之奇甘于梅花作品已成收藏家和國家領導人出訪國外贈送外國首腦的珍品，無論在中國國內或是海外，發祥的梅花原作已成爲收藏家和梅花愛好者的目標。筆者具悉蔣緯國先生、陳香梅女士都收藏有發祥作品。

曾記得，三年前帶朋友去紐約，參觀聯合國時發現了一幅收藏的中國畫藝術珍品—梅。但見，那蜿蜒曲折的梅軀杆，如鐵打銅鑄，櫛茨鱗枇的枝條仿佛鋼筋鐵骨，墨色濃淡協調時隱時現，仿佛看到陽光照射下活靈靈的梅斗嚴寒堅強不屈，昂首屹立蒼穹之下。那一朵朵傲雪綻放的梅花有不同角度，不同的姿態，不同的色澤，格外絢麗奪目，其繁盛更不同往常，其構圖的內在意蘊更非同小可，其無限的意境更讓人觀賞流連忘返。真可謂「大音稀聲，大巧若拙，至于無形」。真可稱鬼斧神差巧奪天工之佳品。尋著作者，我赫然在落款處見到—鄭發祥！

日前灣區好友引薦，與剛剛在華盛頓首府舉辦完個人專題畫展的鄭發祥先生，談及他的作品，在中國之旅，歷經近30年他無休無止，風雪中，月光里，孤燈旁，他飽蘊心血畫著他情有獨鐘的梅花。他得益于八閩畫家林葆生先生、福州畫院秘書長章先芝的指導，他師古人更有突破，學今人而有創新，技巧新奇將傳統的沒骨畫法與墨骨混寫溶爲一體，時而淡后焦，時而重彩輕描，韻含風骨氣韻的天成，世

鄭發祥先生的藝術生涯，「中國報導」專題欄目：一剪寒梅「爲題藝術專題片中所說：鄭發祥出生在福建一個普通農民家里，走南闖北，四海爲家，盡管孤燈淒冷，但他出自己坎坷的經歷，把梅與自己所深深的吸引去了。回首自己坎坷的經歷，長大了他作過建築工人，走南闖北，四海爲家，盡管孤燈淒冷，但他植物照片，過訪了中國梅園，爲拍了1000多首古今寫梅的詩詞，親自2000多首古今寫梅的詩詞。

梅，一直是中國畫的藝術大師們的目人學者，專家品評爲「氣韵藏葵，昂揚生色」「香中別有韵」「冰肌玉骨」「仙姿灑落淨無塵」以有人評價爲「雪滿山中高士臥，明月林下美人來」又贊「凌歷冰霜節堅，獨成一家」「爲梅，他可以舍去」所以人稱梅痴，藝術界業人士稱之爲梅痴。發祥先生可謂發現了梅的真諦——士合影。

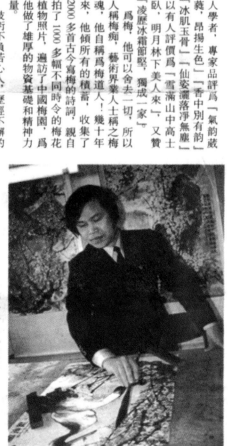

▶ 鄭發祥在現場作畫。

◀ 鄭發祥在紐約個人畫展上同陳香梅女士合影。

僑報 THE CHINA PRESS

2003年9月9日·星期二　No.3974　SEPTEMBER 9, 2003 · 农历癸未年八月十三

50¢

15 E. 40 ST., NEW YORK, N.Y. 10016 Tel: (212)683-8282 Fax:

梅韵飘香

郑发祥"梅之韵"纽约艺术展经过四天的展出于9月8日在中华公所礼堂圆满结束。据了解，此次郑发祥在纽约的首次个人艺术展的参观者达数千人次，成交额约20多万。开展头一天，郑发祥的《冰魂皓态古今颂》和《香雪海》巨幅梅花图每幅以12.86万美元的造价被美东华侨同乡会购买收藏，之后陆续有众多单幅作品售出。郑发祥说，展览中每天都有人连续不断地前来欣赏和参观，有的人来过好几次。他说，中国人无论走到哪里，还是爱梅花，爱中华文化。他的感受是："华埠的文化艺术正在向欣欣向荣的方向发展。"图为展览大厅一角。（图与文：本报记者李杭）

世界日報 WORLD JOURNAL

二〇〇三年八月九月九日·星期一

鄭發祥潛心畫梅　9月華埠展「梅之韻」

【本報記者林拉若的報導】「梅之韻」的藝術家鄭發祥籍貫福建長樂、直刻著稱的藝術家鄭發祥，將於今年9月5日至8日間，於福州華埠中華公所舉辦一場名畫展。

星島日報 SING TAO DAILY

2003年9月11日·星期四　紐約大都會版 TRI-STATE EDITION

月下風姿
賀讀者人月兩圓

鄭發祥「梅之韻」紐約藝術展經過四天展出，於八日在中華公所圓滿結束，這次首次個展參觀者眾，成交約廿多萬，開展首天，其「冰魂皓態古今頌」和「香雪海」巨幅梅花圖每幅以十二萬多造價，被美東福建同鄉會購買收藏。今天是年度中秋節，特送「月下風姿」給本報讀者，中秋合家團圓，幸福美滿。

圖與文：周靜然

大河報 DAHE DAILY

2005年11月2日　星期三　农历乙酉年十月初一

郑州设场拍卖名家字画

本报讯　河南·日信2005年秋季文物艺术品拍卖会昨日起在大河锦江饭店举行。在昨天上午进行的书画专场拍卖会上，除名家作品外，一些实力派书画家的作品也受到了追捧。被誉为"梅花奇才"、"画梅圣手"的青年书画家郑发祥的《春意情浓浓》12万元成交。在春季拍卖会上，他的大幅作品《香雪海》曾卖到65万元。□首席记者张体义

郑州新闻 ZHENGZHOU XINWEN

第5版

旅美艺术家郑发祥绘画作品

《香雪梅》在郑
拍出65万元

本报讯（记者 李颖）5月6日，河南2005春季文物艺术品拍卖会在郑州举行，拍卖会吸引了国内的收藏家以及来自加拿大、英国、新加坡等国家的一些艺术品爱好者参与竞拍。当天上午，当拍卖师宣布以45万元的起拍价拍卖当代旅美艺术家郑发祥的绘画作品《香雪梅》时，立刻在现场掀起了小高潮。

被誉为"梅花奇才"、"画梅圣手"的青年书画家郑发祥，现任国世界艺术家联合会秘书长，在世界各地举办过30多次大型艺术展览。在拍卖现场，拍卖师宣布以45万元起拍他的绘画作品《香雪梅》，喊价就一路飙升，随着拍卖师的拍槌落下，来自加拿大的吴先生最终以65万元的价格得手。

当天的拍卖会，受众人瞩目的商代玉戈更以480万元的价格成交，据悉，本次拍卖会涉及品种多，品位高，拍卖成交总额达3220万元。

中國文化報 ZHONGGUO WENHUA BAO

中华人民共和国文化部主办

1998年5月7日　星期四　第89期（总第1636期）　每周二至六出版　国内统一刊号CN11-0089　邮发代号1-115

本报讯　由泰国中华总商会、泰国东方文化基金会、泰国书画盆景艺术协会、泰国金利实业投资集团有限公司及中国南方书画院联合主办的'98中国美术家泰国大汇展近日在曼谷举行。泰国中华总商会主席郑明如和中国驻泰国领事馆总领事杜坚，以及泰国中华书院院长等泰国各艺术社会团体的代表参加开幕式。

此次大汇展是中国艺术家在泰国历年来规模、声势、阵容最大的一次，大汇展作品有中国画、书法、油画、水粉画、水彩画、版画、烙画、雕塑以及中英文画册和音像制品。

据悉，尽管目前泰国面临经济滑坡，但此次大汇展的艺术品总成交量在300万泰铢左右，中国艺术家郑发祥的一幅《松鹤图》成交价为28.8万泰铢，系此次成交价的最高价位。

（文欣）

明報 MING PAO DAILY NEWS

2003·09·01　癸未年八月初五　星期一

鄭發祥舉辦「梅之韻」畫展

【明報紐約訊】有「梅聖」之稱的華裔書畫藝術家鄭發祥定於九月五日至八日在華埠中華公所舉辦主題為「弘揚梅花人文精神」，撰興華埠文化經濟」的個人作品展，屆時將展出他數十年來精心創作的近百幅梅花書畫藝術精品。

鄭發祥的梅花風格獨特。他重在觀察、體驗和理解梅的自然姿態，以及清麗超俗，傲雪凌寒，不妖不媚的氣質，巧妙地運用了繪畫中「物與我」的關係，在被敝「韻」的同時，也側重「氣」的描繪，在他的筆下，梅花不僅淡雅、生動，且意高旨遠。

鄭發祥近期在紐約組建「美國世界藝術家聯合會」，他表示，九月中華公所畫展後，聯合會將舉辦一系列推動東西方文化藝術交流活動。他認為，將中國傳統藝術產業化是將中國藝術推向美國主流市場的有效途徑，聯合會將致力於這方面的工作。

鄭發祥一九五六年出生在福建長樂一個普通工人家庭。他出生後不久即趕上「三年自然災害」，被饑餓和病魔所折磨，幾乎夭折。在閩江邊的沙灘上，他用短短的木棍畫下了梅花。這是他人生的第一幅作品。

鄭發祥曾就讀於中央美術學院、徐悲鴻畫室、中國藝術研究院研究生部。他在大陸以外地區舉辦過數十次個人藝術展。

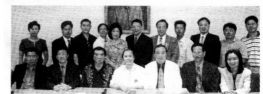

福建同鄉會、美國世界藝術家聯合會等向社區推薦即將舉辦的鄭發祥畫展。前排左四為鄭發祥。　〔郭森攝〕

目錄
Catalog

45、一身筋骨一身鐵 Bones and Muscles all over the Body and Iron all over the Body

46、歲月之痕 The Years' Trace

47、嚴冬消盡春來早 Severe Winter Disappears and Spring Comes Early

48、綠梅錚錚傲霜雪 Green Plum Blossom Clanks to Brave Frost and Snow

49、春光 Spring Scenery

50、願借天風傳春訊 Hoping to Borrow the Sky Wind to Send Spring Message

51、鐵骨屹立 Aweather Passing Writing and Snowflake Standing Towering

52-53、春之聲 Spring's Voice

54、醉春浮羅 Drinking Spring Floats Display

55、春歸大地 Spring Returns to the Good Earth

56、梅花春酒圖 Plum Blossom is Free and Easy in Spring

57、樹立風雪 Trees Stand in Wind and Snow

58、火紅不盡寒春來 Red as Fire Isn't to the Greatest Extent and the Cold Spring Has Come.

59、春夏秋冬 Spring, Summer, Autumn and Winter

60、戰勝風霜骨更堅 Surmounting the Wind and Frost, the Bone Is even more Solid

61、寒凝大地發春華 The Cold Coagulates the Earth and Produces Glorious Flowers in Spring

62、紅梅頌 Ode to Red Plum Blossom

63、冬韵 Winter Rhyme

64、嚴冬過盡縱春雪 Severe Winter Is Over and Releases Spring Snow

65、春的韵律 Spring's Rhythm

66-67、國香頌 Ode to National Fragrance

68、梅花酒圖 Plum Blossom is Free and Easy

69、銀裝 Silvery Dress

70、報春 Reporting Spring

71、香溢寰宇，雀耀春暉 Fragrance Overflows the World, and Sparrows Dazzle Spring Sunshine

72、天涯春消息 Spring Message around the Skyline

73、春光無限 Spring Scenery Is Infinite

74、春信 Spring Message

75、芳溢寰宇清聲人間 Fragrance Overflows the World, and Freshness Sounds around the World

76、早春 Early Spring

77、嶺上紅梅映日紅 Red Plum Blossom on Mountain Shines Red Sun

78、玉艷萬青 Jade Beauty Is Evergreen

79、春潮 Spring Tide

80-81、冰魂皓態古今頌 Ode to the Past and Present with Icy Soul and Bright Posture

82、春消息 Spring Message

83、春妍 Spring Beauty

84、冬韵 Winter Rhyme

85、春花爛漫 Spring Flowers in Full Bloom

86、寒冬的對歌 Cold Winter's Singing in Antiphonal Style

87、怒放的季節 Season is Blooming in Profusion

88、月下美人 Beauty below the Moon

89、梅花歡喜漫天雪 Plum Blossom Joys Snow all over the Sky

90、國香 National Fragrance

91、大地發春華 The Earth Produces Glorious Flowers in Spring

92、歷盡冰霜百練身 Experiencing in Full Ice and Frost, the Body is Tempered Thoroughly

93、素艷雪凝樹 White Snow Coagulates Trees

94-95、東風着意百花開 East Wind Acts Carefully, and Hundreds of Flowers Are Blooming

96、清如許　　　Freshness is so

97、梅花聲蓄幾春秋　Plum Blossom Sound Is Stored up for a Few Years

98、壽相　　　　Looks of The God of Longevity

99、嶺上浮香瑞氣融　Fragrance Floats on Mountain and Lucky Atmosphere is in Harmony

100、春韵　　　Spring Rhyme

101、美德春風香四海　Virtue Spring Breeze is Fragrant all over the World

102、暗香裘袖　　Darkly Sweet Scent and Fur Sleeve

103、報曉　　　Heralding the Break of a Day

104、春歸大地　　Spring Returns to the Good Earth

105、潔心傲骨　　Clean Heart and Unyielding Character

106、占盡春光　　Accounting for in Full Spring Scenery

107、嫣紅朵朵伴情濃，無限生機在此根　Bright Red Flowers Accompanies Thick Affection, and Infinite Vital Force In Rooted Hereon

108、迎春曲　　　Music to Meet Spring

109、鐵骨獻暖心　　Iron Bone Dedicates Warm Mind

110、伍色梅　　　Five Colors Plum Blossom

111、芳溢環宇，清聲人間　Fragrance Overflows the World, and Freshness Sounds around the World

112、鐵幹虬枝占風情　　Iron Trunk and Curly Branches Occupies Amorous Feelings

113、關山第一枝　　First Branches at the Gate and Mountain

114、神州點燃梅花香　　China Ignites the Plum blossom Fragrance

115、香雪撒河山　　Fragrant Snow Scatters on the Land

116、晴雪　　　Fine Snow

117、春陽艷　　　Spring Sun is Gorgeous

118、鐵骨玉姿　　Iron Bone and Jade Appearence

119、墨梅　　　Black Plum Blossom

120、署梅吐艷　　White Plum Blossom Spits Beauty

121、滿月冷挂珊瑚枝　　Plenilune Hangs Coldly Coral Branches

122、嚴寒香溢　　Chilliness Fragrance Overflows

123、雙清　　　Double Freshness

124、寒香圖、國香、鐵骨春　Cold Fragrance Picture, National Fragrance, Iron Bone Spring

125、冷月美人　　Beauty of Cold Mooon

126、人間春情　Spring Affection all over the World

127、鐵骨發新枝　Iron Bone Produces New Branches

128、怒放　　　Plum Blossom is Blooming in Profusion

129、冰魂舞　Icy Soul Dance

130、瑞雪迎春　Auspicious Snow Welcomes Spring

131、深心托豪情，努力愛春華　Deep Mind Supports Lofty Sentiments, and Try Hard to Love Glorious Flowers in Spring

132、綠梅錚骨傲霜雪　Green Plum Blossom and Glossy Bone are Proud at Frost and Snow

133、天姿獨色　　Surpassing Beauty and Unique Color

134、春在枝頭已十分　Spring on Branches is Full

135、梅開五福，年年餘　Plum Blossom Opens Five Fortunes and Every Year Has a Surplus

136、暗香疏影 萬玉爭輝　Darkly Sweet Scant and Sparse Branch Ten Thousand of Jades Vie for Brightness

137、婀娜多姿　　Graceful and Varied in Postures

138、欲綻香英　　Wish to Burst Fragrant Hero

139、夜半梅花入夢香　　Midnight Plum Blossom Dreams Fragrance

140、千秋風韵盡堪傳　　Charm throughout the Ages is Handed down

141、綠萼蔓橫波醉彩霞　Green Calyxes and Tendril Transverse Wave Drinks Rosy Clouds

142、凌空舒鐵梅　Iron Plum Blossom Stretches in Being High up in the Air

143、鐵骨丹心　　Iron Bone and Loyal Heart

144、生命不息　　Life Does not Cease

ISBN 0-9754751-0-X
發行：環球出版集團
Global Publishing Group
NO.1692 86th ST Broodly,Newykrk.NY 11214 USA
Tel:001-718-837-2000 718-435-3805
Executive:Wang jin chuan Wang ying chuan
Translators:zheng yun
Photographer:qiu fu jiang
Bin Ding and Layout Designer:Wang Lin Lin

出版：環球出版社
Global Publishing Group
印制：龍祥彩色制印有限公司 設計印刷